SECRET LIVES IN ART

Also by Jill Johnston:

Paper Daughter

Mother Bound

Gullibles Travels

Lesbian Nation

Marmalade Me

JILL JOHNSTON

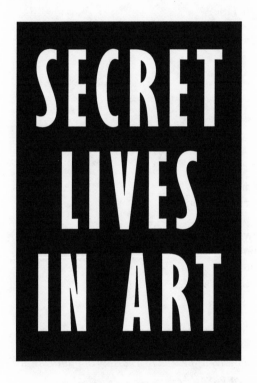

SECRET LIVES IN ART

ESSAYS ON
ART, LITERATURE, PERFORMANCE

a cappella books

Library of Congress Cataloging-in-Publication Data

Johnston, Jill.
 Secret lives in art : essays / by Jill Johnston. — 1st ed.
 p. cm.
 "These essays were previously published, with the exception of the
 introduction"—T.p. verso.
 ISBN 1-55652-233-9 : $24.95. — ISBN 1-55652-232-0 (pbk.) : $16.95
 1. Art criticism—United States—History—20th century. 2. Arts,
 American. I. Title.
NX640.J65 1994
700'.973'09045—dc20 94-25868
 CIP

© 1994 Jill Johnston
Published by a cappella books
an imprint of
Chicago Review Press, Incorporated
814 N. Franklin St.
Chicago, IL 60610

*These essays originally appeared in a variety of publications. A complete listing of
sources is given on page 231.*

Acknowledgments

I am deeply grateful to Ingrid Nyeboe for her support, encouragement, and assistance in the work involving these essays, both in the writing and in the collecting of them.

I thank also Richard Carlin and Chicago Review Press for their interest in collecting the essays. I appreciate Richard Carlin's intelligent organization of them, as well as his friendliness in dealing with many details in the production process.

I owe a great deal to Elizabeth C. Baker, the editor-in-chief of *Art in America*, and Rebecca P. Sinkler, the editor-in-chief of the *New York Times Book Review*. Most of the pieces in this collection have appeared in those publications, and both women have worked with me closely, providing incisive and wide-ranging editorial criticism.

Contents

III

IV

Introduction

This collection of essays, written between 1984 and 1994, represents an integration of commentary on both self and the work of others that seemed inconceivable heretofore. But another sort of integration has perhaps made this possible, and that is the greater incorporation of biographical information about artists into considerations of their work. It was the taboo against even *perceiving* biography as relevant to work that caused me to defect from criticism in the 1960s. Elements of the life were only identifiable as fiction, that is, as attributes of the work alone. Criticism at that time was still essentially New Criticism, or formalist criticism, devoid of information beyond the work itself. The text or picture or dance was as isolated as possible from other features of communication. They were complete, self-sufficient objects, free of the artist's intentions, of historical necessity, and the viewer's own ideas of value and meaning.

During my first life as a critic, before the mid-1960s, I considered my job mainly a descriptive one. Each work was an independent phenomenon, requiring some account of its details to acquit

1

myself, glossed by an implied or direct aesthetic judgment. Gradually I became bored with both my descriptions and my aesthetic ideas, as well as frustrated by the codes polarizing art and life, at length displacing the art object with writings about myself. Unable to integrate art and life, I went overboard for life, projecting my own in lieu, I could say, of all the others. Art and life remained separate in my new enterprise: the writing was the art, which was *about* the life. Years later, during the 1980s, in writing an autobiographical volume, I produced some views connecting earlier writings with the life I had been leading then, using primarily dates to uncover "coincidences" of my aesthetic interests with life passages and problems. It had become clear, for instance, that my interests were inseparable from the people, the artists, who brought these interests to my attention. Seeing myself as having been embedded in a certain "art family," playing a role within it, I could correlate my styles of writing and selective points of focus with hidden agendas for placement within the group, for the fulfillment of emotional needs in general. I could see how it all worked, or didn't work, in both broad and detailed patterns. After completing that volume, I turned my attention to criticism again, hoping to apply methods that had been useful in thinking about myself to others whose work I had once been constrained to consider in such isolation from their lives.

Not surprisingly, my first critical effort, after a lapse of some eighteen years, was lavished on a work actually featuring the life of the artist, one year's worth of it at least, with conditions of "art" laid down on it—that being primarily the artist's attachment by a six-foot rope to a partner during the whole year. Tehching Hsieh, the Taiwanese immigrant artist, was known for his marathon self-brutalizing events. For Hsieh, the *conditions* of his year-long ventures—as in this case the rope binding him to a partner, the documentation (one photo every day and the amassing of other supporting evidence), and announced openhouses for viewing of the couple—were foreground; he saw the life upon which the conditions played as inconsequential. I, on the other hand, saw the art (i.e. conditions) and the life as interchangeable. I saw no "background" here. Nor did I see much background for the work as a whole. The work seemed an immediate metaphorical extension of his life in America as a stranded emigré, or representation in extreme terms of the difficulties encountered in a new world. The life he

lived "inside" the work was predictably hard, given the conditions he created for it. This was not art *about* life. This was art reproducing life by simple artifice. It was a commentary on a kind of life. What was it *for*?

As a critic, what is done exactly is always less interesting to me than why it is done—a question I'm accustomed to directing back to family: the original, the imagined, the constructed. A demonstration like Hsieh's looks like the clear appeal of an outsider for admission, or at least consideration, to an urban art family. With such a view, making him very human, not just a maker of things, we would want to know whether his ploy worked, and if not what his next moves were and if so how that affected him too. His new moves as an artist would be dictated by responses to his demonstration. If accepted or understood, he might, as many artists do, want to go on continuing to feel like an outsider, creating conditions replicating a primary sense of rejection. He might keep doing the same thing until he recognizes what he is doing himself. It's very complex, the mechanisms and varieties of interaction between artist and society.

The huge responsibility of the critic in mediating between artist and society became apparent to me in 1987 when I took on a show by Jasper Johns for *Art in America*. This was a watershed assignment for me in my new life as a critic. Working on the Johns it became apparent that I had unwittingly aligned myself with a theme that mirrored my own. Scores of critics had dealt with Johns before me. A number of them had identified a leading motive in his work: the tantalizing concealment of subjects. Now I would discover this for myself, but in unexpectedly grand style, as by chance I stumbled upon a mysterious figure whose identity Johns had been camouflaging successfully in his work for six years. Tracking the figure was for me a familiar and satisfying quest. It reproduced sensations I have whenever I tackle various projects in search of my own family, in particular the father I never met. Fate had drawn me toward an artist whose drive to suppress information (of all sorts, and in many ways) has been as exsanguinating as my mother's was to make a mystery out of my father, turning me into a vocational detective.

Especially where critics choose their own subjects, I've concluded that a body of their work will end up reflecting any complex at the core of their own story. This would have a significant bearing

on responsibilities to artist and society, for critics to be clear about where they stand, at least to themselves, in relation to subjects mirroring their own.

The essence of my story can be found in *Fictions of the Self in the Making*. Even before my Johns foray, I had grappled with subjects close to the concerns arising from my tale of origins. A paradigm of the absent father in fact informs almost all the choices of subject here, both before and after *Tracking the Shadow*, on Johns. The two Bloomsbury essays for example, one published in the *New York Times*, the other in *Art in America*, are only ostensibly about Bloomsbury and the preservation of Charleston as one of England's treasure-houses. As I say in *Painting Charleston*, the essay printed in *Art in America*, what interested me about the house was Angelica Garnett, daughter of Vanessa Bell and favorite niece of Virginia Woolf, who published a memoir in 1985 called *Deceived with Kindness*, about her early life at Charleston and her position in the family as the illegitimate child of Duncan Grant, whose paternity was withheld from her until she was seventeen. It interested me so much that I arranged to meet Garnett and her English friends in Dallas when they were raising funds for Charleston. The brutality of my encounter there may be implied in the *Times* essay, but is obscured completely in the *Art in America* piece. If I had had my critical druthers, I would have felt free in such exercises to show how my meeting with the English in Dallas precisely reproduced social dynamics and feelings I've experienced in England in pursuit of my father's family—and how this resonated in turn with the background of the Bloomsbury descendant, Garnett, whose story originally hauled me in as a critic.

In an ideal criticism, the playing field leveled through the immersion of critics in the work they describe and interpret, any "story behind the story" would naturally be integrated into the ostensible subject. Such a criticism would no longer be criticism (as we know it), but a true dialogue with the powers that be—those to the right, left, and center of the critic in our class-organized civil democracy.

Problems of critics in deconstructing work can be seen as identical in principle to questions underlying their own lives—universally left unaddressed in the practice of criticism. Roland Barthes has said a text that is readable is composed entirely of what is already known, that the classic realistic text is a tissue of clichés.

What do we know? The imagery and narratives that constitute art discourses are rooted in deep social assumptions, which are things we don't know. The coercive forces of society that act on our lives and impress our work are merely understood, like parts of nature. A meaningful order, or nomos, is imposed on the discrete experiences and meanings of individuals. Cracking art codes is not possible without undermining, or acknowledging, personal prejudice—the "tissue of clichés" by which we habitually perceive the world, and selves in world. Being addicted to the "readable," we're willing to be thrilled by formalist pyrotechnics and the purely aesthetic, or to be reassured by the production of codes mirroring what we already know, whatever won't upset *given* identities. Art reflects our comfortable stations in life. We like that reflection even if we hate our stations. We'll never know the difference if we don't question "what is already known." Once we do, we find a story, or a story behind a story. What was "given" was a story, which we always took for granted. Armed with stories, we approach art with a certain determination to find the story there too. *What's the story?* It's the cliché question voicing suspicion of appearances.

Art is certainly biographically deprived, notwithstanding the fledgling autobiographical tradition that now exists particularly in writing, dance, and performance art. Artists have placed their work above and outside their lives, even if mindful that everything they do is somehow informed by their lives. In *Intimate Moves*, on the Belgian choreographer Anne Teresa De Keersmaeker, I attended work that was insistently gender-specific in its "feminine" gestures, imagery, and narrative, raising in my mind the interesting question if the work was not a *commentary* on received ideas of gender behavior. In talking to the choreographer I discovered that she believed such assumptions. The work, therefore, was an uncritical display, merely a kind of depiction, however artful and original. Obviously even the personal story she was telling (of grief over love betrayed) was dominated by received opinions and formulaic gestures—of how females behave under certain conditions. The "story" was biographically deprived of the story behind it—the commentary on what was socially given or received. Any commentary constitutes another story, newly minted.

All the men covered in these essays had absent fathers—there perhaps but absent for them. The British artist Richard Long may

be an exception. As related in *Walking into Art*, I was unable to get near him. My father project in his case, an odd one perhaps considering his relative youth, appropriate only on account of his gender and nationality, is probably the least transparent of my essays on males. In the case of Robert Wilson, my subject in *Family Spectacles*, also a younger man, his revelations about his own father gave me special insight into his work as well as into my special reasons for identifying with males like him, with absent or antagonistic fathers. Robert Bly was an ideal quarry for me—a father figure himself, with a giant beef about absent fathers. He presented himself as a kindly father, willing to see me as well as impart his own intimacies, and all-importantly as a terrific target. Not content with my identification, or my yearning for acceptance, I had to do him in, expose the sexual politics underlying his message for men, I take my ambivalence in this case to be the conundrum for all women who wish to be embraced, acknowledged, by "the father" and at the same time to terminate his power.

Most of the women in these essays had fathers with whom they over-identified, usually as victims. Combing work for the codes governing art, no critic should miss the various tropes in work by and about women showing how women are *culturally* deprived of fathers. There's a great pathos in women's work generally, at the seam where a personal familial identification with fathers crosses with the power of fathers that obliterates them. Women like Germaine Greer, Canadian novelist Sylvia Fraser, and Musa Mayer (daughter of artist Philip Guston), all represented here in reviews of their books, are clear about their disadvantages in relation to the fathers who held them in thrall. The English artist Dora Carrington, of an earlier generation, was tragically ignorant of her position. Where any woman (or man) is not clear, I find my most interesting work "creatively juxtaposing the facts . . . to discern a hidden picture of abuse," as I put it in *The Inner Life: When Reality Fails*.

Ultimately I look for an end of such "interesting work." Exercising authority of this nature over the work or life of another is not my idea of a liberating activity. And I have no illusions that my methods or interpretations are helpful to artists. My ideal is a playing field where artists, critics, and audiences mutually interact. I imagine getting there through the development of broad consensuses to question all codes governing our shared histories. Unmasking

the various languages that have obscured both our important dif-
ferences and our common roots in culture, we perform acts of
recognition cutting across all the lines of class, gender, race, and
age that divide us.

Fictions of the Self in the Making

I

I've read somewhere that women transform themselves, or set themselves on some path of achievement, only after an awakening. I don't know if this is so true anymore. I'm sure it was generally true before the early 1970s. Before then I had two awakenings myself, both of them pertaining to the vocation of writing. Quite inconveniently, my first coincided with marriage and motherhood, causing a conflict of interest and a burden of responsibility that was simply untenable at the time without extraordinary support.

That was in 1957–58. My "calling" was to nothing more romantic than writing criticism. It was a powerful summons nonetheless, and I was undeterred in its pursuit for seven years (plying my trade in the *Village Voice* and *Art News*). In the end, my awakening helped to cost me my new family.

The conflict between personal achievement and family responsibility also contributed to my second awakening. Now it was the

8

mid-1960s, when waking up was a kind of epidemic, highly communicable, and often fatal. It was nearly fatal for me. But since I survived, another career as a writer hove into view. This time my awakening was of an interior nature. I actually discovered just then that things were going on inside me, that I had a whole life of thoughts, feelings, and attitudes rooted in a past that had been conducting itself autonomously, disconnected from my surface life.

The subterranean thoughts that erupted at that moment consisted mostly of fantasies, centering on my long-dead father, whom I had never met and who had never been married to my mother or even lived with her. Until his death when I was twenty-one, he had always been described to me by my mother as already dead. My new introspection gave me for the first time the striking and novel idea that I had a story.

Until then, evidently, I thought only the world and other people had histories. Or else I thought histories were done deals, full of dead facts, not accounts that people had actually made up (and continue to make up, ever casting the same sets of facts into different accounts) or that I could make up myself. I had been given some facts. Nobody had made a "story" out of them. Somehow I sensed I had a mission here. And I became strongly motivated to write about myself instead of others, or rather the work of others. I converted my criticism for the newspaper into a personal anecdotal column, and by 1969 had signed my first book contract, with the working title of "Autobiography."

II

I've read somewhere that "the woman's quest for her own story" has been the subject of much literature in the past two decades. When I signed on to write my autobiography, I was sure I already had a story. Then it grew clear that I didn't know how to tell it, and that my "quest" would become the search for a method. Gradually I realized, in the course of three unsuccessful attempts (between 1969 and 1980) to fulfill three different book contracts, that the story and the means of telling it are one and the same. "History," Jacques Lacan said, "is not the past," or "is the past insofar as it is historicized in the present." Yet we may be missing essential facts from the past, making the creation of context difficult or impossible. In 1969, for instance, I had lots of facts about my life but I had

yet to learn I was a woman, that is, a member of a (disadvantaged) caste within a political system. This lack of a political vision meant that I didn't know how to assess the circumstances of my birth, much less the consequences of my father's abandonment or my mother's lie. Nor could I appraise the critical conflict I had experienced between family and career. Raised in an all-female family, with a mother who had a career, then sent to all-female schools, clearly once I entered the world of men through marriage, the domain of the father, I was going to find myself in a place I didn't understand. But in order to understand my lack of understanding I would first need to learn that women themselves did not have stories, or were not supposed to have them, that minorities and outsiders in general lacked stories.

The quest for a story is the quest for a life. The search itself is the subject of a new kind of literature, what might be called a plebeian autobiography. This is a most significant cultural development, promising more fatal awakenings than have hitherto been imagined possible, especially once the form is canonized.

III

I've read that Roland Barthes called biography "a novel that dare not speak its name," and that the stories we tell ourselves about the past *become* the past. Eventually that is what I discovered for myself. Recently a friend wrote to me about his dead father, saying that at thirty he thought he was really beginning to understand him. Now, he says, at sixty-five he's finding ever-new aspects: that is, the facts he remembers are the same, but his present-day interpretations are different. His interpretation of the same event is different today from what it was in 1985, 1975, 1960, or 1955.

I wrote back saying how essential the facts are to me, as close as I can get them and maintain them—the birth, death, and marriage dates, recent and ancestral; the names, places, vocations, career moves, travels, family upheavals, illnesses, anniversaries, celebrations; the feelings, the words both uttered and heard, books read, events in their minutiae as well as broad outlines, and so on. We can endlessly move the facts around, make them do things, act on them, pitch them in different contexts.

As we remake the past, we alter the way we see ourselves in the

present and the way we cast ourselves into the future. This is not the concept of the traditional autobiography, usually the prerogative of the famous or powerful, who look back at a life of accomplishment and tell a straight chronological and "factual" story. In 1989, a *New York Times* reviewer of Tobias Wolff's memoir *This Boy's Life* asked rhetorically: "Isn't it premature (if not presumptuous) for a young writer with three slim volumes [of fiction] under his belt to lapse into his anecdotage? Aren't memories, after all, the domain of elders . . . who are persuaded that a summing up is in order?" The judgment the question was playing off was that the life can't be *written*, it must be lived first, then written *about*—provided it meets certain standards of achievement and propriety. Of course, when we write the life, we are making it up (not the facts but the ways of seeing and organizing them), and this is a political act of self-recognition.

IV

I've read somewhere that a certain man—a writer on men's issues— saw the task of life as exchanging an unconscious myth with a conscious autobiography. He saw himself undoing the ways he had been taught to believe a man should be. I don't believe he thought this meant annulling his power, the one attribute on his list that, as a man, he might continue to take for granted. For a woman, a conscious autobiography means facing not only her past as a "female impersonator"—the realization that every accoutrement of her sex has been culturally determined (a counterpart to the male in drag)—but the ways in which she has been and continues to be victimized in that role, even when she no longer looks or acts or dresses or for that matter feels the part.

The efflorescence of autobiography in our time, plebeian by nature, is probably due to the tremendous outbreak of victim consciousness in America, arising from the political consensus developed by the civil rights and women's movements. The traditional autobiography has hardly ever been a medium for victims. On the contrary, it's been a repository for winners, those born that way or those who made it against the odds. Their subject is what has been done; the past is sealed in some achievement. In the new

plebe autobiography, writing and self-creation are synonymous. Like Maya Angelou, the writer may create more than one autobiography, establishing a profession where none really exists. Reality is been construed, rather than merely reflected. *Scribo ergo sum.*

V

I've read somewhere that Käthe Kollwitz, when old, found familial ties growing slacker. She wrote that for the last third of her life there remained only her work as an artist. Possibly when I am *really* old I will find familial ties growing slacker. But in the last third of my life, these ties have tightened around me like the ropes of a racing sloop. I often feel in fact as if I'm in a race—against time. I have family business of a variety that is supposed to occur at a much earlier age. Anyway, it's hard to imagine, like Kollwitz, a life of work not informed by family. To me, life and work are one body, and family is what shapes the life. Family would be powering my life, as it does everybody's, even if I remained oblivious to it. But family, the immediate extension of self, is obviously critical to any writer writing her life, any writer not writing about the life that has occured already.

Most regular people writing their lives are not products of any intact patriarchal family, or else they have come to realize that what seemed ordinary in their backgrounds actually had strange and unassimilable factors. The autobiographies of Geoffrey and Tobias Wolff—*The Duke of Deception* and *This Boy's Life*—told of a family sundered and a father who was a scam artist on a grand scale. Like the Wolffs, Richard Rhodes, author of *A Hole in the World*, and one of two brothers abused as children, sought identity in an early disturbed history, long before achievement takes over as subject.

To establish the normality of every peculiar situation, to help show, in fact, that every situation is peculiar, to institute the centrality of every person, every kind of family, to celebrate difference is the direction of the plebe autobiography. The woman-headed family, for instance, widespread as it now is, is still considered deviant. My postponed family business, focusing as it does on my two children, four grandchildren, and female partner, has much

to do with my struggle to embody an authority that was missing in my early history. My mother and grandmother were good caretakers, but they never assumed the authority of their absent fathers and husbands, could never step into that vacuum. Their lives lacked self-definition. They didn't have stories—or their stories were never constellated.

VI

I've read Monique Wittig, the French feminist, who has said: "A text by a minority writer is efficient only if it succeeds in making the minority point of view universal, only if it is an important literary text. *Remembrance of Things Past* is a monument of French literature even though homosexuality is a theme of the book." I would amend the first part of this statement to read, "A text by a minority writer only succeeds if it becomes an important literary text." Then we could say that the stigmatized subject (any minority) has been overlooked, forgiven, in being subsumed under the category of (great) literature. Wittig's comment about Proust bears this out. Proust's work "is a monument of French literature *even though* homosexuality is the theme." But Proust became a "monument" decades ago, long before the homosexuality in his text was decoded or widely recognized.

Around 1969, I found out that men ran the world, and that I was a member of quite a few minorities. My writing had been developing idiosyncratically, in a hermetic, personal, free-associative manner. Now I had to incorporate political exposition and diatribe. In my own view, politics definitely cramped my style. Between 1969 and 1975 or so I was split between the personal, the literary, and the political, trying to crossbreed them in convincing new forms. I also had my hand at creating the "universality" of "the minority point of view" in *Lesbian Nation*, a personal and political tract but not a unified text.

In my next book venture, my second attempt at writing an autobiography, I opted for literature, aiming to write the third unreadable book of the century—following *Finnegans Wake* and *The Making of Americans*. After all, Gertrude Stein's monumentality was due largely to how she obscured her homosexuality by saying effectively nothing in a prolific and outstanding way.

My sexual orientation by now was no secret but my origins still were. Under contract with Random House in 1975–76 to write a book called *My Father in America*, I delivered 430 pages in a single paragraph, all lower case, minimally punctuated. The book was jammed with appropriations (uncredited quotations) and studded with non sequitur, that smashing device for evasion, digression, obscuration, and escape. At the end my editor was outraged that he couldn't find my father in it. Nor much of anything else, I wager.

VII

I've read Carolyn Heilbrun on Dorothy Sayers. She wrote that Sayers believed her son's "illegitimate" birth to be sinful, and was afraid she might be found out. She also suggested that in her "sinfulness" Sayers's true destiny as a woman was revealed. What does this mean? My mother was eight years younger than Sayers, who was born in 1893, and she, too, was afraid, indeed in mortal fear, of the consequences of having a child out of wedlock. Living independently, outside the bonds of marriage, my mother was freer than other women to pursue her interests. Yet she found single motherhood very difficult. Living in fear, with a secret, under protection of a cover-up, in time she would regard me as integral to the problem of her choice, identifying me with her transgression. She had had to lie and present false credentials, and she could never take me into her confidence. She could never tell me the truth about my father. Her complicated conformity—to the social order that she had defied in having me—set her against me. And I, having no knowledge of the social order that guided her, naturally colluded in her judgment.

Here, I came to believe, was the essence of my story. The facts had accreted in a way that pointed to psychological and political truths. I had been stillborn, legally speaking, without male ancestry or inheritance rights. I was my mother's walking secret. I belonged to a huge unrecognized minority with untold stories. If I was going to exist (bring a story to light), it would only be by exposing my mother and the scheme of the fathers, by (re-)creating my own "past."

In my mother's "sinfulness" lay my own true destiny. Here was an autobiography "that dare not speak its name," one with great novelistic potential. And I didn't have to make anything up, in the

sense that fiction writers invent facts. I seemed ideally "dead" as a candidate for the new autobiography, in which the quest for a life is itself the subject. For me, it began on paper. And in the 1980s, when finally I felt I had the method and a language, I called the second volume of my autobiography in progress *Paper Daughter*.

VIII

I've read Clive James's *Unreliable Memoirs*, in which he says that his ideal of autobiography had been set by Alfieri, the eighteenth-century Italian dramatist and poet, whose description of a duel he once fought in Hyde Park is mainly concerned with how he ran backward to safety. After 1975 I was definitely doing that, though it never seemed necessarily ideal. As I understand now, though, a war was over, and the losers—the backlash against the women's movement already apparent to some of us—had to jump ship and swim for their lives, or go down in a whoosh and bubbles of martyrdom. It was not hard for me to choose. Instinctively, I struck out for shore, not having the least idea what I would find there.

Cut adrift by my newspaper, at first I found no writing assignments at all. To the right of me, the establishment said no, they would not support me any longer in my outrages; to the left of me, the radicals whose causes I adopted and championed said no, they would not rescue me from the establishment.

While my writing career hung in the balance, and the world was changing, my mother, from whom I had long been estranged, was getting ready to die. Evidently my renewed acquaintance with her reminded me of my conservative upbringing, because at length I sat down before a blank page and shaped a sentence, then another and another, as if I were writing a primer.

The pieces I wrote then were perhaps as close as writing can get to the still life. An excess of speed had turned into repose. I had reoriented myself to syntax and common usage. This was important for my autobiographical project because the improprieties of style to which I had been accustomed had not proven the best vehicle for getting my story across. In general, during the late 1970s I was in revolt against my immediate past as an iconoclast. Nothing illustrated this better than my disowning a 1976 Canadian-made film about myself. Seeing myself cavort on screen like a child with no cause, no responsibility, no particular intelligence, I threatened the filmmakers with a libel suit if they tried to show it anywhere.

IX

I've read that Henry James said, "The way to affirm one's self *sur la fin* is to strike as many notes, deep, full and rapid, as one can." In his old age, he felt that all of life was in his pocket, as it were, and he could "try everything, do everything, render everything—be an artist." I hardly feel that all my life is in my pocket. But I like the idea of striking "as many notes, deep, full and rapid," as one can. Implicit in the thought must be the assumption of having a good many notes to strike.

It's true that age brings deepening perspectives and the sense of a big palette. It should also bring, I believe, an increasing sense of the dimensions of what can never be known. When we're young, we think we know everything, and we're constantly surprised by the unimaginable. When we're older, we know we don't know much, and we're no longer surprised by new information. A certain boredom overtakes us. Convinced at last that we can't know very much, we become less avid to learn things, much more occupied going deeper into what we feel we already know. If we can't fit things into what we know, we forget them.

If we *are* striking many notes, they might be heard as one blended, resonant deep chord. Struck therein should be the keynote of compassion. In the New Agey 1970s, 1976 to be precise, during the time of my mother's dying, I was brought by the devotee of some guru to a reader of chakras—those points along the spine designated by yogis as centers of power. This reader told me that my "third" chakra—the one that corresponds in some way with the heart—was pretty faint, and that I was accustomed to drawing the energy up from that point into my head and astral region for intellectual purposes.

It was a fancy, and I suppose tactful, way of telling me I was still rather a merciless person. I took the reading to heart, dwelled on it, somehow let it act on me, giving my mother's death and my family issues a meaning they might never otherwise have had for me.

X

I read everywhere these days that the modern nuclear family is in disarray. This being true, it is also under reconstruction, and not, so far as I can tell, with any one design or blueprint to the exclusion of

others. Our time is a pluralistic and experimental one. In my own case, the notion of recreating the past through autobiography is inextricably tied up in family. Once I realized I was not alone (I did have relatives out there), a refugee from a broken family, blown forever into bits, I could imagine reassembling these parts of myself.

My mother's death planted the foundation of a new house. She had grown up in a large, coherent American family, coherent at least on her mother's side. (Her father had broken off from his side, becoming embedded in her mother's.) Then, with her own independence and a child who embarrassed her, she set the stage for a family inconceivable in her time. I am writing now of a family in the making, the product of a woman (myself) who once supplanted family with her own career of writing, for the reason that the traditional marriage she made, in 1958, flew contrary to the only model of family she knew: a daughter, a mother, a grandmother, and a mother's extended family, which by then was without a visible patriarch.

It's clear to see that women should not have to choose between family and career, that like men they should be free to have both. As women write (or otherwise construct, as in therapies) themselves into existence, reconstituting their own histories, just as clearly they will be inventing new families, reflecting their axial position in the creation process. Some of these new families may look traditional, with a Mom and Dad and the kids and all, but if the woman has succeeded in defining herself, the morphology will be decidedly different. The relationship of the parents to each other is likely to be that of siblings and friends rather than parent (husband) and child (wife), as traditionally understood. And the children are more likely to be recognized as people than treated as property or objects.

For myself, the Dad remains a shadowy figure, in my writing as in life. My plebe autobiography in progress has not encompassed him yet. He's in the works, though, and I've long considered him essential to understanding myself.

XI

Nowhere have I read that autobiography might someday, perhaps soon, constitute a literary genre as persuasive as fiction has been. But even while fiction (and poetry) remain the standard for creative accomplishment in writing, a revolution is taking place, a form is

under development, a challenge to the preeminence of fiction as the creative test for a writer. As the form grows, attracting more and more practitioners, I have to suppose that it will finally be recognized apart from the traditional autobiography. Change is at the heart of the new autobiography. It is never too late to be what you might have been.

As we write ourselves into existence, the class, race, and sexual political structures of society inevitably change. The notion of who has rights, whose voice can be heard, whose individuality is worthy, comes under revision. Ideally, all will be heard and respected. The shame of difference will evaporate. Change will be as fundamental to our daily diet as bread. And as this happens, the culture will expand. We associate culture with the achievers, the "stars," not with the people who live down the street. "Once the landscape is detailed and historicized," Carolyn Steedman writes in *Landscape for a Good Woman* (a narratively spare and interpretively rich English plebe autobiography that came out here in 1987), "the urgent need becomes to find a way of theorizing the result of such difference and particularity, not in order to find a description that can be universally applied (the point is *not* to say that all working class childhoods are the same, nor that experience of them produces unique psychic structures), but so that the people in exile, the inhabitants of the long streets, may start to use the autobiographical 'I,' and tell the stories of their life."

1993

Why Iron John Is No Gift to Women

In 1990 I was one of perhaps millions who felt beguiled and moved by Robert Bly after watching Bill Moyers's ninety-minute profile of him on public television. I had a very uncritical response to the man and the things he was saying. It sounded to me as if he was simply out to improve men, make them into better people, get them in touch with their deeper feelings and what Bly called their "lost fathers."

This could only be good for women, I thought, and I'm sure other women felt the same. Bly himself seemed like an ideal father—huge and accessible, white-haired and kindly, serious but not heavy, funny without being silly, warm and emotionally present. You felt you could know him. What's more, it seemed he had something to teach daughters about their lost fathers too.

Then I read *Iron John*, his "book about men," just out in paperback after sixty-two weeks on the *New York Times*'s hardcover best-seller list, and I noticed a disturbing element in his thinking. Charmed as I was by the television interview, I had not really heard

Bly's leitmotif of male initiation as the exclusion of women. In *Iron John*, you can't miss it. Central to the book is a boy's initiation story, derived from a traditional fairy tale in which the boy is cast as seeker, the mother as impediment, and a girl as the prize at the end of the story.

The theme of the absent father must be as relevant to women as to men, but Robert Bly himself doesn't really think so. He can say, "Much of the rage that some women direct to the patriarchy stems from a vast disappointment over [a] lack of teaching from their own fathers," but his only concern here is the damaging effect of such deficits on "the daughter's ability to participate . . . in later relationships with men." He has no apparent interest in what the fathers' teaching—or lack of it—might mean for daughters entering the world.

Bly is addressing men in his book; yet he has said *Iron John* is a "gift to the community," and he has plenty to say about women in it. In fact, though he acknowledges and perhaps applauds the new enlarged role of women in the world, his program for men, as defined in *Iron John*, depends strictly on women playing their traditional roles at home.

Sometimes Bly says the patriarchy is over, gone with the traditional pre-Industrial Revolution father—that nineteenth-century man whose bond with his sons was still intact when they labored side by side on the farmlands, before office and factory work took the father away. Inescapably, however, both the post-Industrial Revolution father, whom Bly also describes as "dead," and his "new man," now supposedly in the making, remain the beneficiaries of that still thriving, surely healthier-than-ever system of privilege endowing one sex at the expense of the other.

In 1991 I spent a day with Bly, sitting around his kitchen table at his house in Minneapolis. His wife, Ruth, a Jungian therapist, let me in the door. They had recently moved into the house, a large 1899 Victorian dwelling on a broad, tree-lined street. When I arrived Bly was still at an astrologer's nearby, having a reading; I retired to their bathroom adjoining the kitchen to finish blow-drying my hair.

Back at the Marriott, where I had spent the night, I discovered I had forgotten my brush, causing me to look a little wild, in my opinion, as I had used the dryer and attempted to push my hair into shape with my hands. So on my way out of the hotel to get a taxi to

Bly's house, I had bought a brush. I wouldn't have wanted even remotely to resemble Iron John—that streamingly hairy figure (also known as "the Wild Man") in Bly's fairy tale.

If my lapse was telling me something about my subconscious wish to please this author—whose thesis I found regressive—I was happy not to look "wild" when Bly appeared in his kitchen doorway. He consumed the entire space within the frame, it seemed, and looked exactly as I expected he would: gruff and feral, yet benign and wholly accessible. Eventually we pleased each other a lot, though it meant nothing for the future of daughters and fathers. He thought I was lively, he said, and he told me enough about himself to satisfy my speculation that *Iron John* is the story of Robert Bly's own life.

Iron John was originally "Iron Hans," one of the fairy tales collected by the Grimm brothers in the early nineteenth century. In the story the boy, a son of a king, loses his golden ball one day as it rolls into the cage of the Wild Man who has been locked up in the castle courtyard ever since a hunter found him lurking at the bottom of a pool. The Wild Man (whom the king calls Iron John) refuses to give the ball back to the boy unless he opens the cage. When he tells the boy the key to the cage is under his mother's pillow, the boy steals the key and lets him out. Then, for fear of being punished, he follows the Wild Man into the forest.

As mentor to the boy, the Wild Man first introduces him to nature, then sends him into the world to learn about poverty and real people, a period Bly describes as a descent into "ashes." The boy does lowly work until he gets older and finds the kingdom where he's living at war. With the help of Iron John, whom he calls on whenever his need is great, he becomes a successful warrior, saving the king from his enemies and winning the king's daughter in a contest involving golden apples and various horses.

Using the tale as an armature, Bly hangs his social commentary about the state of the contemporary male on it. He sees "thousands and thousands of women, being single parents . . . raising boys with no adult man in the house." And he notes the absence in general of "older men [to] welcome the younger man into the ancient, mythologized, instinctive male world." He says "the old men outside the nuclear family no longer offer an effective way for the son to break his link with his parents without doing harm to himself." Bly thinks it's time for new models.

The creation of a "new man," one worthy to carry on the tradition of patriarchy, inevitably calls forth old myths. With *Iron John*, Bly invokes a long, venerable tradition of stories and rites surrounding male deliverance. Otto Rank, in his 1914 essay "The Myth of the Birth of the Hero" (with which Bly is unfamiliar, he told me), outlined the stories of fifteen such redemptive heroes. Among them were Moses, Oedipus, Perseus, Paris, Cyrus, Tristan, Romulus, Hercules, and Jesus. Typically, these boy children were exposed or abandoned by one or both parents, sometimes suckled by wild animals or a humble woman, and found and raised by shepherds or herdsmen. Ultimately they triumphed over all obstacles to achieve rank and honors, in outstanding cases to found states and religions and so forth.

Robert Bly's life story resonates here. With *Iron John*, Bly, at age sixty-five, has become a father figure to a host of younger men, a highly respected spiritual leader with a clear mission. Though he had visibility in the 1960s as a well-known peace activist and winner of the 1968 National Book Award for poetry, his sudden far greater prominence as a guru for males was the result of a stunning crosslap between personal history and the times. Just when the backlash against the progress made by women took form at the beginning of the 1980s, Bly was emerging from what he sees as a certain lifelong, unhealthy identification with his mother and women to discover his estranged father.

Bly became a champion of men at a time when many males were enduring a crisis of masculine identity in the wake of feminism. He and others (Susan Faludi covers them with panache in her best-selling book, *Backlash*) began seeing what they euphemistically called "soft males"—limp men with low self-esteem and a heightened vulnerability to women, men suffering a remoteness from their fathers and a feminization of sorts because of the women's movement. The backlash has hit women along every front, and *Iron John* has been its most successful literary product. The story of its author, in itself and as cloaked in the book, tells us something about the difficulty many men have in establishing a sense of themselves as sons of their fathers—that is, as heirs to the patriarchy. It also demonstrates the threat posed to many men by even a hint of women's freedom.

Bly, whose ancestry is uninterruptedly Norwegian on both sides and whose forebears settled in Minnesota, was the younger of two

sons and perforce he had to leave home, his "castle," just like the boy in *Iron John*. Bly's father, a farmer, was home, but he was absent anyway as far as the boy was concerned, clearly closer to Bly's older brother. When Robert was ten, his father became even more absent as alcohol overtook him. Bly said his father was not an abusive or violent type of alcoholic; what he remembers is an intense feeling of being left out as his father drank in hilarity with his buddies.

Emotionally, Bly had been claimed by his mother—he told me he "ingested her nervous system." He said his mother "had tremendous shame" since childhood and Bly "took [her sense of shame] in completely."

He described his mother in her marriage as a "codependent" in a house with his father, an alcoholic, "high-powered man"—a woman with "brains enough to get out of the house," who had enjoyed working for a while in the county courthouse, then came back home again, "locked in, by this ogre in his castle."

Bly clearly felt injured by overidentifying with his damaged mother. In *Iron John*, he comments indirectly on himself: "I think men get used to picking up women's pain when they pick up their mother's pain." He and his mother were in the same boat—lacking sustenance and interest from the man of the house. "To be without a supportive father," he writes, "is for a man an alternative phrase for 'to be in shame.'" He told me he blames his mother in a way for the "negative view" he picked up about his father, a view that reinforced his sense of himself as a victim. But he lets his father off the hook here.

A theme of men as victims of women runs through the literature of the men's movement as strong as a fault line. Here is Bly on "the whole experience in this country of young males, '60s or '70s males, who listen carefully to what women have said about their oppression, much of which is absolutely true . . . and they aren't happy, in fact they look beaten up." But others in the men's movement have used even stronger language. Sam Keen, in his best-selling men's book *Fire in the Belly*, writes, "Men are angry because they resent being blamed for everything." Robert Moore, author with Douglas Gillette of *King, Warrior, Magician, Lover* and a Jungian analyst who often coleads men's groups with Bly, says, "It is time for men . . . to stop accepting the blame for everything that is wrong in the world. There has been a veritable blitzkrieg on the

male gender, what amounts to an outright demonization of men and a slander against masculinity."

Bly claims his book "does not constitute a challenge to the women's movement" (which he has said he "supports tremendously"), but obviously it does, if the story of the boy in *Iron John* means anything at all. Crucial to the story is the boy's separation from his mother, who has to stay at home and take care of the boy, for the appearance of a male mentor to be significant or necessary. If the mother doesn't stay home the boy will have no good emotional reason for being pried away. *There would be no initiation story.* At home, she gives rise to the "mother's son," a son unduly attached, in critical need of deliverance. In our unbalanced society, with the father not required to be a true parent in the early stages of the child's life, the mother's function includes not only full responsibility for the early care of boys but also the insult of being left at home in a society that has no respect for domestic work. Bly says boys have to *steal* the key from under their mothers' pillows (to release the Wild Man). Why? "Because [the mothers] are intuitively aware of what would happen next—that they would lose their nice boys."

And we might add that they know their devaluation will be complete as their sons enter the world of men and leave them behind. Male initiation *always* has to do with gender distinctions and the devaluation of women. If women were important, boys wouldn't need to get away from them and mothers wouldn't need to cling to their boys.

So how did Bly get away? His first break came when he enlisted in the navy at eighteen, understanding that of the two brothers, "one of us had to go." It was 1944. Laughingly, he said his father and brother "thought that was fine," that he "might [even] get killed."

After Bly left the navy, he went to college, graduating from Harvard in 1950. Then he descended, like the boy in his fairy tale, to a difficult place—in his case the life of an impoverished poet, with no friends, in New York. His mentor was the dead poet Yeats. I told him I guessed as a young man he would've been kind of nerdy, not caring about football, baseball, beer drinking, the John Wayne ethos, and so on. And he replied, "Absolutely . . . [but] Yeats said I was all right." He became a nature poet, paralleling the

boy's entry into the forest with the Wild Man. But he was also in the world, doing "lowly work" as a housepainter.

After three years he returned to Minnesota and married in 1955. During the 1960s and 1970s he raised a family—he has two daughters and two sons—and led seminars around the country for women on the subject of the Great Mother. Apparently his anger at his father and his denial of that anger helped to keep him in thrall to the "feminine." Though a traditional provider, he had still not escaped what he calls the "force field of [his mother's] bed"— where, it could be said, the "key" remained hidden under her pillow. Possibly the death of his older brother in 1971 stirred some change. He says he was forty-six (and that was in 1972) before he even acknowledged his father in his poetry. To one interviewer, he said that at forty-six he began to "open up his long sheltered masculinity."

It took almost a decade for the transformation to take hold. In 1981 the Lama Commune in New Mexico invited him to lead a workshop for about forty men, and thus was launched his career as mentor to men. He was amazed, as he revealed himself to them, to hear echoes of his own problems with his father. During the 1980s he says he acquired male friends for the first time, and successfully confronted, or approached, his father. He no longer led women's groups. He remarried in 1980, shortly after he and his first wife divorced (to one interviewer he said that "sexual intimacy" came back to him in the 1980s), and he told me he stopped colluding with his mother and leaving his father out.

Bly ended his conspiracy with his mother by pointedly excluding her—as his fairy tale demands (*now* he had the key). His father was in bed in the mid-1980s with part of a lung removed. When Bly went to see him, he was in the habit of visiting him briefly in his bedroom, then spending an hour and a half in the living room talking with his mother, saying good-bye to his father in the bedroom before leaving. So Bly told me he began to imagine, "What does he think when he hears the son in there talking to the mother—that's nice, he has a good relationship with his mother? And eventually I realized I'd been in conspiracy with her and I said I'm gonna have to end this . . . so I'd go and sit down by my father, and my mother would wait for me to come into the living room . . . and now I wouldn't; I continued sitting in there, not

saying much, and then she'd have to come in and sit down on the bed . . . nothing was said, but it became clear.

"When I realized so many . . . other men had a similar grief [about their fathers] some change happened in me. I stopped regarding him as a peculiarly rejecting father—it was just a father. I thought, when one changes, the other changes, so I walked in; my father looks at me, he said 'What've you been writing lately?' I looked under the bed, I mean who could it be? And I didn't say anything, and he said 'What are you writing these days Robert?' And I said well I'm writing a book in prose about men, and I've written about eight poems on you, do you wanna hear 'em? He said, 'yes.'" So when Bly went again he read one to him: "Here's a small bird waiting to be fed, mostly beak, an eagle or a vulture . . . I do not want or need to be shamed by him any longer." That was the critical line. Bly said, "He heard me, and that was an amazing thing for me."

And as all this was happening Bly was elaborating his initiation story for boys, and becoming Iron John himself, a kind of "male mother"—that nurturing, life-giving prototype variously identified historically with shamans, holy men, seers, witch doctors, gurus, a personage always qualified to rip off the function of the mother and give second birth to her sons, ushering them into the world of fathers. Bly was a man who knew the thirst of men for what he calls the "positive father substance" and could help lead them to water.

Before I left his house in Minneapolis, he had the idea of leading me to Canada. Although the men's groups Bly leads exclude women entirely, and he firmly told me that I wouldn't be allowed in, even as an observer, to one of these, he does from time to time lead mixed groups. In a week or two he was going to guide a group of about 450 men and women, on a university campus north of Toronto, with Marion Woodman, another Jungian analyst, and he thought I would find her ideas compatible with mine. I did go there, and I didn't find her ideas compatible at all, but I discovered the full scope of Robert Bly the performer—a phenomenon of rare virtuosity and ardor. He's a stand-up comic, troubadour, storyteller, literary critic, group therapist, and emotional catalyst all in one.

These "conferences" are the sort of thing I avoid like violent movies. I've never considered for a moment dancing, shouting, exercising, drawing trees, or *sharing* with a horde of strangers.

Thus I hovered on the outskirts, just watching Bly do his thing. Once during an "exercise" break, he passed me in a 450-person conga line foolishly snaking through the auditorium seats, and he made me join the thing. At one point, after Bly asked for volunteers—six men and six women—to come on stage and tell the audience, in two and a half minutes each, what made them angry about the opposite sex, the whole group separated.

The men stayed with Bly in the auditorium, the women went with Marion Woodman across the campus to a gymnasium. I went reluctantly with the women and heard more sad stories and complaints about men, none of them grounded in any feminist context. Their leader, in any case, I learned later from reading some of her stuff, is someone who believes, among other things, women should stop trying to be men in the world and return to "feminine" basics. Before leaving, I had lunch with Bly in his star suite, where I told him I would have liked to stay behind with the men when the group was segregated. He smiled mischievously and said he was sure that could've been arranged. It was polite of him, and perhaps signified a desire to perceive me as a "token," but his traditional, prefeminist understanding of gender makes him powerless to lead daughters in general into the world—that is, into "men's societies."

In all the men's literature I've read, only Robert Brannon—an editor and a scholar who knows the men's movement from its early days (beginning in 1970) when it was completely an adjunct to feminism—registers an objection to exclusive men's groups. In a recent article in *Man!* magazine he says, "We have a responsibility not to discriminate," and that "it's not very different from having an event that is open to the public except for people who are black or Jewish. When women are excluded because they are women, how different is it from a 'whites only' sign?"

But Brannon acknowledges the oppression of women *as a class*. Given the many angry statements by men about themselves as victims of shaming (by women), it's clear that they see *themselves* as an oppressed class—and, as such, entitled to exclusive meetings to redefine their position, search out a new identity, and regroup apart from those they feel have tarred them. The drumming, chanting, and other ritual acts intrinsic to the men's meetings could be said to help them restore their sense of lost power. But the fact is that white men are not an oppressed group. These meetings smack of the paranoid and racist overreactions of the David Dukes of the

world, who feel that white (male) societies are threatened by black advances, however minuscule these advances actually are.

Bly has gone from one extreme to the other. At one time he identified regressively with the matriarchists, leading those Great Mother seminars, imagining that we'd all be better off if we set the clock back thousands of years and reclaimed the values of the so-called feminine. Now, just as romantically, he would like to reclaim a certain traditional masculinity: a state where fathers and sons were bonded in a common all-male workplace. To facilitate rebonding, he figured out how to adapt the "feminine," or co-opt it, by dredging up an old model of masculinity, hidden within the patriarchy, which incorporates it—the "male mother." Bly, Joseph Campbell, another mentor of his, and Carl Jung—the great touchstone in the "mythopoetic" men's movement—are fine examples of the type. The Wild Man is someone who knows the mother well and has fought successfully to inherit the mantle of the father, making him an ideal figure to deliver the mother's boys to the world when her job is done.

Bly, like Jung before him, is caught up in the "archetypes" of the masculine and the feminine. Men and women are defined by a given nature, fixed and unalterable, cast as opposites (the feminine embodying Eros, the masculine Logos) in a system reflecting the political status quo, under the guise of political ignorance. Bly never grasped, it seems, the core concept of feminism, that the attributes of masculinity and femininity are cultural fabrications, rooted in a caste system in which one sex serves the other. You can tell he missed the point and instead imagined that feminism meant the idealization of "the feminine," the reclamation of the Great Mother, when he says, "More and more women in recent decades have begun identifying with the female pole, and maintain that everything bad is male, and everything good is female."

Under the influence of feminism, that was the unfortunate polarization *he* made. And now, under the influence of the backlash, he finds that "everything good" is male, or some mythic good male, now being reclaimed. He would like to reassure us that the Wild Man is no savage or killer, but rather a man of a certain "fierceness"—in touch with his elemental nature, a primal masculine force or something. But I think the distinction, whatever it is exactly, is irrelevant to the concerns of women. Women are used to the whole gamut of men—from savages to soft guys—and they can't

be that impressed with the benefits conferred on them by "nice ones" when they're still far from having political equality. Possibly Bly et al. suspect that if their "new man" is reassuring enough, women will be better persuaded to continue in their historic roles: stashing keys under pillows and playing "mother."

Bly's whole initiation structure is based on an old concept of the mother, now grossly belied by the droves of mothers out in the workforce. Has he forgotten about his mother's pleasure when she got out of the home, working at the county courthouse, making brief escapes from the man who dominated her, tasting a bit of economic freedom?

To make himself truly useful, the Wild Man could go back to the "castle" and relieve the boy's sisters, who not only come and go every day, taking part in the boy's world, but also take care of the business the boy leaves behind at home.

But we also need wise men like him to help introduce the mothers and sisters to the world. Many women are still bewildered and intimidated by the rules of a game they never learned. Our culture is desperate for change: men need to be initiated into primary parenting and real domestic responsibility, as well as the world; women need to have the onus of total parental obligation lifted, and to be afforded the complete set of keys for admission to the world.

1992

Sins of the Fathers

With *A Dark Science: Women, Sexuality, and Psychiatry in the Nineteenth Century*, Jeffrey Masson, who inspired the wrath of the psychoanalytic community in 1981 by making public certain damaging material about Freud that had been previously withheld, provides a kind of appendix to his first book, *The Assault on Truth*, subtitled *Freud's Suppression of the Seduction Theory* (Farrar, Straus & Giroux, 1984). With the earlier book, Masson hoped to incite a revolution within psychoanalysis, if not its very downfall. It focused on that dramatic year in Freud's life, 1896–97, when he renounced his so-called seduction theory, according to which the disabling illness known as hysteria, afflicting women primarily, was caused by sexual abuses in childhood. This renunciation represented a fundamental shift in Freud's thinking toward the belief that the accounts of violence reported to him by his patients were largely fabrications.

Freud first announced his reversal in a letter to his close friend Wilhelm Fliess dated September 21, 1897. He now believed that "such widespread perversions against children [were] not very probable," and he could no longer accept "the surprise that in all cases,

the *father*, not excluding my own, had to be accused of being perverse." Masson holds in *The Assault on Truth* that a botched case of Freud's—that of Emma Eckstein, whose story he outlines in some detail—may well have been a key influence in Freud's abandonment of the seduction theory. Emma Eckstein nearly died when Freud referred her to Fliess (an ear, nose, and throat physician), who operated on her nose, apparently to "cure" her of her masturbatory habit, leaving in, by accident, a half meter of surgical gauze, which subsequently caused massive bleeding. Freud ultimately exempted his friend from responsibility, and decided that Emma had bled out of longing for the psychoanalyst!

In *A Dark Science*, Masson follows up this horror story with a catalog of abominations that were practiced against women and children by medical science in the nineteenth century, and in which he finds the context for Freud's thinking. Masson selected eleven cases representing nine physicians from what he considered to be the major French and German psychiatric, pediatric, and gynecological journals between 1880 and 1900. These case histories make, as feminist professor of law Catharine A. MacKinnon puts it in her preface, pornographic reading. The small selection includes a tale by one Auguste Motet about several children whom he examined and deemed to have "falsely accused" some adult of abusing or molesting them. A text by another French physician, Alfred Fournier, describes a common belief at that time: that children fabricated stories of having been raped or abused for purposes of blackmail or revenge.

But Masson's true list of atrocities describes the work of those doctors who either castrated or maimed little girls and young women in order to "cure" them of their hysteria or habits of masturbation. In one example of the latter case, two small girls suffered incredible torture, culminating in cauterizations (burnings with red-hot irons) of the clitoris that would make *The Story of O* sound pale. The selections in this book are mostly gross examples of the (still) prevalent attitude that victims are to blame for their own fate.

Though Masson conjectures that Freud may have actually begun to believe that his patients were lying, Masson's judgment of Freud's recantation is fairly clear: he had a "failure of courage" and diabolically changed his theory to save his professional skin. Other readings of Freud suggest a more complex, richer version of his

great crisis during 1896–97. In the furor over Masson's findings
and excommunication from the psychoanalytical community, two
outstanding works by women dealing with the same subject have
been overlooked.

Marie Balmary's *Psychoanalyzing Psychoanalysis: Freud and the
Hidden Fault of the Father* was published in France in 1979, and in
the United States in 1982 (Johns Hopkins University Press); Marianne
Krull's *Freud and His Father* was published also in 1979, in Ger-
many, and came out here in 1986 (Norton). The approaches of
these two women are wildly different, yet on several essential
points they agree: (1) no account of Freud's life and work means
much without considering his family background; (2) the life of
Freud's father Jakob contained secrets that were hidden from Freud
and that vitally affected him; and (3) the death of Jakob Freud had
everything to do with Sigmund's abandonment of his seduction
theory.

Nowhere in either of his two books does Masson mention Freud's
father—a remarkable omission considering how central fathers are
to Freud's original seduction theory. Freud himself, as Marie Balmary
makes very clear, never mentions Laius, the father of Oedipus, in
any of his writings (except in connection with Oedipus's crime),
and it was the Oedipus complex, following the death of Jakob, that
Freud developed to replace his seduction theory. Some guilt of
Jakob's must have been transferred to his son, who evolved a
theory making sons in general responsible. With the Oedipus com-
plex, Freud truly reversed himself, substituting for the misdeeds of
fathers the murderous desires, or fantasies, of sons. During the year
following Jakob's death, Freud initiated his self-analysis, with-
drawing his attacks on fathers, finding aggressive impulses in child-
ren toward parents.

By using Freud's own method of psychoanalysis—to regard an
omission in the course of an analysis as an effort at concealment,
and to seek causes behind ostensible causes that are insufficient to
explain symptoms—Balmary dismantles Freud's Oedipal defenses,
brilliantly connecting his preoccupations with his protection of his
father.

The work of both Balmary and Krull is based on important
discoveries made in 1968 by Josef Sajner and Renée Gicklhorn,
who examined the state archives of Freud's birthplace, in Freiberg.
There they found that Freud's father was not married twice as

everyone, including Freud, thought, but three times. Freud's mother, Amalie, was actually Jakob's third wife, and she was preceded by "Rebekka," who disappeared mysteriously from both the registry and Jakob's life. They also found that Freud had been born eight months after his parents were married rather than ten months, as his mother had told him.

Because there was a cover-up, a fault or a scandal is assumed, though its exact nature is still uncertain. But the omission of Oedipus's father in Freud's writings tallies perfectly with Freud's cover-up of his seduction theory—that is, "the fault of the father." Balmary asks: "What happened before the birth of Freud?" For these two questions are really one. Just as Freud isolated Oedipus from the story of Oedipus's father—and so appeared to make Oedipus alone responsible for all that befell him—so Freud leaves his own father out of his life story, constructing a theory that would absolve fathers in general.

The faults of Laius were outstanding. He caused the death by suicide of a king's son whom he had abducted and enjoyed homosexually; he violated the interdiction not to have children because of his first crime; and he concealed this violation by exposing his son, Oedipus, to the elements. The fate of Oedipus, then, is completely related to the sins of the father. As Balmary observes, "Freud seemed to have ignored that Oedipus had invented neither the murder of a parent nor the union with a forbidden person; that the first murder was committed not by the son but by the father; and that the first sexual crime is not attributable to Oedipus."

Jeffrey Masson, in his way, has become another Oedipus, as Freud saw the mythic king: a man who has committed a "crime" against the father (Freud), and who has therefore been victimized by the psychoanalytic profession (of "fathers"); a man who never mentions his own father, and who, like the father, shows signs of needing to be rescued. Masson has aligned himself with feminists, who themselves have taken an interest in his work. But, for women, the exposure of more crimes or atrocities by "fathers" in something like *A Dark Science* can be deceptively helpful. Such presentation of brute fact remains an important step in liberation. But, the mediation of facts by insights that would help victims understand their oppressors is essential in the full liberation process—not to excuse the oppressors, but to learn several vital things: how to stay out of their way; how to identify them; how to take responsibility for

themselves; and how not to become the oppressors once they stop being victims.

Masson has to be a curiosity for women. His real issue is his personal struggle with male authority figures, living or dead, and women simply form a coincidental part of his problem.

1987

Daddy, We Hardly Knew You

A subtitle for Germaine Greer's book *Daddy, We Hardly Knew You* about her father could be "What's in a Name?" Or better, "What Sin a Name?" For two uninterrupted years Greer searched on several continents for her father's origins under her surname of Greer. At the end of her search, she discovered that her father was not a Greer at all. "Daddy"—Eric Reginald Greer— turned out to be a colossal liar and impostor.

This is a very sad story, which his daughter glosses with her rage and transcends with her vast knowledge of all sorts of things. At the same time it's a significant allegorical tale of a daughter's search for identity. To know who we are is to know, in a most important sense, what's in our names. Daughters still receive their surnames conditionally. They belong to their fathers until they marry, when they adopt extrafamilial names. And even if they don't marry, they are not bonded by name with their fathers the way sons are. Family research by daughters is an exercise in self-empowerment, in (re)claiming both paternal lines, the father's and the mother's,

which is so much more difficult to recover since the names keep changing in the maternal line.

Greer always felt that she was her father's daughter. She resembled him strongly, and she imitated him unconsciously. With *Daddy, We Hardly Knew You* she has made the imitation manifest. Driven to achieve from a young age, a denizen of libraries, propelled from her native Australia by a scholarship to Cambridge University in England, Greer duplicated her father's life of exile from his origins. Going back, rooting around, uncovering lies, his daughter found out what made her learn and what made her run.

Sometime after Reg Greer died in 1983, Germaine Greer was given "a lot of money" by the British publisher Hamish Hamilton to write a book about her father. Greer had inherited no money or property from him, but she had an outstanding legacy of suspicion and wanted to know who he was. Her father was a man without a past. Greer, who was born in 1939, had no information whatsoever about his family. She did grow up with him, but she and her mother, sister, and brother never asked him any questions. And he had a good act. He was a *"toff"*—"so affable, so genteel, so well-dressed, so nicely spoken."

Reg Greer sold advertising space in a Melbourne newspaper. His wife and children always believed he was born in 1904 in Durban, South Africa, of English parents who were traveling to Australia; that he went to school in Launceston, a city in Tasmania; and that at some point his parents had returned to England and died.

Greer's book reproduces the frustration she endured in her quest. She keeps us waiting for passages, pages, even chapters, as she digresses most knowledgeably, often entertainingly, on subjects of background interest to her story or of apparently no relevance at all. There are, for example, two chapters detailing the appalling conditions on Malta during World War II; the siege, the blitz, the disease, the destruction; and what it must have been like there for her father, who spent eight months working in damp tunnels as a secret and confidential publications officer for the Royal Air Force, decoding enemy messages. In one chapter, actually called "Sidetrack," her account simply turns into a travel book as Greer traverses the length and breadth of Australia five thousand miles in all, describing the hills, the great eucalyptus trees, the vegetation, the wildlife, and the terrible things the settlers have done to the land.

On this trek she was supposed to be looking for Greer relatives,

but by then she knew she wasn't likely to find any, and she doesn't bother her readers with the search either. Readers might want to skip ahead to pick up the narrative proper. It's a great mystery story that is frequently overtaken by asides.

What Greer was lacking in knowledge of her father she makes up for with her lore of her father's homeland. Finding nothing, she fills the vacuum with the large metaphor of country—father and land being loosely synonymous. Along the way, especially when more directly on the path of the quest when the quarry seems hot, she unloads some marvelous theatrical prose. An episode on the road when she avoids killing a kangaroo rather spectacularly with her rented Holden car is my favorite. But I'm partial as well to her descriptions of the incredible bureaucratic obstacles thrown up against people doing family research, not least of them the truculence or apathy of the clerks in the various houses of records. Anyone who has done this kind of search—and I've been to the wall, and over, in Britain—will identify with Greer's frustration, admire her persistence, laugh at her accuracy, and rejoice in her discoveries.

At last, after two years of investigating Greers in Britain, Ireland, South Africa, and four Australian states—having written over fifteen hundred letters to Greers everywhere and to many family historians researching Greers, having visited numerous Greer graves, appeared on television talk shows, and published her father's picture in mass-circulation newspapers—the sleuthing daughter struck gold in Tasmania. Four friendly archivists assisted her in the final stage. It was a Miss Record who actually delivered the name.

Greer was ecstatic. "We've got him! Got him!" she exulted. And "Liar! Liar! Liar!" she laughed and yelled as she tore along the road to Launceston to find the descendants of the foster family who raised her father. She found out that her father's foster mother, whom Greer calls the "heroine" of her story, had raised altogether over twenty-five children. It may be difficult at this point to identify with Greer's feelings. I was transfixed by the story, dismayed by a couple of Greer's responses. Triumph, yes. Rage for a time, definitely. Gloating too, maybe. A furious and lasting contempt, not so good. The disappointment, of course, was great.

She asked herself, "Did you really think you'd find out your father was a brilliant refined young man with a great future and distinguished connections who just happened to lose touch with his

family?" She did. She thought "he was a prince in disguise." She had not even been able to turn her father into a war hero—mustered as he was out of Malta with an "anxiety neurosis." But as accumulated incidents proved to her—and most damning of all— he had not loved her!

If one of the traditional barriers between daughter and father— the daughter's destiny as the child who will give up her father's name—didn't exist in this case, a more serious barrier did stand between Reg Greer and his daughter Germaine. The father never knew his own original name or the identity of his parents; he changed his foster name and covered his tracks in other ways as well, and left home in Tasmania without looking back. Evidently he feared his eldest child's intelligence and curiosity. He maintained a lofty distance, expressing little or no interest in her. She says he never read a word she wrote or saw or heard any program she made. He certainly never protected her from her mother, who was rather mad as mothers go.

In the end Germaine Greer can't reconcile her father's lack of love with her understanding of the fear that made him lie to conceal his lowly origins. His lie gave her her freedom—to exist, to make something of herself in a new world and then, after he died, to recover the truth, redeeming father and family. But the lie still leaves her feeling gaspingly betrayed.

What's in a name? Here it was a whole personal tragedy rooted in the terrible social coercions of class and patrimony. Greer has undertaken, in her words, "the most important quest" of her life. Possibly her next project will be to fulfill another articulated goal: Early in the book she says, "This business just has to be lived through, if I am to grow up to the point where . . . I forgive my parents."

1990

Lies My Mother Told Me

Wendy W. Fairey writes that her mother, Sheilah Graham, the Hollywood gossip columnist and lover of F. Scott Fitzgerald, always said "Je suis mon ancêtre," meaning "she had created herself—her history, her success—and was her only point of reference." Indeed, Graham had an amazing story, and she celebrated her self-creation in nine autobiographical books. With *One of the Family*, her first book, Fairey intelligently advances that project, and by adding her own story tells the part that her mother never could.

Sheilah Graham, who died in 1988 at the age of eighty-four, "was a woman who lied all her life," her daughter writes. It was not until Fairey was fifteen years old, in 1957, that she discovered her mother had obscured her humble beginnings. She was born Lily Shiel in England, the youngest of six children of Russian Jewish immigrant parents; her tailor father died when she was an infant, and she was placed by her mother in an orphanage when she was six years old. The vague story Graham successfully perpetrated about herself was that she had been born to an upper-class English family but had become a showgirl and later a journalist because she

41

found society boring. With the publication in 1958 of her first book, *Beloved Infidel,* commemorating her love affair with Fitzgerald from 1937 to 1940, Graham perforce came clean about her past, or some of it.

Fitzgerald was perhaps one of just two men Graham ever loved. She adored her first husband, Maj. John Gillam, who was more than twice her age and delivered her from poverty when she was young; he taught her many things in his Pygmalion role and cheered her on as she lied her way into English society. When Fitzgerald died, she longed at the age of thirty-six to have a child. Born twenty-one months after Fitzgerald's death, Wendy Fairey was supposed to be a boy, to be named Scott, she reports, but was viewed in any case "as a substitute for the love that [her mother] had lost." Fitzgerald was the "spiritual father" to Sheilah Graham's children (Wendy Fairey has a younger brother, Robert, a writer of detective novels) and, as it would turn out, the only father she ever really allowed them.

A practical and clever survivor, Graham made her children legitimate by marrying a man she fooled into thinking was their father, altering her marriage date somewhat, and going to her grave with the secret of her children's real paternity. This is where Fairey's story really begins. Six months after her mother's death, Fairey was informed by a family friend that her actual father was not Trevor Westbrook—the Englishman her mother had so guilefully married (and never lived with, by the way)—but the English philosopher Sir Alfred Ayer, a family friend, whom Fairey had not met until she was eleven.

She was ecstatic to learn that this man from the inner elite of the Eton-Oxford intellectuals, whom she had always greatly admired, was actually her father. But was he really? Part of the interest of Fairey's book lies in her tracking the clues, some more convincing than others, to establish with certainty the identity of her father. Most convincing of all is the fact that Freddie, as Ayer was known to family and friends, himself claimed paternity. "I am your father," he wrote to her, adding, "Your mother and I became lovers in New York during the winter of 1941–42." Ayer was in the process of divorcing his first wife then, and Graham had told him she "married Trevor Westbrook in order to legitimatize her child."

Like many children who have been victimized by a parent who lied to survive or better themselves, Wendy Fairey has the classic

compensatory drive to tell nothing but the truth. Call it revenge, if you like. In writing a book that resounds with authenticity, she exposes her mother's transgression, and indicts her putative and real fathers as well. Yet she revered all her parents (except Westbrook, but most of all Fitzgerald), if only for their status in life. One of her struggles is to reconcile her awe and sense of privilege with her experience of her parents as people and with the wound she sustained as the child of a lie. Her chief struggle has been to find out who she is apart from her beautiful, outstanding mother, who essentially played both mother and father.

Sheilah Graham takes her place, in her daughter's memoir, among a select company of accomplished women of the post-Victorian generation who found themselves in awkward situations, trying to have a child while remaining free of marital enslavement (Dorothy L. Sayers and Rebecca West come readily to mind). It may seem surprising that Fairey makes only a single reference, given its boldness and clarity, to her mother's status from a feminist point of view, especially as she concludes that she "built" her mother "into a kind of feminist heroine: a woman whose lies reflected a virtue of autonomy—she did not need fathers for her children." This sense of her mother is quite overridden in her book, as we might well understand, by the consequences for herself of that autonomy. "What worried me was . . . my fear that harboring a guilty secret had set my mother against me."

However, Fairey, a professor of English and a former dean at Brooklyn College, admirably fulfilled her mother's dreams. Where Sheilah Graham once escaped the London slums, her daughter brilliantly escaped the glitter and superficiality of Hollywood, her mother, and her "lucrative but ignoble profession." The ghost of Fitzgerald, who had educated Graham in his famous "college of one" reading course, hovered over Fairey's academic progress and triumphs. She says, "My mother wanted to be a serious writer." And with her thoughtful, literary autobiography, Fairey has become just that.

1992

Divided Against Her Father

Near the end of her autobiographical study, *My Father's House*, the Canadian novelist Sylvia Fraser says, "Imagine this: imagine you discover that for many years another person intimately shared your life without your knowing it." With this mild injunction, she has precisely described the amnesia that is the outstanding feature of the amazing and bizarre syndrome known as multiple personality disorder. She has said it, however, only to dramatize the effects of her personal experience as a victim of this kind of amnesia. In her late forties, the author discovered that another self had periodically taken over her mind and body since she was about seven. Fraser never uses the phrase "multiple personality" in her book, perhaps because she is unaware of the term—not surprising when so little is known about the phenomenon. Mental health professionals themselves are just beginning to come to grips with it; in 1980 the American Psychiatric Association published new diagnostic criteria and therapeutic guidelines for multiple personality disorder.

No guidelines or criteria are necessary to grasp this extraordinary tale of incest and child abuse. The defense young Sylvia Fraser created against such abuse—an alternate personality—while not clinically identified, is sharply delineated. Unwittingly, perhaps, Fraser has provided specialists and general readers with a striking example of the entwined phenomena of child abuse, incest, and multiple personality.

In Fraser's case, her father's continued sexual abuse of her, from the time she was two and a half until the age of seventeen, when she left home for college, was compartmentalized in such a way that just one extra personality was created to deal with it. Technically, hers is a case of *dual* personality. In most of the cases with which we're familiar—Eve, Sybil, Billy Milligan, most recently Truddi Chase, all subjects of popular books—the victims developed a number of personalities, not only to cope with the trauma itself but to protect themselves from barbaric childhood environments. But whether dual or multiple splitting occurs, the genesis, mechanism, and functions of the disorder are the same.

Unable to cope with her father's demands, yet required to do so by threats, force, and the fear of not being loved, by the age of seven Fraser unknowingly split herself in two, designating the "other" or submerged self to carry on the unwanted affair. She then was able literally to forget about it. Every time her father had sex with her, she blacked out or went into a "fugue state," her other self taking over. Typically, though she knew nothing of this other, "bad" self, the "bad" one knew all about her. Until she was forty-eight, the author had no memory of the abuse. In a sense she was able to "sleep" through the horrendous times of violation.

The function of multiple personality is to protect the child. One or more spontaneously conceived personalities arise and intervene to hold the pain, feel the grief, experience the event, and keep the memories. In complex cases, different personalities emerge. The core personality sleeps on, having very little life of its own, becoming subject to all kinds of bizarre experiences, "waking up" for instance in a strange place perhaps days, often *years*, later.

Sylvia Fraser's book is the first by a victim of multiple personality who happens to be a professional writer. Her previous five works of fiction, she implies, were preparations for this important task of autobiography. She says, "My life was structured on the uncovering of a mystery." That she has not given her illness a technical

term, whether purposely or not, has its refreshing aspect. Without being distracted by the "freak" element, one can relax and enjoy Fraser's writing, which is rich yet superbly honed. Her narrative of growing up female in the North American middle class of the 1940s and 1950s is as telling a chronicle of the times as *The Catcher in the Rye* or *To Kill a Mockingbird*. And the story is developed at the pace of a good novel. The book is, in fact, a case history that doubles as literature.

But it's something more as well—a fast-moving detective story in which the author uncovers her own past as victim, leading us deftly toward the dramatic moment in her late forties when she recalls a memory of her "other self." We already know about this self because the author has interspersed her narrative from the beginning with italicized passages representing the dreams, thoughts, feelings, and experiences that she pieced together from retrieved memories after her revelation. An amazing aspect of Fraser's story is her spontaneous recovery. She indicates having undergone some Jungian and Freudian analysis (learning, she says, how to interpret her dreams), but in the end, after these and various alternative therapies (Rolfing, yoga, etc.), and following a close encounter with death, she reports having her first recollection of childhood abuse on her own—at what she calls a "banal" setting of lunch with friends. She then sought professional help from a hypnotherapist to recover specific memories. It's impressive that Fraser then moved on to resolve her family conflicts.

Today, her father has died, her mother is aged, her only sibling, an older sister, lives far away. The rage that manifested itself in childhood in unaccountable convulsions, periods of screaming and choking and turning blue, as well as "normal" fits of anger, has been assimilated, and she has turned to the work of dissecting her "family romance." She says she "became the other woman before she was five." She knows that her father "expressed his love in a perverted way," that she was a stand-in for her mother and that her mother not only failed to protect her but was so unconsciously enraged by a rivalry she couldn't acknowledge that she stigmatized her younger daughter as the "bad" child.

In a moving conclusion, Fraser grants her dead father her under-standing and forgiveness, and confronts her aged mother with the devastating information of her father's criminal acts. She also enlists her sister's help in corroborating the past.

My Father's House is a stunning example of what could be done to change society through the affecting, self-observing, literary enterprise of victims. Autobiography of this dimension could play a part in understanding and eventually in stopping family crime, from which many other crimes arise. Sylvia Fraser demonstrates that the cycle of abuse (the villain/victim/rescuer patterns in all families) can stop with the victim only when *she* decides to cast off the role.

Fraser may be right when she says, "All of us are born into the second act of a tragedy-in-progress"; but she is surely still speaking only for herself and a vanguard when she adds that we "then spend the rest of our lives trying to figure out what went wrong in the first act."

1988

Living on Borrowed Importance

After Philip Guston died in 1980, a homage to him in the form of talks and remembrances by friends was produced by the Poetry Project at St. Mark's Episcopal Church in Greenwich Village. Musa Mayer, Guston's daughter, recalls her contradictory feelings about the event in *Night Studio*, an intimate memoir of her father, her first book. She wonders what was wrong with her, why she couldn't pay homage too, why she couldn't be grateful for the small part of him she had known, her share in the myth of the great artist—without being bothered by reminders that he had never measured up as a father. Throughout her book, Mayer poses Guston the man against Guston the famous painter, searching for her own identity in the chaotic impressions of these opposing states. As much an autobiography as a memoir of her father, *Night Studio* is a rich study in father-daughter relations and in the changing consciousness of women of Mayer's generation (she was born in 1943) played against backdrops of traditional family life.

Nothing was so traditional, Mayer discovered, as her own family

setting, despite the unconventionality of the artist's milieu and her father's participation in it. "I was a little shocked," she says, "to realize my parents had played those archetypal male/female roles to the hilt. And that I'd followed suit, without even thinking." But artists have tended, in fact, not only to play the social roles but to magnify them—staunch or desperate in their conformities, foolishly visible in their rebellions. Outsiders by background and profession, male artists have been especially dependent on the services of women, excessively macho in their alcoholic fraternity. This was true at least of Philip Guston's generation. His more famous peers— Willem de Kooning, Jackson Pollock, Franz Kline—are by now legendary for their bar brawls, their molls and put-upon wives, and their personal instabilities.

Guston was much more the family man, and for that reason perhaps not quite so successful as his wilder contemporaries—an equation Musa Mayer seems to make when she says that for her father "the rewards of marriage far outweighed the risk of mediocrity." But Guston had a classic outsider's profile, and his devotion to his wife, also named Musa, didn't deter him from leaving her twice for other women (on the second occasion for a year), from being generally boorish if her interests in any way conflicted with his, from commanding all the space he felt he needed to develop his work, or from eating, drinking, and smoking self-destructively.

Philip Guston was born in 1913 in Montreal, the youngest of seven children. His parents, Rachel and Leib Goldstein, had fled Russia and the pogroms in 1905. In 1919, seeking better job opportunities, the family moved to Los Angeles, but Leib, now called Louis, ended up as a junkman, collecting trash in a horse-drawn wagon. When Guston was ten or eleven years old, he found his father's body hanging from a rope in a shed. By the time he was twelve, he was drawing seriously, and had evidently decided to become an artist. At the Otis Art Institute in Los Angeles, which he entered on scholarship in 1930, he met his future wife, Musa McKim, as well as his lifelong friend Reuben Kadish (whose son Danny would one day marry Mayer).

Musa Mayer grew up to be quite like her mother: she married an artist (Danny Kadish), always devalued herself and admired her father, and became a second caretaker and champion of her father's work and reputation. But it must have been her greater sense of deprivation, along with an acquired feminist consciousness, that

contributed to her eventual breakaway and relative independence. If both mother and daughter lived on "borrowed importance" (Mayer says she always felt invisible until recognized as her father's daughter), the daughter felt acutely that she was competing with the world for her claim to her father's attention, and that what he gave to the world (especially to his grateful students) he never gave to her. This is not a case of abuse per se—Guston was apparently very fond of his daughter—but of neglect and direct discouragement (from becoming an artist) and of her being used for her father's ideas and problems.

After her successful rebellion in the 1970s—she left an unfulfilling marriage, embarked on a career as a counselor in the Midwest, and made an equitable relationship with a man eight years younger than she was—Musa Mayer returned to New York to deal with her father's legacy. Now studying fiction at Columbia University, and having written a memoir of depth and clarity, she has obviously gained a sense of self she never had before. Yet in her conclusion to this book she equivocates mightily over her new-found freedom, trying to justify her mother's sacrifice, and invalidating her old feelings about her father as a person, by joining the world in its homage to the myth of the great artist. She says her attempt to turn him into "an ordinary man . . . never sticks." Her father "was brilliant . . . And I was not." She and her mother "lived with a great and irresistible force . . . that tormented and exalted him, and all of us." She quotes Goethe on love, invoking the child's need to cherish its abusing parent: "The only way in which we can come to terms with the great superiority of another person is love." She excuses the tyranny, the inequality of it all, by appealing to "true greatness." Everything "depends on the redemptive power of Art."

In just a few quick strokes, at the end, Mayer makes a case (implicitly) for the traditional family, from which she, in practice at least, has largely escaped. But the last phase of her escape, in the 1980s, toward a creative medium, has been made possible in some part through her father's legacy. Here is the rub, no doubt. How can you fault a man who empowers you in his death, the final test of all the sacrifice?

1988

The Inner Life: When Reality Fails

Three books by and about women whose mental experiences were extraordinary should reinforce the view that we still know very little about our inner lives, and that we tend to discover them only when driven in on ourselves by traumatic circumstances. *When Rabbit Howls* by Truddi Chase, perhaps the most bizarre of the three, dramatizes to an overwhelming degree the creation of an inner life to compensate for an intolerable reality. Hers is an extreme case of child sexual abuse, which she screened out through the development of multiple personalities—more than ninety of them.

Although the abuse of power by men, sexually or otherwise, is not a theme in the other two books—*The Search for Omm Sety* by Jonathan Cott and *Welcome Silence* by Carol North, M.D.—a close reading reveals hidden forms of unacknowledged abuse. North's story is a study in schizophrenia, while Omm Sety (an Englishwoman born in 1904 as Dorothy Eady) was not *apparently* suffering from any mental illness. Her tale is a remarkable one of reincarnation, a retreat from her contemporary life as the child of English parents,

51

caused, we are led to believe, by nothing more than a fall down-stairs that knocked her unconscious at the age of three.

Inner worlds created spontaneously in reaction to some trauma, whether perceived as "ill" or not, mirror reality in various distorted ways. The reality being mirrored or reproduced consists of power-ful others—patriarchal figures, often parents or authorities—who have managed to invalidate their victims' experience or violate their sense of self. Some victims simply retreat, without organizing inner analogues of reality. These stories, however, and most of those we have read (Eve, Sybil, Mary Barnes, Daniel Schreber, Mark Vonnegut, to name just a few) show people who have created strong inner structures by which they have tried to survive a kind of "death" to the real world. Other people, like Shirley MacLaine, more consciously pursue their inner resources when reality fails them. Help, in other words, doesn't just happen to them.

Truddi Chase, known in her book *When Rabbit Howls* as "the woman," "perished" tragically at the age of two when sexually penetrated by her stepfather. From then until she was sixteen, her stepfather continued to rape and brutalize her, and she was subject as well to her mother's physical and emotional abuse. "The wom-an" has no memory of the abuse. One of her presenting symptoms when she became a client of psychotherapist Robert Phillips (who provides both introduction and epilogue to the book) at a private clinic in Maryland was a considerable amnesia. What little she did remember had to be recalled by one or another of her Troop members, as her personalities collectively called themselves. She was by that time a woman of forty, a successful realtor, divorced with a young daughter. Besides amnesia, her symptoms included a lack of relationship to time, headaches that "didn't hurt," a tre-mendous amount of energy, and the frequent use of "us" or "we" when speaking of herself: classic symptoms of multiple personality. A powerful structure lay behind these symptoms. When the child "died," she simply dropped out; her mind, with its emotions and incipient thoughts, went to sleep. Asleep, she "dreamed" over a period of time, probably in reaction to repeated assaults, the daz-zling array of personalities whose purpose it was to protect the sleeping child—absorb the blows and deal with the world, using "the woman" as a facade.

The Search for Omm Sety and *Welcome Silence* present very different kinds of "inner worlds," with comparatively little family

background to help us understand their alternative realities. In *When Rabbit Howls* (Rabbit, by the way, is the personality who held the pain for the child), the recovery of family history is integral to the therapeutic process, in which the personalities simultaneously learn to identify themselves and each other. With Carol North, an American born in the 1950s, and Omm Sety/Dorothy Eady, their symptoms or inner worlds mushroom and consume their lives, seemingly detached from early sources. Nonetheless, like Truddi Chase, both North and Eady sustained traumas at a young age that provided clear points of departure for their excursions into unfamiliar territory.

North, apparently, was scared literally out of her mind by a fire that threatened to burn down her house when she was six. After Dorothy Eady's tumble down a flight of stairs at the age of three, she was declared dead by the family doctor, laid out on her bed, then discovered an hour later sitting up, alive and well. Soon, Dorothy had recurring dreams of a fantastic space—a huge building with columns, a garden, and tall trees—that she began to consider "home." At age four she discovered that "home" was ancient Egypt, and the rest of her life became a clear trajectory toward her eventual "return" there.

Carol North, on the other hand, had no place to go, except to college when she was older, and in college the disturbances she had suffered since she was six were heightened to the point where she became the frequent inmate of a mental hospital. Strikingly unlike Dorothy Eady's, her "other world" was a frightening and debilitating intrusion on her everyday life. She heard voices and saw what she called Interference Patterns (multicolored designs in the air), experienced paranoid delusions, and other symptoms associated with schizophrenia.

Her background sounds normal enough. She was the youngest of four children; she was small and thin. Her father was a corporation man, her mother a dutiful housewife. They were churchgoers and had high expectations of their children. Carol was determined to become a medical doctor. Her parents urged her to achieve, yet her mother was "critical of everything," and she often felt that her mother read her mind and "stole" her thoughts. Her "voices," which could be said to project a true state of affairs (inner thoughts not made conscious) supplied contradictory messages. One set was supportive, saying things would be okay; the other told her she was

"dumb" and would flunk out of school and ultimately tried to make her commit suicide.

In North's superficial, protective, if not unconscious, account of her family life, her evolving sexuality and any covert seductions between family members go completely unmentioned. Yet there is one detail tucked into her story that suggests something more serious than a fire to account for her dissociations. The first voice she records hearing asked her if she wanted a cigar. When she was young, she often "saw ghosts and heard voices offering her cigars." She said, "One night I was awakened by a man calling my name. A powerful presence filled my bedroom. I opened my eyes. There was Jesus, standing over me, right next to my bed. . . . The intensity of His presence horrified me. I wasn't ready for Him yet."

Was this the man who offered her cigars? She doesn't say how old she was when she had this "vision." Dorothy Eady was fourteen when she had a similar experience. "I was asleep, and I half woke up, feeling a weight on my chest. Then . . . I saw this face bending over me with both hands on the neck of my nightdress. I recognized the face from the photo I had seen years before of the mummy of Sety . . . then he tore open my nightdress from neck to rim." Sety was Sety I, a pharaoh of the nineteenth dynasty whom Dorothy claimed to have known intimately in her former life as an Egyptian girl.

Dorothy's story of her early life—unlike North's and brief as it is—abounds in clues suggesting immediate connections between her fantasies of Egypt and struggles with her parents. This is not to say that Eady herself, or Jonathan Cott, who writes eloquently of her life and accomplishments, made or even hinted at such connections. The facts that suggest them are embedded, almost hidden, in descriptions confirming Dorothy's tale of reincarnation, highlighted by her precocious Egyptian studies, translating hieroglyphs at a young age, and so forth.

Creatively juxtaposing the facts, it's possible to discern a hidden picture of abuse. After her accident, Dorothy would be found "sitting in her room or under the dining-room table and weeping for no apparent reason." Her father, an "authoritarian in matters of discipline," sometimes beat her. She had recurring dreams of a high priest beating her with a stick, at which point she would wake up screaming. When she was seven, her father brought home the literature in which she found pictures of the building with columns

from her early dreams (King Sety's temple) and a photo of Sety's mummy, which she excitedly showed to her father.

Besides being a master tailor, Dorothy's father was a part-time magician and conjurer! Around 1920, when Dorothy was sixteen, he decided to switch careers, and gave up tailoring to run a large cinema. One of his live acts was his daughter, singing things like "Somewhere in the Sahara" in Oriental costume. Mr. Eady "applauded wildly after each song." When Dorothy was thirty and living in Cairo, married to an Egyptian (she stayed married only three years), her parents came to visit her, and her mother woke up one night and saw a man standing near her daughter's mattress, looking at her. She thought it was Dorothy's husband, but Dorothy said her husband had not returned that night. Her mother demanded to know who it was then, and Dorothy said, why, it was King Sety I—of course.

After Dorothy left home for Egypt, in 1933, her father had "bouts of severe depression." He died within two years; in the same year when Dorothy separated from her husband and she began to receive visitations at night from Sety, with whom, she said, she had sex. Dorothy, now called Omm Sety, was an adept at both "channeling" and astral travel. The story of her life as an Egyptian girl in the reign of Sety was "dictated" to her by a personage called HorRa. And possibly all of her visits with the king, whom she claimed materialized, were accomplished by "out-of-the-body" experiences.

My hypothesis is that Dorothy gained distance from her seductive, abusive father by absenting herself from her contemporary life as a twentieth-century English girl. Her dream life took over, creating another world in which "the father" appeared in the guise of a loving, much less threatening figure, over whom importantly, *she* had control. After all, she (re-)created him. If Dorothy was indeed sexually abused by her father, we know from current histories—Truddi Chase's outstanding among them—that the memory of such abuse could have been suppressed. What did come back to her, however, was the memory of an abusive king, which she transformed into a tale of "eternal love."

There is a vivid correlation of the "facts" of her early Egyptian life, and certain facts of her life as Dorothy Eady in England. At three, she was knocked unconscious, and at three in ancient Egypt her "soldier father" deposited her at the temple at Abydos to be

brought up as a priestess (her mother having died when she was two); at fourteen the mummy of Sety appeared to her in England, and at fourteen in ancient Egypt, Sety seduced her by a lotus pool. The girl (called Bentreshyt then) became pregnant, was cross-examined by the high priest, confessed her "crime," and committed suicide to save the name of the king. The king was heartbroken when he found out and spent three thousand years, the story goes, looking for her.

The message here seems to be that "the father" returns in one guise or another. Dorothy's twist is a good one. She re-created a scene in which she had been sacrificed, bringing back the offending king as her updated "imaginary" lover, installing him as a psychic component (perhaps with her father's help), then carrying on as the virgin priestess she was originally meant to be, with the short interlude of marriage to a contemporary Egyptian, her escape vehicle from England. Her dream of returning to live and die in Abydos was connected with the desire to correct history. Once in Abydos, the king could "visit" her, but they could no longer have "sex"— and so this time around she could live to an old age, with a "father" who loved her eternally and platonically.

Dorothy/Omm Sety channeled King Sety extensively. Many of her diary entries quote the king at length. Channeling is a phenomenon currently made popular to some extent by Shirley MacLaine, who has consulted a number of channelers around the globe. MacLaine sought this kind of help for reasons not unlike those that drive other people inward. Her story in *Out on a Limb* is a fair example of a woman who creates or discovers her inner world to compensate for feelings of powerlessness in reality. MacLaine didn't make this connection herself in her book, but there are two distinct halves to her story—the first in which she describes her frustrating affair with a powerful English politician, the second in which she recounts her unfolding psychic life, mediated by various channelers and astral travelers. It isn't difficult to see how the latter emerged in reaction to the humiliation and defeat she must have experienced in relation to a lover who overwhelmed her, who would never leave his wife, and who had to conduct their affair in great secrecy. MacLaine felt driven to locate her own sources of power. Her story, after all, is that of an actress, not of a woman versed in realpolitik. Significantly, her "best friend"—her confidante—in *Out on a Limb* was Bella Abzug.

An important aspect of MacLaine's ongoing story must be her struggle to become emotionally independent of men. One of the ironies of this struggle for women like MacLaine is that when they become receptive to "otherworldly" influences, their mediators and voices tend to be the male guru or the wandering dead male soul seeking a "channel" through which to be seen and heard. As in this life, so in the other—it often seems. But if the project is to install a psychic equivalent of social power, it's easy to see how the images and voices of male figures are adopted for that purpose. Anyway, these are all tales with successful or promising endings.

Truddi Chase has laid her devastating case before the world, and her Troops will apparently learn to live cooperatively with each other, surviving without the fear and guilt that had paralyzed them. "The woman"'s creative therapist discovered that her personalities were completely against integration, and he didn't try to make them merge, as the goal is commonly defined in helping victims of multiple personality. Also, he was able, at last, to convince the Troops that they were not responsible for the abuse they had suffered, and that the stepfather was the guilty one. At the end of the book, a very persuasive story of revenge against the stepfather is fabricated by the leading Troop member.

Carol North is still a young woman, but she has already attained two of her goals: to finish medical school and to terminate her disturbances. She became one of just a few people who have been "cured" of such symptoms by dialysis treatment, after conventional methods failed. Presumably, the treatment removed some unidentified substance, a chemical, from the blood, responsible for producing schizophrenic symptoms. For North, an unequivocal return to reality was essential to carry on her business here. The artifacts from her inner world had confused her, involving her in impossible dualities. For Truddi Chase, it was essential for her to learn to live with her "artifacts," as they formed the very base of her survival.

Dorothy Eady, who died in 1981, didn't have to give up her alternative world (though there were certainly threats—as a teenager, for instance, she was committed to a mental hospital several times for observation). She was ultimately able to move into that inner world and live it out, casting off the "real world" into which she was born. At age three, she was a born-again Egyptian.

Omm Sety has left a legacy of triumph over great odds. Without

formal education, she became a respected Egyptologist, excelling in an esoteric field that belongs to men. Because of her scientific acumen, her eccentricities were tolerated or embraced. And she succeeded in her life's goal, to live and die next to the temple of Sety in Abydos. (From another point of view, she didn't end so well. The Egyptian Antiquities Department in Cairo, for which she did extraordinary work for many years, paid her pennies. She lived in poverty as a latter-day Isis, a woman who devotes her life to the task of resurrecting her dead husband.)

I wouldn't equate these stories with the adult searches of MacLaine and others. Yet if you think of MacLaine, for one, as a grown-up whose "child" was suddenly activated when she found herself out of her depth in an affair with a powerful man, it's possible to see that her need for help was equally great. When "help" just happens to people—when inner constructs spontaneously develop—it tends to go unrecognized or to look bizarre. Not surprisingly, the need for such help also goes unidentified. The feeling of powerlessness, of not existing, isn't understood or verified.

Ideally, it seems to me, we would like to live in a world that doesn't *drive* us inward, but that already includes the spiritual side. A more equitable world, for all minority groups, would obviously diminish the need to resort to the kind of help that becomes defined as "mental illness." But a greater integration or availability of the spiritual side should also diminish this need. All the stories we read by people who have journeyed to the "other side"—for one reason or another—are helping us achieve this goal.

1988

For Sylvia

O ne might think that an account of growing up lesbian in
England during the 1920s would make a quaint tale of perse-
cution, something remote and historical; but key aspects of Valen-
tine Ackland's wispy yet trenchantly told story in *For Sylvia* may be
amply found in today's lesbian literature: the horror of parents on
learning of their daughter's "aberration," the pressures to con-
form, the threats and punishments, the need for secrecy, the flight
of the daughter into some brief unhappy marriage or into drugs,
alcohol, obsessive travel, indiscriminate sex—these are familiar
contingencies described in any recent work of the genre. Equally
familiar are the strong avowals of pleasure in knowing another
woman intimately, the sense of rightness and of happiness in love,
despite social opposition. Ackland's story has it all.

Valentine Ackland was born in 1906, a child of conventional
well-off parents, her father a West End London dentist, her mother
an Anglo-Catholic. She wrote *For Sylvia* in 1949 as a gift for the
author Sylvia Townsend Warner, her lover and companion of
nineteen years, during a brief hiatus in their relationship when
Sylvia had moved out of the house they shared in Dorset. (Their

experiment in separation failed, and Sylvia soon moved back in.) The book was a confessional project, an effort on Valentine's part to set some records straight, to explain herself, in particular her alcoholism, which was never acknowledged between the two women. She also wrote it as a testimonial to her devotion. They lived together another twenty years until Valentine died in 1969.

Valentine's struggle with family, church, and society, to free herself of men and to live happily with a woman of her choice, lasted about eight years, from age sixteen to age twenty-four. Her struggle with alcohol was much more protracted, and wasn't resolved until she was forty-one. Periodically she consulted physicians about her problem; they were amused, disgusted, or indifferent. Finally she had a miraculous kind of self-cure, which she describes at the very outset of her book as the "crisis" of her life. One night in 1947 she stumbled drunk to bed in "sickness and despair," knelt down to pray as she had not done for many years, asked if God was there, and got no reply. Out of this sense of nothingness, toward evening the following day after "feeling desperately ill," she felt suddenly that she was "walking in tranquility and with perfect confidence." She never drank again.

Valentine felt that her alcoholism was unrelated to her lesbianism but was, rather, the result of finding a drug that mitigated her extreme shyness and self-consciousness. It's hard, though, not to link her addiction and her sexual identity when you read that she imbibed for the first time on her wedding night (at nineteen) at her mother's house. She "poured out a stiff brandy and soda and drank it off"—then tried to have sex with her new husband, whom she already loathed. A week went by and she remained a virgin.

She would endure a number of horrors in her contest to become herself—her augmenting dipsomania, a pregnancy and miscarriage, sex with many strangers of both genders, and the constant intrusion of her "vampire relations," as Sylvia later portrayed Valentine's mother and sister.

Valentine's father died when she was seventeen, just after she fell in love seriously for the first time with a girl. Her ever-vigilant older sister caught her out by reading her letters; she told their mother—"who tried to hush it up"—her father found out and much hell broke loose in the family, described in a commanding passage—the stuff of classic lesbian literature. Her father was brutal and her mother, though gentle, colluded in a plan to send her

off to a domestic training college—a kind of Siberia for errant daughters.

Apparently Valentine's mother loved her very much; but the child had a sensitive nature, and her mother's love was mediated by the succession of hateful nannies typical of that class and time. Added to that, Valentine had a saturnine, uninterested father and a sister given free rein to bully and persecute her.

But Valentine was also creative and intelligent. She wrote poetry all her life, and she precociously understood the difference between her own nature and a society that opposed her. Near the end of her book this duality is expressed in her wistful yet straightforward style: "My life has been strange and as I have set it down here it has seemed to be unhappy. But in fact it has been one of the most blessed, one of the happiest lives ever lived on earth."

1986

Imagine a New Kind of TV Soap: Bloomsbury Comes to Dallas

In 1936 Virginia Woolf's nephew Quentin Bell wrote a play presenting his home at Charleston, in Sussex, as an archaeological ruin of the distant future, visited by tourists. Bell called his play *2036*. He was only a half century off. In June 1986 his prophetic scenario came true when a restored Charleston was opened to the public. Both Bell and his half sister, Angelica Garnett, children of Virginia's sister Vanessa Bell, have been very active in the movement to preserve their old homestead.

Charleston will attract people for its interest as an art object—the two painters who lived there over a period of sixty years, Vanessa Bell and Duncan Grant, turned the old farmhouse into a veritable canvas for their obsessive decorative work—as well as for its intimate associations with the historical Bloomsbury crowd. At

Charleston, art and literature had a common meeting ground; painters and writers gathered there for years to work and talk to each other. Tourists may be happy to know that they are standing in the midst of an art object where the Woolfs, the Stracheys, the Bells, Morgan (E. M.) Forster, the Sackville-Wests, Maynard Keynes, and other assorted peculiar and talented artists, intellectuals, and hangers-on sat around endlessly talking.

Part of the efforts to preserve Charleston has centered on tapping the endless appetite for Bloomsbury things among Americans. Twice in an eighteen-month period, the descendants have ventured to a somewhat unlikely outpost of Bloomphilia—Dallas—in search of funding for their project. One foray saw Bell and Garnett (seventy-six and sixty-eight years of age respectively as of this writing) leading an impressive contingent of English folk—among them the actress Lynn Redgrave, the novelist Margaret Drabble, her husband, Michael Holroyd (Lytton Strachey's biographer), the actor Robert Hardy, the Bloomsbury art historian Richard Shone, and Britain's "architect laureate" Sir Hugh Casson—in a series of literary lectures (ranging from fascinating to tedious), exhibitions, films, and slides, various movable feasts, and a dramatic reading of Virginia Woolf's only play, *Freshwater*, done originally in 1935 by and for the family at Vanessa's home in Gordon Square.

Why did American money and British culture collide in a place like Dallas, for the purpose of preserving an old farmhouse in Sussex? Charleston is far from being a "treasure house," and Duncan Grant and Vanessa Bell are considered lesser English artists. More baffling, why are people fascinated by this esoteric group of post-Victorian Englishmen and women who, besides their culture and achievements, were xenophobic (anti-American at least; Virginia herself wrote, "These poor damned Americans . . . so ugly, so dusty, so dull, so long winded"), effete, loose in their morals, sexist certainly (despite the feminism of their central figure), and in many ways self-destructive?

These questions arose after I joined the Bloomsbury expedition that descended on Dallas in March 1986. There I learned that the spirit behind Dallas was an Englishwoman named Deborah Gage, whose family owns the estate (Firle Place) upon which Charleston rests. In 1980, two years after Duncan Grant died (Vanessa Bell died in 1961), she discovered this great artifact—a thirteen-room cottage, its interior completely saturated with paintings, murals,

ceramics, sculptures, carpets, textiles, and fabrics, designed and/or executed by two figures who were charter members of "Old Bloomsbury"—right in her backyard, so to speak. She also found the place in sad repair, about to be put on the auction block. So she talked the trustees of the Gage estate into letting her form the Charleston Trust. The National Trust agreed to accept Charleston on one condition—that there be an endowment of one million dollars to maintain it in perpetuity.

Charleston has opened, but that endowment has yet to be raised. What has been collected is nearly another million, of which $400,000 has come from America alone, through private donations, making structural repairs and restoration of the house and gardens possible. Gage's big thrust in America has been in Dallas.

Here was a most unusual meeting, English wit and refinement with an American city noted most recently for providing the setting of an immensely popular and sinfully vulgar nighttime TV soap. And though Deborah Gage chose Dallas because of her connections there, and the crude wealth that might be unearthed, the coincidental link between our TV soap and Bloomsbury seemed a felicitously significant one, which might even serve to answer questions relating to our interest in these people. The publishing industry, surely, caters to something much beyond the literary concerns that gave birth to the public Bloomsbury. Before there was literature, there was simply a group of young people who met to talk and socialize at 46 Gordon Square, to discuss ideas and books (somewhat later venturing into polymorphous perversity and other personal stuff unknown in conversation between the sexes). The key to their ultimate soapy fascination for people must lie in the personality, and I looked for it in their descendants and friends in Dallas.

The principal survivors, Quentin Bell and Angelica Garnett, both took after their mother, Vanessa, and Angelica's father, Duncan, by becoming artists. Bell, an art historian, is also a potter and ceramic sculptor; his chief literary output was his official biography of Virginia, published in 1972—a book that was instrumental in setting off the second wave of interest in Woolf/Bloomsburiana. An exhibition of Angelica Garnett's paintings opened the festivities in Dallas; but recently she made her own contribution to the public voracity for Bloomsbury tidbits with an autobiography called *Deceived with Kindness*. The literary persona of Virginia was represented in Dallas by Margaret Drabble, who lectured on the writer

and on the "Post-1945 Novel." There were two impressive men in the group besides Quentin Bell—Sir Hugh Casson, an impish witty fellow, who was seventy-five at this time, architect and former president of the Royal Academy of Arts in London, and Sir Peter Shepheard, a big square-cut man with a kindly granite face, leaning on a cane, the landscape architect responsible for restoring Charleston's gardens. Though unrelated to or descended from Bloomsbury in any way, they looked thoroughly incorporated—bon vivant men of the establishment.

More completely unrelated was Barbara Wedgwood, the only American in the group. An author and lecturer on Victorian literature, she has a claim to Bloomsbury through her husband, Hensleigh Wedgwood, whose grandfather helped Sir Leslie Stephen edit the first *Dictionary of National Biography*. Wedgwood called her lecture "The Tempestuous Victorians." By "tempestuous" she apparently meant sexual and unmarried (nothing else in her lecture sounded like a tempest), foreshadowing later developments in the Bloomsbury gang when the true material for a soap could be said to have fructified. "Sexual and unmarried" was nothing in the period between the wars, as Bloomsbury flowered and the revolt against parental influence was fully realized, generating a blueprint for the kind of saga of incestuous relations that delights the audiences of *Dallas*, *Dynasty*, and the like—developments that would ultimately also appeal to Americans who have a passion for things British.

The romance between England and America goes all one way. Americans adore Roots, Ruins, and Royalty, which represent for many of us the half of ourselves we left behind; the English hate American money, naturally equated with Americans, on which they feel dependent. Certainly the antipathy of the Bloomsburies is well known.

The Bloomsbury heritage is an important English commodity in a chain of attractions ranging from the Queen's Guards to beef pie and scones. The Empire is now a museum, and the British system depends for its survival on its ability to lure historians and tourists to its ruins—restored, indicated, or intact. The linchpin in this system is the landed aristocracy, which has formed itself into a tacit network—a business concern—of treasure houses, over 350 of them, with the Government as de facto landlord, enabling titled

families to maintain possession of their estates through tax deferral, aid in upkeep, and income from a paying public. The Gage estate is one of them and Charleston, once a rental property, now a subsidiary attraction, is obviously a choice addition to the British Empire's fossils.

Barbara Wedgwood, the American lecturer, put it this way: "It doesn't matter if the public likes the art; Charleston will be amusing, just as the Pavilion of Brighton is." The lives of Bloomsbury are amusing to people in just that way, quite apart from the literature. My own involvement tends to be the reverse: I take the lives seriously and find the literature entertaining. I prefer some autobiographical writings of Woolf's, published in 1976 by permission of Quentin Bell and Angelica Garnett and called *Moments of Being*, to any of her novels, save perhaps *Orlando*.

I had looked forward to meeting Angelica Garnett because of her serious story, which has naturally provided the sprawling Bloomsbury market with another amusing life. What I find in her story is some cumulative expression of Bloomsbury's license, the sacrifice of a child to art and to sexual confusion paraded as freedom. Her parents, including her putative father, Clive Bell (Vanessa's husband), broke society's primary rule of legal paternity to have her, then furiously conformed by covering it up, perpetrating the fiction that Clive was the father, leaving the child herself in the dark. Later, when she grew up and married, she was also ignorant of the fact that her husband had once been intimate with her biological father. Here were the makings of a problematic life, the least acceptable sort of life as "lives" go; yet here, too, was the real stuff of soap, the stock-in-trade of a market that has begun to dwarf the literature from which it sprang.

Imagine a different kind of TV soap, called, perhaps, *Bloomsbury* (why not?), centering on some literary matriarch called Virginia, powerful and sharp-tongued, a Virgin Genius married to a kind, self-sacrificing barrister (I would cast Leonard in his father's profession), and her prominent artist sister Vanessa, whose illegitimate daughter Angelica ends up marrying a man who once had an affair with Angelica's (secret) father, who in turn had once dallied with Adrian, brother of the two sisters, who ends up being a psychoanalyst, an important man in the community who successively fails to rescue various members of the family and cast from committing suicide.

Suicide, incest, bastardy, adultery, and homosexuality would be the leading intrigues, along with great schemes at the top of the art and literary worlds for making and undoing reputations. Insanity would also have to figure in. Child molestation could not be left out. Key episodes might revolve around one of Virginia's breakdowns, when doctors discover that her elder half brothers, the Duckworths, one of them a powerful publisher (in competition with Virginia's own Hogarth Press), had sexually molested her as a child. A marital crisis would have to develop when Virginia "elopes" for a week to the continent with a well-known sapphist and noblewoman called Vita.

Young lives aborted, not necessarily by suicide, would certainly be given play. Brilliant men and beautiful women would be the leading equation in the soap. However—and this I believe is one key to the great success of the historical Bloomsbury—the men would also be pretty or terribly handsome, with the women equally lustrous and intelligent, or more so. The homicide and illness from our executive-suite soap could perhaps be included. The essence would remain the same: the wielding of power or advancing of positions through the discomfort of others, a poor writer's or artist's fantasy of the mighty—how awful and how attractive at the same time.

Curiously, all these elements are insidiously contained in *Freshwater*, which Virginia wrote to amuse her sister's children, superimposing the Victorian predecessors of Bloomsbury, both family and friends, on her Bloomsbury contemporaries. The reading of the play at the Dallas Museum of Arts was quite gala. All were in formal black. Lynn Redgrave, playing the lead role of the young Ellen Terry, was stunning in a black velvet pantsuit with a long strand of pearls. The cast sat on stage in a semicircle, and was introduced in barker style by Robert Hardy, who wore a green velvet smoking jacket. The Dallasites, about 150 of them, lapped the play up, laughing frequently in all the right places. Afterward they were treated to drinks and a spread of fishballs and strawberries in the museum lobby and a chance to meet the cast.

The Dallasites were prepared to laugh all the way from the bank, tripping on to a $600-a-plate black-tie dinner at a hotel, where jewelry was auctioned off (a man was auctioned off, too: an oil tycoon, alone at the dinner, was offered by a woman for an evening

on the town; someone claimed him for $5,000), all in behalf of establishing new ruins for Americans to view abroad.

I wouldn't mind myself staying in America and having the occasional chance, as in Dallas, to see a sampling of some of Britain's grand and witty old men up close. The grand old men of Britain— Quentin Bell, Sir Hugh, and Sir Peter were eminent representatives of the breed in Texas—are ruins enough for me. I doubt I would want to know these men, or them me, but I love to look at them and listen to them. There is simply nothing like them in America: privileged, spoiled people, both eccentric and established, rhetorically eloquent, who put on the most artful appearance of not taking anything seriously, yet convey great depth and weight.

The keynote in Dallas was surely the famed British wit. Margaret Drabble tried, but she succumbed, as did others, to seriousness, in particular I believe over an understandable need to be perceived as a worthy candidate for Virginia's mantle. She was not that obvious about it, but the drift was unmistakable. She quoted, for example, from Stephen Spender's diary, "We met Margaret Drabble and we liked her very much." She said she felt "let in to a corner of Bloomsbury," but she also asked, "Am I mad? Am I going to talk about someone in front of people who knew her?" I rather thought she was—a little mad.

In 1977 Quentin Bell, in an introduction he wrote to an excellent book about Virginia and Leonard called *A Marriage of True Minds*, asked, even then, "Haven't we had enough?" By enough he meant "a spate of Lupine studies" in criticism, following his Official Life. In lives—wherein one would find the facts or "the truth"—he felt we could never have enough, or at least enough of Virginia and Leonard.

In both houses and lives the English could only hope, at this time, that nobody will be easily sated. Americans, certainly, are not likely to lose interest. The opportunity to fossilize Britain has not been lost on American business. Money and ruins have united to create a curious alliance of rebellious children turned grateful descendants with angry parents turned immortal ancestors.

1986

Painting Charleston

In 1986 I found myself drawn into the strange orbit of a house in Sussex, England, which a group of people were trying to save for posterity. This was a dilapidated farmhouse called Charleston, lying in the Sussex countryside at the foot of Firle Beacon, the highest point in a range of downs between Eastbourne and Newhaven. Its distinction was that it had been inhabited off and on over a span of more than sixty years by the artists Duncan Grant and Vanessa Bell, along with their family and friends, collectively known to the world as Bloomsbury. Several miles away in Rodmell is Monk's House, now a National Trust property, once inhabited by Vanessa Bell's sister Virginia Woolf and her husband, Leonard.

England's National Trust was not interested in saving Charleston or acquiring it as a property. Grant and Bell are considered minor English painters, and of the thirty-six houses owned by the Trust that are associated with well-known people, including writers, political figures, and royalty, practically none are the houses of artists. (Turner's and Constable's may be the only two.) One-third of that number belonged to writers. But the people who formed the Charleston Trust in 1980 (with the understanding that the National

Trust would take the house once a sufficient endowment—a million dollars at least—had been raised) felt that Charleston itself was worth turning into a national treasure. Over their sixty-year tenancy there, Bell and Grant had decorated the place everywhere by painting on walls, mantels, doors, and furniture; and in addition to pictures and sculptures they had made pottery, fabric designs, mosaics, and a garden. They may have been "minor" painters, but they are deemed to be important figures in the history of the decorative arts in Britain.

I found out about the house by becoming interested in a book. In 1985 Angelica Garnett, daughter of Vanessa Bell and favorite niece of Virginia Woolf, published a memoir called *Deceived with Kindness* about her early life at Charleston and her position in the family as the illegitimate child of Duncan Grant. With her book, Garnett appended an unusual colophon to the cumulative pile of Bloomsbury memorabilia. Born on Christmas Day, one month after the end of World War I, under charged and secretive circumstances, Garnett tells a story that reads like an ironic backlash to the freedom from Victorian restraints that gave rise to her birth.

When I flew to Dallas in March 1986, I met Garnett and her half brother Quentin Bell, along with other English folk who were congregating in Dallas to raise money for Charleston. Three months later I flew to England for the official public opening of the house, by then almost completely restored—though still far from having the support necessary to gain the protection of the National Trust.

When Duncan Grant died in 1978 at the age of ninety-three, Charleston was in a state of great disrepair. After Vanessa Bell's death in 1961, Grant had gone on living there, in later years holed up alone in his studio. Neither Grant nor Bell ever thought of Charleston as a future museum. They painted and repainted surfaces, one on top of another, whenever the spirit moved or some area looked dim and worn; they disregarded what was underneath—whether older artwork or crumbling supports. They never owned the house, and never tried to turn it into something solid or fancy. Also they would not have imagined that their reputations as painters would warrant saving one of their houses for posterity. They had been key figures in the English postimpressionist movement in the teens; they were very successful during the 1920s and 1930s, especially Grant. But their reputations had waned by the late 1930s, and they continued painting for themselves, their friends,

and the love of it—though not without a measure of public recognition—until they died. Vanessa's son Quentin, though, did imagine Charleston as a future museum. In 1938 he wrote a play presenting the farmhouse as an archaeological ruin of the distant future, visited by tourists.

The house is a nice-sized, squarish brick-and-flint structure consisting of about fourteen commodious rooms on two floors with a couple of attic studios. It dates from the late seventeenth and early eighteenth centuries, though a late sixteenth-century frame structure was revealed during the recent restoration. In 1925 Grant and Bell added a large studio on the ground floor, facing the walled garden. They leased the house from a farmer who in turn leased it from the Firle estate, which was then and still is owned by a family called Gage. Nearby is a village called Firle, still existing in a feudal relation to Firle Place, the palatial manor house of the estate. For a while at the turn of the century Charleston was a summer boardinghouse.

The occupancy of Grant and Bell had everything to do with World War I. Members of Bloomsbury were moving to the country. The men of Bloomsbury were seeking exemptions from military service as conscientious objectors. It was Virginia Woolf who discovered Charleston, in 1916, writing to her sister that it has "a charming garden, with a pond, and fruit trees, and vegetables, all now rather run wild, but you could make it lovely."[1] Vanessa had been living in Suffolk with her male brood—her two young boys, Julian and Quentin, sons of Clive Bell, along with Duncan Grant and his lover David Garnett. Moving to Charleston in October 1916, Grant and Garnett (Clive Bell had departed) continued the agricultural work required for exemption from service, being employed full-time at a neighboring farm. And Vanessa was now within four miles of her sister, then living at a house called Asheham.

Angelica's story dates from the period of this ménage. Her birth in 1918 was a kind of resolution to a wartime domestic imbroglio. Vanessa was in love with Duncan; Duncan was wild about David Garnett, or Bunny as he was called, and very jealous of Bunny's heterosexual flings in London; Bunny was jealous of Duncan's (platonic) intimacy with Vanessa, whom he tried in vain to seduce; Vanessa stoically put up with Bunny and the relationship between the two men in order to keep Duncan close to her. Then Duncan gave up on Bunny and became sexually involved with Vanessa. By

the time Angelica was born of their union, they had resumed their platonic alliance. And by then David Garnett had moved to London.

The Bell/Grant ménage was perhaps wilder than most extended step- or half-children families of our own times. This was single motherhood with imaginative twists. A woman of upper-middle-class origins, Vanessa married respectably (Clive Bell was from coal money), had two children, watched her sister flirt with her husband for a couple of years, and had an affair that wasn't a secret with a married man (Roger Fry) whose wife had been committed permanently to an institution. Then she settled down for life with Duncan Grant, a man who loved other men (including, at one time, her brother Adrian), entertained his lovers and sometimes invited them to live with her, had a child by him, and pretended her husband was the child's father. In effect, she incorporated Duncan as one of her children. All the while she let her husband come and go, along with his mistresses (Clive always kept rooms at Charleston). Vanessa accommodated a wide circle of visitors including the leading wits and homosexuals of the day, most of them Cambridge alumni like her two brothers; she lived casually in old clothes (her sister Virginia reported that she had "slipped civilization off her back" and "splashed about entirely nude, without shame," and Clive said she had ceased to be a "presentable lady")[2] and messed up all her furniture and walls by painting on them.

Vanessa, Virginia, and the whole Bloomsbury gang were children just coming of age when Queen Victoria died in 1901. Most of them came from large families (Vanessa and Virginia had six siblings, three of them halves) crammed into huge high houses with dark interiors and many small rooms shared by various servants. The dissolution of the Victorian way of life (well-run nurseries, gloomy airless rooms, high teas, cumbersome dress, endless proprieties) was underway in the Stephen family by at least 1895, when Sir Leslie Stephen's wife, Julia, died. When Sir Leslie himself died in 1904, Vanessa immediately closed down the Stephen manse, a tall, narrow, stucco-and-brick seven-story structure at 22 Hyde Park Gate in Kensington, and moved with her siblings to a very different part of town. Though Gordon Square in Bloomsbury was a prosperous middle-class neighborhood, Virginia found it "the most beautiful the most exciting the most romantic place in the world." She said "the light and the air after the rich red gloom of Hyde Park Gate were a revelation. Things one had never seen in the

darkness there—[G. F.] Watts pictures, Dutch cabinets, blue china—shone out for the first time in the drawing room at Gordon Square." *Life* was happening in Bloomsbury.

To make it all newer and fresher, the house had been completely done up. "Needless to say the . . . red plush and black paint had been reversed; we had entered the Sargent-Furse era; white and green chintzes were everywhere; and instead of Morris wallpapers with their intricate patterns we decorated our walls with washes of plain distemper. We were full of experiment and reforms. We were going to do without table napkins, we were going to paint, to write, to have coffee after dinner instead of tea. . . . everything was going to be new, everything was going to be different. Everything was on trial."[3]

This brief description prologues the future style in houses and daily life of the Stephen family and their friends. With the Omega Workshops, inaugurated by Roger Fry in 1913, a fully developed decorative idea began to shape the interiors of Bloomsbury houses. By 1916, when Charleston became one of Bloomsbury's country retreats, the Victorian origins of Bloomsbury had been corrupted and transformed. The English postimpressionist movement had fully unfolded, the new style of decoration of houses had become de rigueur, and attitudes toward sex and marriage had quite unraveled. The basic code of Bloomsbury was to remain "free and civilized." Charleston was a monument to this kind of life, its darker sides not visible in the house's trappings and artifacts. With its sensual grace and playfulness of design, its rich washes and lush muted colors (lavender grays, salmon pinks), it makes evident the connotations of pleasure in transmuting all functional objects into esthetic forms. Everything subserved the making of pictures, the designing of the interior, the play of wit and intellect when Vanessa's and Duncan's headier friends came to visit or stay. The Bloomsberries subscribed to the esthetic precepts of Walter Pater and G. E. Moore that "by far the most important things are the pleasures of human intercourse and the enjoyment of beautiful objects."

During the war, half the year was spent at Charleston, the other half at Gordon Square in London. After the war the family returned to London, using Charleston for weekends or holidays. Beginning in 1927, time was also spent in Cassis, a small French fishing town on the Mediterranean. In 1939, on the eve of another war, Charleston became Vanessa's and Duncan's permanent home.

So what was it like living at Charleston? When I visited the house, I tried to imagine spending time there. In the beginning the place had no electricity or central heating or telephone or water except what was hand-pumped, and I couldn't imagine that at all. Some time during the 1920s radiators were installed, and in the 1930s electricity came in. Richard Shone has written that what the Bells lacked in comfort and luxury was made up for by pictures and books, and the "striking decorations by Vanessa and Duncan on the walls, doors and furniture."[4] You might say that the lack of comfort and luxury is what made Charleston a candidate for designation as a National Trust property—it's the gall these people had to paint things everywhere that gives the house its distinction.

I like the decor myself, but what makes the place truly interesting to me is not anything that would inspire England to want to save it. Charleston was actually created around a secret and because of a war. There was a real war, from which Charleston was a refuge, and a family conflict, which was resolved by a secret birth. The conflict was between Vanessa's overwhelming desire to paint and her maternal role. Angelica's actual birth in 1918 was no secret, of course, but her paternity was, and this really made possible Vanessa's life as a painter, with Duncan as her companion. Bloomsbury, after all, was just an enclave; behind and around them was still the society of their elders—proper relatives like Clive Bell's parents, innumerable inquisitive kin on Vanessa's side. A correct pose had to be struck. Clive Bell's pretense at being Angelica's father was successful even within Bloomsbury. Only an intimate group, which included Virginia and Leonard Woolf and David Garnett, and perhaps Roger Fry, knew the truth. Angelica herself, as was customary in such cases, was kept completely in the dark.

So Vanessa wrested a child from Duncan, freed him from paternal responsibility, maintained house for him, and accommodated his lovers. In return, he stayed by her and provided the example she needed of a painter close at hand whose work she admired. Not a bad deal for Duncan, huh? When I tried to imagine living there, it could only have been as Duncan. Or else as one of Vanessa's two boys, who ran around wild and learned about the world by reading plenty of history and politics. Or I wouldn't have minded being a privileged visitor, especially during the summer when I could have sat in the garden with Clive and his friends—Lytton Strachey, Maynard Keynes, Desmond MacCarthy, Francis Birrell, Raymond

Mortimer—discussing literature and theoretical principles of art or life. Even now, the walled garden is, in its restored state, a small Elysium, teeming with flowers and plants, structured by graveled paths, lawns, mosaics, and modest statuary.

Conversation in the garden by Cambridge intellectuals would have seemed a lot more important than what Vanessa and Duncan were doing in their studio—messing around with paints and still-life arrangements. But it would have been flattering to pose for them, while sitting in the garden being amusing and bookish. (There's a photo of Fry, Grant, and Vanessa *all* painting Strachey in another Bloomsbury garden.) The two painters had a reputation, after all. They were endorsed by two eminent art critics of the time who belonged to the club: Vanessa's husband, Clive Bell, and her (ex-)lover Roger Fry. Not bad for Vanessa (the painter). I like her work very much myself, especially her portraits, but frankly I can't imagine being Vanessa (the woman) at Charleston or anywhere else.

Nor would I have wanted to be her daughter, Angelica, who was "deceived with kindness." Yet Angelica is the person I would have been, had I lived there. Sometimes we read books by people whose stories are similar to our own, and fly long distances to write about their houses. Finally we may find out we have little in common with these people whose stories sounded so similar. Then we may construe a shared reality which was belied by meetings revealing class antagonisms and individual or national differences.

In Angelica's book I found familiar evidence of the kind of life you might expect for a fatherless child whose mother lied to her, despite the fact that life at Charleston was an idyll. Angelica grew up in a beautiful place surrounded by creative people. She was doted on, adored, spoiled, and overly protected. She matured with practically no sense of the world, much less of politics broadly or narrowly defined. And while she was enclosed by affection, material comfort, and the privilege of her class, she was woefully deprived of recognition for herself. Mothers and daughters have been traditionally bound to an absence of identity, but this was a special case. Here a mother unwittingly bought a certain autonomy for herself through depriving a daughter of her paternal rights. Such rights have constituted a source of identity for every daughter, however she may have failed to use them, for example, by giving up her name in marriage.

The partial liberation of Vanessa from a history of paternal

tyranny (her father, the Victorian patriarch) and maternal suffocation (her mother, the self-sacrificing nonentity) is the story largely underlying the domestic arrangements and the decor of Charleston. Charleston is a unique concatenation of the old and the new, with the old subsumed within the profusion of colors, bold designs, personal imagery, improvisational freedoms, of a class gone wrong. The Bloomsbury style in art was echoed in a certain bohemianism of daily life, though this bohemianism was still ancestrally privileged. Vanessa had a private income, maintained servants, collected valuable objects, and kept quarters in several places. Charleston's main room—the studio on the ground floor facing the garden— is an artist's environment where you might miss the privilege that made it all possible.

From 1925 to 1939 both Grant and Bell worked in that room; during and after World War II, Vanessa increasingly used a studio of her own on the attic floor. During the war, Duncan's London studio was destroyed, and the one at Charleston became his main place of work. After Vanessa and Clive died in the 1960s, Duncan gradually moved into the studio and lived there as well. The funk and neglect of Duncan's last years have certainly been banished by the restorers, but the clutter, the artist's mess, the down-at-heel look, seem convincingly retained.

Tacked to the mantel over the fireplace and resting on top of it are a number of postcards, photos, sketches, and exhibition notices, disposed in calculated disarray. A pither stove stands in front of the (blocked) fireplace. Above and below the mantelshelf are fine examples of the characteristic wall paintings at Charleston. Still lifes in faded ocher, whites, and greens appear up high on either side of a kind of totem figure—a cast of a sixth-century A.D. Chinese Bodhisattva (the original of which was once owned by Roger Fry). Below the mantel and flanking the recess of the fireplace is a pair of standing male (or very androgynous) nudes painted by Duncan in the style of Picasso's big-woman period of the 1920s, reclining on their elbows on a trompe l'oeil extension of the top part of the recessed fireplace. Between the figures, and on this painted perspectival extension, is a large (painted) bowl with water and goldfish in it and two ringed handles. The whole ensemble, with blue-and-white tile work constituting the inside wall of the shallow fireplace and the "enshrined" Chinese figure at the top, is the

artist's "altar," the offering to his gods. Two comfortable arm-chairs, one of them English circa 1880 (probably the one where Duncan sat all the time), rest on either side of this configuration.

The decorative work inspired by the artists' Omega Workshop days of 1913–19 is abundant in the room. It's the element that complements and continues the wall designs to form an integrated environment. The Omega Workshops were another of Roger Fry's inspirations. In 1912 Fry had organized the Second Post-Impressionist Exhibition (at London's Grafton Galleries), with a fair representation of English work. At the end of that year he began raising money to start the Omega Workshops (of which Bell and Grant were codirectors)—a collective of English artists affected by postimpressionism and interested in being paid for doing crafts related to their art. At least twenty artists found employment at the workshops at different times. They were paid for their work by the day or the week, and all the work was sold anonymously. They designed fabrics and rugs, painted furniture and pottery, and took commissions to paint the homes of friends or society people (to "disguise the drabness of London life," as Vanessa put it) in a style that became very distinctively Omega. A special calligraphy developed; for instance, Bell and Grant worked borders with continued crisscrosses, rows of dots within circles, vertical columns of circles connected by parallel lines, or small squares alternating with circles.

These simple devices pervade the decorative work at Charleston. In Duncan's studio a coffeepot thrown and decorated by Quentin Bell is on the mantelshelf. A tiled tray with a still life by Duncan is on the floor in front of the pither stove. Various pots, one decorated by Vanessa, are on a window ledge, likewise an urn with figures, dated 1914, by Duncan. Duncan and Vanessa shared a number of stylistic devices and subjects, but Duncan painted most of the figures in the house (like the winged Pan playing a mandolin painted on a log box or the boy riding a dolphin on a tabletop) and Vanessa most of the flowers, which are especially prominent on many doors.

There are ceramic brooches by Quentin and a walnut glass-fronted cabinet containing Omega pottery, Wedgwood plates by Duncan and Vanessa, and a painted ceramic Madonna, circa 1915, by Vanessa. This cabinet, an early nineteenth-century piece which once belonged to William Thackeray and came by descent to Vanessa (Vanessa's father's first wife was a daughter of Thackeray), is typical of the solid bourgeois stuff in the house that grounded these

people in their past. Some of it was inherited, some acquired in their travels, some no doubt bought at auction. The other impressive old piece in Duncan's studio is an Italian chest of drawers, purchased in Rome in 1920 by Clive (the biggest collector in the group, along with Fry and Maynard Keynes) and installed in 1939 when other valuables were brought down from London to be saved from the blitz.

Another idol adorns this chest: the striking likeness cast by sculptor Stephen Tomlin in 1931 of Virginia Woolf, whose visits insured England's interest in saving Charleston. The companion bust of Leonard is over where it belongs in the garden at Monk's House in Rodmell. In the Omega tradition, all chairs, tables, cabinets, and ordinary and contemporary manufactured items are enhanced by figurative or abstract designs, painted, tile-set, or cross-stitched.

The other rooms are tidy and spare compared with Duncan's studio, yet have the same air of casual intervention, of ornamentation that remains simple and improvised—looking intimate, however formal in conception. Three restored rooms at Charleston were once used or inhabited by Clive Bell, clearly the man of the house, with his library and bedroom (despite his flourishing lives elsewhere—abroad or at home in London, where he kept a flat near Vanessa's on Gordon Square). Besides Duncan, the only other "man of the house" now memorialized at Charleston is Maynard Keynes, an early lover of Duncan's, long predating David Garnett. Keynes wrote *The Economic Consequences of the Peace* at Charleston during 1919 and kept a room there until 1925, when he married the Russian ballerina Lydia Lopokhova.

Not all the approximately 162 paintings now hanging in the rooms, halls, and passageways at Charleston were there during Bell's and Grant's occupancy, and a number are missing. The valuable French pictures collected by Clive, and those from Vanessa's and Duncan's studios in London brought down along with the heirlooms and Clive's library in 1939 (e.g., a Picasso, a Gris, a Matisse, and a Vlaminck, purchased before World War I), are not there now. But small works by Doucet, Derain, Pissarro, Signac, de Segonzac, and Toulouse-Lautrec are hanging in the rooms.

A number of these pictures are on loan to the Charleston Trust. This is a permanent collection with replaceable elements. Each room is hung with the pictures thought to be most appropriate to

its former function or occupant, whether the pictures originally hung there or not. As a group, the pictures reflect the interests of many people in the Charleston or Bloomsbury cast of characters. It would be as impossible, however, to "read the story" from the picture collections as from the decorations, at least without a guide. Roger Fry, for instance, a main player in the family and one of the three recognized Bloomsbury artists, and, of course, the man responsible (as Omega founder) for all this decoration, is represented by his own works—a French landscape, a sepia ink drawing of Auxerre, a copy of a Giotto, an Omega woodcut photocopy, a 1911 oil called *Floods near Guildford*, and another oil of a Mediterranean port from 1915.

There is no inkling here of, say, the great passion Fry conceived for Vanessa beginning in 1911 and lasting long after she terminated their affair, fell in love with Duncan, and reestablished her family facade. Now as then, the pictures on exhibit tend to be as unrevealing as the literature once was. Virginia Woolf's biography of Fry, for example, published in 1940, is outrageously devoid of a certain essential Fry, because so many of the principals were still alive when she wrote it. Woolf mentioned merely his "new friendship with Vanessa Bell," how much the Clive Bells were to "mean to him," and how he took care of Vanessa in the spring in 1911, when she traveled to Turkey with him and Clive and fell ill there.[5] Anyway, it wouldn't be inappropriate to see one of Fry's portraits of Vanessa (there's a fine one dated 1916) hanging in the Charleston museum.

Evidence of Angelica's status at Charleston won't be found in the remains there either, nor will Duncan's long practice of homoerotic art be discovered, unless you have access to a storage space where, I hear, some of it is stacked.[6] There is, however, a 1935 pastel by Duncan of Angelica, now hanging in Vanessa's bedroom, that says a great deal about the aspirations and hidden motives of the family. The pastel is a piquant portrait of Angelica, aged seventeen, dressed for the part of Ellen Terry in *Freshwater*, Virginia Woolf's only play, performed in 1935, by and for the family, at Vanessa's London studio. Woolf had cast her niece in the part of Terry when Terry was herself seventeen, an actress-to-be staying in the household of one of Vanessa's and Virginia's great-aunts, circa 1864. There Terry was scandalously married off, by connivance of two of the great-aunts, to G. F. Watts, famed nineteenth-century portraitist

and allegorist, then more than twice Terry's age. The marriage lasted barely a year. A fate oddly similar to Terry's awaited Angelica. The role of Terry—victim of adult designs—precisely expressed certain realities at Charleston, and predicted others. Two years after the play, in 1937, when Angelica was nineteen, she was informed by Vanessa that Duncan was actually her father. A year later David Garnett, Duncan's peer and ex-lover, twenty-six years Angelica's senior, began courting her, and in 1942 they married. Duncan and Vanessa were aghast, and there was nothing they could do. Garnett and Angelica had four daughters and stayed married for two decades. Then she divorced him, and he died some time later. After Duncan died, in 1979, Angelica woke up. Her book testifies to her evolving consciousness since then.

In an updated performance of *Freshwater* in Dallas in 1986, Angelica, aged sixty-eight, played her mother's original role of Julia Cameron, the innovative nineteenth-century photographer, another great-aunt of Virginia and Vanessa. Lynn Redgrave was imported to play the young Ellen Terry. Angelica, though once groomed to be an actress, had long since become a painter like her mother. Quentin Bell, aged seventy-eight, a potter by vocation, looking much like his grandfather Sir Leslie Stephen in long flowing beard, took the part of the poet laureate Tennyson.

New chapters, new houses, are now in progress. Quentin and Angelica naturally decorate their own houses. Both Quentin and Angelica have been leaders in preserving Charleston, their memories a chief resource for the many people involved in the restoration. Angelica herself undertook to paint some of the walls in the plain distemper she remembered. The house has been restored, structurally, to a condition long predating the state in which Vanessa and Duncan found it in 1916. The copious accounts of the restoration, the arduous task of removing wallpapers and paintings on plaster surfaces, all stress the conflict over making a museum of a place that was in its heyday so eminently an interior of constant change. The restorers hope they have left a semblance of the life that was once lived there. They hope that visitors will find it the way they might have if they happened to look into the house while its occupants had gone out for a walk.

Some visitors may see it that way. But Charleston looks like the dead really cleaned up after themselves, leaving only the most calculated evidence of their charming disorder and unfinished states.

Both gardens and house have that sanctimonious air of something important having happened there, and of important people having lived there. The museum hush hangs over the visitors as they wander gratefully from room to room, watched over by proper ladies with blue-white hair who play guard at every chamber.

In a way, Charleston has become a satellite museum of Firle Place, where tourists can view the great portraits and truly grand effects of one of England's treasure houses. Fittingly, it was Deborah Gage, a descendant of the Gage family from whom the Bells leased the house, who rediscovered Charleston after Duncan died and decided to spearhead a movement to save it, fulfilling Quentin's wish for a miracle to happen. Gage's mother gave me a tour of Firle Place when I was there. If you consider Charleston in relation to Firle Place, some aspect of the English class system, with curious variations, should become apparent. Like the nobility, the Bloomsbury crowd loved antiques and the French and Italian old masters. In their copies of old masters and their modest antiques, they naturally aped the grand aristocracy. With their obsessive portraits of themselves, they produced a gallery echoing the family pictures of their landlord. The pictures are small by comparison, and they did it all themselves, but the pride in family descendancy, the drive toward posterity, the interest in showing the pictures off, are the same. Likewise their collection of contemporary French masters, affordable and small, placed them in diminutive proximity to the peerage. The tokenism seems to have been important.

Bloomsbury writers and artists on the whole were well off and didn't have to sell their work to survive. The production of Bloomsbury artists was much more for themselves than the world. This may account for the world's lagging recognition, despite a perhaps growing acknowledgment of the important place of Fry, Bell, and Grant in the history of English modernist art.

The huge production of these artists, especially Bell and Grant, has yet to be presented in a major retrospective or reproduced in books that show the breadth of their careers. In the meantime, Charleston is a kind of de facto museum, the one place you can go to get a feeling for what the total Bloomsbury art interests were all about.

1989

Notes

[1] Quentin Bell, *Virginia Woolf: A Biography*, vol. 2 (New York: Harcourt Brace, 1972), 32.

[2] Letter to Violet Dickinson, April 10, 1917, in *Letters of Virginia Woolf* (New York: Harcourt Brace Jovanovich, 1976), 23.

[3] Virginia Woolf, *Moments of Being* (New York: Harcourt Brace Jovanovich, 1976).

[4] Richard Shone, *The Bloomsbury Portraits* (New York: Dutton, 1976).

[5] Virginia Woolf, *Roger Fry: A Biography* (New York: Harcourt Brace and World, 1940), 169–70.

[6] Angelica Garnett and her daughter Henrietta have effectively blocked the publication in England of a book by Douglas Turnbaugh about Duncan Grant, *Duncan Grant and the Bloomsbury Group* (Secaucus, New Jersey: Lyle Stuart, 1987). Turnbaugh's book emphasizes Grant's homosexuality and features reproductions of some of Grant's homoerotic art, though not the raunchiest examples. Turnbaugh succeeded in having published in England a book of reproduced paintings and drawings by Grant of his homoerotic interests (London: Gay Men's Press, 1989) with an introduction by himself.

Carrington: A Life

Gretchen Holbrook Gerzina has written the first biography of Dora Carrington (*Carrington: A Life*), but it's hard to imagine anyone having waited breathlessly for it. Carrington, as she was called, was a slight figure in the sprawling Bloomsbury circle of the late teens and 1920s, known barely for herself, and hardly at all for her paintings. She was chiefly famous then, and is now, for her unofficial marriage to Lytton Strachey, the one Bloomsbury male whose literary reputation approached Virginia Woolf's. Still, Carrington has roused great curiosity (the way she organized, or didn't organize, her life was unusual), and there's been a certain belated recognition of her work.

Carrington was born in Hereford in 1893 and committed suicide in 1932, aged thirty-nine, shortly after Strachey died of cancer. Gerzina's biography fills out what we know about her from several sources, including Carrington's *Letters and Extracts from Her Diaries*, published in 1978 (with an introduction by David Garnett) and Michael Holroyd's biography of Strachey published in 1971. Gerzina is sympathetic to Carrington as an artist—that is, to her

problems in being or becoming one—but not very contemporary in her assessment of Carrington as a woman.

Carrington's conflict between her career as an artist and her expected role as a woman was complicated by her resistance to being a woman at all. As a student at the Slade, she cut her hair in a bob (one of the first, it was said, to do so) and she liked wearing trousers. She's been described by lots of people as boyish. She often said she hated being a girl, and that she hated her mother and adored her father. Carrington entered the Slade in 1910, the very year Roger Fry mounted the first postimpressionist exhibition of French masters, rocking England's conservative art establishment. She was a gifted art student, winning scholarships and prizes, but in school her friendship with fellow student Mark Gertler already interfered with her ambitions as a painter. Much of Carrington's time and energy was absorbed in her six- or seven-year struggle with Gertler to be his friend and to resist his amorous advances. In the process, she deferred to him as the artist. The literature on Carrington gives her bad marks for leading Gertler on, and Gerzina rather mindlessly reiterates that judgment. Yet she provides all the evidence for understanding Carrington's needs. By 1917 Carrington was safely domiciled with Lytton Strachey, a father figure who unequivocally loved other men. This arrangement solved one problem for Carrington but left her to her own caprices in several dangerous ways.

Strachey was a busy, popular man, especially after 1918 and the great success of his *Eminent Victorians*. He lived with Carrington at Tidmarsh, the home she made for them in the country; but he traveled a lot, he often stayed in London or visited friends, he was lionized by society, and he had romantic interests. By 1919 Carrington had a romantic interest of her own in Ralph Partridge. Her father had just died; evidently she needed more emotional attention than Strachey could afford. She capitulated to Partridge sexually, but then became torn between him and Strachey. A certain classic triangle was born. Carrington was desperate not to lose Strachey, her father protector. Partridge, who had fallen in love with the ambivalent Carrington, pressured her furiously to marry him. Strachey had fallen in love with Partridge—an arrangement closely echoing the then recently dissolved triangle at Charleston, in Sussex, of Vanessa Bell, Duncan Grant, and David Garnett.

In each case it was the male/female bond that won out, but Vanessa Bell got a homosexual partner, while Carrington ended up married to a heterosexual, not at all happy about it, and poised precariously between her husband and Strachey. Ironically, Bell was heterosexual (she endured a long celibate "marriage" to Grant), while Carrington's interest in men centered on them as brothers, friends, or protectors. What she really wanted, emotionally/sexually, was women. In describing Carrington's orientation, Gerzina plies that boring euphemism "bisexuality." As I see it, Carrington's life began unraveling after she married Partridge, in May 1921. The pressures had been great. Strachey liked tying Partridge more firmly to his ménage, and Virginia and Leonard Woolf had colluded by hiring Partridge to work for them at Hogarth Press. They then advised him to deliver an ultimatum to Carrington: either marry him or leave him. Leonard had described Carrington as the classic female: "one who runs when pursued and chases when ignored." And no sooner were the couple married, honeymooning in Paris, than Carrington developed a crush on a woman called Valentine Dobrée, whom she had known at the Slade as an art student. Before long Partridge had snatched Valentine himself, when (in Gerzina's words) they "fell suddenly, passionately, and inexplicably in love." Carrington's next move was to focus on Gerald Brenan, another brother figure; he chased her and tortured himself the way Mark Gertler had. While Brenan tried to get her, she tried to have him as a friend by keeping him hoping.

Though Partridge was carrying on with Valentine, he was enraged by Carrington's attentions to Brenan, and the Carrington/Partridge/Strachey ménage threatened to disintegrate over these new triangles. Things were resolved, but hardly to Carrington's advantage, when Partridge fell in love with Frances Marshall, the woman he would marry after Carrington killed herself. Marshall was able somehow to join the threesome without tearing it apart, and Carrington at that point was happily diverted by her first affair with someone she really wanted (and actively pursued)—though one can say, and she said so herself, that what Carrington really wanted was to be a boy and to have Strachey. Anyway, in 1923 she became besotted with Henrietta Bingham, daughter of the American ambassador to the Court of St. James. If all reports about Carrington are true, this was her first and last affair with a woman,

though she was known to have been attracted to a number of others, including Lytton's niece Julia. In a letter to Brenan, Carrington made her frustrated interests very clear: "I think H. although she gave me nothing else, gave a clue to my character. Probably if one was completely S[apphic] it would be much easier. I wouldn't then be interested in men at all and wouldn't have these conflicts." Brenan replied that for her "own happiness [she] should give up men and become a complete sapphist."

But in that period, such a choice was hardly possible. "Bisexuality," that is to say the pretense of interest in the "proper" sex, was the only feasible course. "Bisexuality" was a way of not being discredited entirely. It was thought that lesbians hated men—which was obviously not true of Carrington. She *loved* men; she just didn't want to be screwed by them.

If Carrington had developed her art, it's possible that she might have endured her confusions better, and survived her engulfing dependence on Strachey. Carrington carved out a no-woman's niche for herself, neither becoming a real wife nor pursuing painting professionally. Gerzina challenges the myth that Strachey and the other men in Carrington's life were responsible for her lack of artistic success. She produces evidence to show that both Strachey and Partridge were personally supportive. There's a touching story about Carrington being consoled, after an exhibition in which she had shown three of her works but sold none, by a commission to paint Lady Strachey, Lytton's mother. However, Lytton evidently had no pull with those Bloomsbury friends who counted in art and might have helped Carrington. There's a chilling story in fact about Roger Fry actually discouraging her from being a serious artist. Later on Fry enlisted her for decorative projects in his Omega Workshops. Now Carrington's name appears alongside Fry's in the list of lesser-known Bloomsbury artists—expanded slightly to include Simon Bussy (the French painter who married a sister of Strachey's) and Edward Wolfe as well as Carrington.

Fry and Clive Bell, the influential postimpressionist critics, never wrote about Carrington's work; and Vanessa Bell and Duncan Grant (all of whom were close to Strachey) never took an interest in her painting. The contrast between Vanessa and Carrington has often been pointed out. While Carrington, by joining Strachey, left her art world friends behind, Vanessa, in joining Grant, provided

herself with a painting partner. There were two other problems for Carrington. She was socially a peg down from the main cast of Bloomsbury characters; and she remained more the English painter than either Grant or Bell, who were so strongly affected by the French postimpressionist masters. Just as Carrington was being formed as an artist, during her student days, the French esthetic overwhelmed England and in particular the milieu that she would soon enter. She loved the French masters herself, but her own work, unlike that of Grant and Bell, was less experimental. She remained tighter, more controlled, more realistic in accurate drawing, attention to detail, and solidity of forms. Carrington's portraits and landscapes are expressive, I think, of an artist looking for security, grounding, enclosure—the things that tended to be missing in her life. Her several portraits of Strachey are surely among her finest work. He is almost always shown reading—his book, his long, dark reddish beard, his inward focus, his attenuated hands, all of one piece.

Carrington had more success with her decorative work than with her painting. She did woodcuts for the Woolfs at the Hogarth Press, signboards for local businesses, and tiles for London shops; she designed rooms for friends and of course the two houses—Tidmarsh and Ham Spray—that she lived in with Strachey. She was also diverted by a voluminous correspondence, which she enlivened with witty sketches.

Gerzina's biography fills one of the gaps in the Bloomsbury canon. It's thoroughly researched and clearly presented. It isn't inspired, but then Carrington's life was difficult, and her art has yet to be seriously appraised. An inspired biography of somebody like Carrington would have to be one that seized her as a paradigmatic figure, bringing into relief the sex/class warfare that was endemic to her struggles to survive and to work. Gerzina approaches such a thesis when she says that Carrington's "fear of exposure, which both exhibitions and sexual intimacy would bring to the fore, was, like her refusal to use her first name, the root cause of her difficulty." But she doesn't expand on this idea; and she was evidently unable to link Carrington's fear of exposure of her work with Carrington's concealment of her love for women (by sexual intimacy she means intimacy with men) and such "quirks" as her refusal to use her first name.

Carrington was a casualty of her time, of patriarchy, and her particular circumstances—a very gifted artist with little confidence in herself who was not set free.

1991

How Dance Artists and Critics Define Dance as Political

W e all see things through our personal histories, with their parts rooted in convention and their parts that became subject to change. These histories come to include reflections on what made us enter into them. Through such reflections I believe we become political, because they address questions of gender, race, class, nationality, and family origins. With political consciousness . . . some knowledge of self and place . . . change becomes possible. I don't know how dancers and other critics link politics with their mediums or lives. I do believe that dance today, though I have hardly seen a great deal of it, is made by choreographers who are much more politically aware than critics are—or else critics generally feel suppressed by their publications, and the difficulty over the explicitness of words. Whether they are consciously not

Lecture Delivered to the American Dance Guild, New York City, 1991

talking about what they see is often hard to tell. But I think I'm right in my impression that dance criticism is not yet addressing major changes in the way dances are presented that challenge old concepts, that dance criticism continues to deal, primarily, with the formal and qualitative aspects of the medium—the way dances look, the way dancers dance, the themes of the works (dealt with descriptively), and so on. Much good criticism is done here. But if criticism doesn't address the central and assumed values—that is, the political underlying content of every work—it is, I believe, operating in a holding pattern, not keeping up with and contributing to the social revolutionary changes of our time.

I don't remember when I began to reflect on my reasons for entering dance, but I suppose it must have been around 1969 or 1970 when I was first exposed to feminist ideas. By then I had long ceased dancing (though not socially), and was not even writing criticism anymore. I did have a developed story in my head of Western theater dancing, but it wasn't till I had a feminist context that I completed this story, and imagined how I wanted it to continue into the future.

I became a dancer because I fell in love with my dance teacher in college. That was all there was to it. Now this dance teacher knew I was an athlete—I had short hair and I excelled in every sport from tiddledywinks to soccer—and I know she found me attractive because of it. But girls had just about no place to go as athletes at that time. You could teach sports to other girls, that was pretty much it. However, dancing had career possibilities. And my teacher must have seen an opportunity to turn me into a (real) girl. I did exactly what she told me to do and went the places she sent me. She took me herself to the Connecticut College Summer School of the Dance and introduced me to all the greats, whom she knew personally very well. José Limón, his wife Pauline, Doris Humphrey, and Charles Weidman were old friends of hers. So after a year or two had passed, and I came to New York to enter professional training, naturally I went to the José Limón studio. I adored Doris Humphrey, but she was crippled then, and was the artistic advisor to Limón's company.

Now when you're beginning to reflect on origins you have to ask yourself who were these people in whose lair or den you ended up? Here were two women and two men in this crucial nexus of dance history. I'm including Weidman here of course, because he was

Humphrey's partner for so many years, as well as Limón's teacher. The four artists shared a common esthetic. Pauline Limón was a musician, composer, costume designer, and manager to the Limón company as well as Limón's wife. At that moment in history, the early 1950s, the hopes of this group were pinned on Limón, then in his prime. He was still very grand. And he was the one outsider to the group, in fact to the dance community at large, unless you count émigrés like Hanya Holm. You could never forget that José was Mexican. He was incredibly exotic, huge, sensual, and noble. And we were all his children. That was clear. What was not clear at all was the sexual or gender politics permeating the classes and company strivings. For, of course, to attend these classes regularly meant that you wanted to be in his company. This was assumed. Possibly others looked around them and understood the gender makeup of the classes and company right away. Oh, at some level we all did. This was a perfectly straight situation. José was a gay man, what some people now call a queer married man, whose dances were absolutely heterosexual. His leading women were small and conventionally attractive and beautiful. He did have one outlet in dances he created for his men, in the tradition of Ted Shawn, and some early Weidman too. But no one would have thought that the twelve men in *The Traitor*, playing Apostles, were participating in a homosexual scenario.

Anyway, you can see there were some contradictions going on in this den where I ended up. Doris Humphrey had worked with a gay man for years—Weidman—and was now working with another. She herself was married to a seaman who was at sea most of the time. The two women *appeared* to be straight, or were assumed to be, while the two men were known to be gay and seen to be actively serviced by women. I think this was a classical nexus in the dance field. In a previous generation, Ted Shawn and Ruth St. Denis played out some version of it. Such realities profoundly influence us, whether we know it or not. That I didn't fit in at Limón's studio you could say was an understatement—but, in some sense, was only half true. I loved the technique and I was good at it. José liked me too. But I knew even then that I'd never play opposite him in *The Moor's Pavane*. I'm sure I wanted to be one of his boys. I competed with the men in class to consume a lot of space and leap as high as possible. Yet I was quote feminine unquote too. I was simply stranded there between the sexes. After four years, I resolved

the conflict I really didn't know I had by breaking a bone in my foot and never returning to class. In retrospect, years later, I realized that I missed my historical time. The time that would have been ideal for me to enter modern dance would have been during the 1930s, when Humphrey and Graham and others had huge companies of women of all sizes and types.

But there was another ideal time, coming up in the near future, the rebellious or avant-garde movement of the early 1960s. By then, however, I was a critic and a mother, and the way I got to participate in it was by becoming its critical champion. In retrospect I realized something else: I had a powerful subconscious understanding of dance in America as a matriarchal tradition. Isadora Duncan was our founding matriarch. I saw her at the head of some family tree consisting of women. The story I had developed, and at length updated, went something like this: There had been something awful going on in Europe called the ballet, which was punitive toward women. But the ballet was the only form of respectable professional dance that existed for women. In the meantime, women in America were tasting greater freedom through the early feminist movement. The ballet had not taken hold here. A woman from California called Isadora, who knew all about ballet and had a free sort of California spirit, invented a dance that didn't bind the body or depend on men to look good. She was succeeded by other pioneering-type women, St. Denis, then Humphrey and Graham, who applied their intellects to dance making to invent whole techniques and formal approaches to choreography. Two dance critics—John Martin of the *New York Times*, and Margaret Lloyd of the *Christian Science Monitor*—came along to champion this indigenous American dance. Then somewhere along in there the European ballet got a foothold in America. Modern dancers welcomed the opportunity to go to ballet classes and strengthen themselves or increase their range, but were powerless to stop an invasion that eventually obscured the through line of the American modern dance. Margaret Lloyd died; John Martin retired. The *Times* hired an Englishman to be its critic who understood only the ballet. Ballet companies sprang up everywhere. The money went to ballet. Modern dance became a poor sister. And women were returned to the pedestal and made to appear silly in tutus and dependent on men to look good.

In thinking about dance in America I feel perhaps the way Native

Americans do about all of *us*. I know the modern dance is strong in America, that there's plenty of it, but I think it should *dominate* the dance landscape. It's *our* invention. The ballet represents exactly what America overthrew when this country was created in the 1770s. That the royal court tradition should prevail here the way it does seems a supreme irony. It's as if the government allowed the one tradition created here by women to be overrun by the very royal hierarchy and aristocracy it had once gotten rid of to exist. You can see I felt strongly about this. In the early 1960s, without really knowing it, I seized on Yvonne Rainer to carry forward the torch of Duncan in America. I saw her in a woolen period comparable to that of Graham in the 1920s, casting off exhibitionist expectations of women, and returning to choreographic basics.

A criticism that approaches *all* dance politically should help us out of this jam. I don't know if women dominate modern dance anymore or not, nor do I believe they should. I only feel certain that the modern dance so called should dominate in America, and that within the modern dance tradition we will find more gender parity than in any other medium or field in the country. What I want to know when I'm reading criticism is very basic: Are the roles in this or that work a mindless reproduction of dominant values—and now I'm speaking of heterosexism, which reigns in the ballet—or are they a commentary on them? Or does it appear that no roles are being played at all? We want these things articulated. I read a review in the *Times* recently commenting on the corsets worn by some men in a dance by Stephen Petronio. The reviewer said the corset could be interpreted in so many ways . . . that they became visual distractions rather than meaningful symbols. I say why doesn't the reviewer, if he doesn't know, ask the choreographer what he intended? Reviewers and critics should be part of a mutually cooperative community, working together to help enlighten audiences, rather than the antagonists they tend to be.

Here's another commentary I read that just floored me. The reviewer wrote that Ralph Lemon rises, takes off his shirt, and, torso bare and stamping to a harmonica while wildly flaying his arms, turns himself into a plantation slave, a painful image that is reproachful to all, including himself. A REPROACH TO ALL? INCLUDING HIMSELF? If *I* feel reproached, I won't feel too empathetic. If the choreographer is reproaching himself, we have the victim convinced he is wrong—a situation many Americans are

now trying to redress. The reviewer should speak for himself, or look around at what is happening in the country, at the new politics of the victim and so on.

When we see a company consisting of men and women of the same size whose movements are the same and who wear the same costumes and who are not involved in partnering, we know we are looking at some strong gender politics. But the criticism we will read of the performances by such a company will highlight the movement patterns, the choreographic form, the performances themselves, avoiding the underlying challenge to gender differentiation going on, which actually determines the patterns, forms, and so on. When we see something as traditional or gender reinforcing as Twyla Tharp's *Sinatra Dances*, we should hear about that first. Anyway, we already *know* the dances are fabulous.

If we're interested in furthering parity between the sexes, we'll want to know whether we're looking at men doing things only associated stereotypically with men, and the same with women. We'll want to have confirmed in print what we thought we saw. If we saw men lifting women all the time, and we see that in print, we might then ask why women are not working out to improve their upper-body strength. Why do they have legs, but no arms? If they can get legs, we know they can get arms. And even if they can't get arms, they don't have to be lifted all the time by people who have them. Nor be dragged and pushed around. Much sexual brutality goes on in dance that's excused or overlooked because it looks so normal. Or because it's just regarded as choreography.

Only yesterday I read this in a review: "A couple's erotic passion is symbolized profoundly by the way a man whirls continually as a woman throws herself at him and hangs from his neck. Like a carousel rider who grabs at a ring, she reaches for him as he passes." The next time you look at a Cunningham work, if you haven't already noticed it, look at how his men push his women around *all* the time, in *all* their partnering exercises. Why do the reviewers continue to ignore this? If the roles were reversed, which doesn't interest me by the way, you would notice it instantly. I recommend reversing many things in your mind's eye when looking at dance, just to see where we still stand in our sexual politics. I can't watch TV or movies without doing this myself. When the woman cries, I put the man in her place and imagine the unthinkable. When a man tells a woman what she thinks, I turn it all

around. As I said, I'm not advocating role reversals. For my own sanity I have to read out the politics that discriminate against me.

I have one more example of recent deplorable dance criticism. When Jim Self presented his dance *Getting Married*, which depicted a wedding ceremony for Mr. Self and his lover Julio Torres, a reviewer's summation of the dance was, "The genuine and touching sweetness of Mr. Self and Mr. Torres clearly suggested that one of the few truly irreconcilable differences among us may be that participation in bedrock social institutions like marriage is not open to everyone." WHAT DOES THIS MEAN? That a genuine and touching sweetness characterizes wedding ceremonies that are not legal? Is this "difference among us" irreconcilable? For example, does it mean such ceremonies will *never* be legal? This was a campy and revolutionary presentation. I happened to see it myself. It was socially extremely provocative. One sentence like that about a dance like this is surely a criminal sort of criticism.

If choreographers are promoting gender ideals, the critics should report this. If choreographers are challenging gender ideals, the critics should report this too. There is no such thing as a dance that isn't committed to either approach, whether conscious or not. The formal properties of a dance, the movements, gestures, themes, set, lighting, *everything* serves the interests of the one approach or the other: the traditional that reinforces assumed gender identity, and the revolutionary that challenges it.

The way to challenge contemporary criticism is to read the lines and between the lines carefully and to send letters of protest to both critics and their publishers. Critics in other mediums are now addressing gender issues with some regularity. Choreography itself may be in advance of other mediums, and it isn't getting the coverage it deserves. And the world isn't finding out just how advanced it is.

Family Spectacles

J ust a cursory reading of the literature about Robert Wilson's
work, along with remarks by Wilson himself, reveals one strik-
ing, ever repeated, disclaimer: he doesn't mean anything by it. I use
that phrase to invoke the cliché whereby people apologize for
something they did, hoping they have not offended: "I didn't mean
anything by it." It seems improbable that Wilson himself would
ever say anything like that exactly. His own remarks about "mean-
ing" focus on a differently expressed abdication of responsibility.
He has said repeatedly that he likes to leave things up to the
audience. "The audience is free to draw its own conclusions, we
don't do that for them." In other words, there are many possible
meanings, and you are free to choose or construe your own. Typi-
cally, Wilson's work elicits a binary commentary: it is both for-
mally beautiful and mysterious. One critic wrote that Wilson is "a
brilliant designer and showman whose willful obscurity is part of
the package." Another that "structure is the subject . . . most won-
derful in its lack of explanatory power."

Robert Wilson's theater is of course well known for its subordi-
nation of text to design. The design is the thing—architectural

structure, spatial arrangement, physical gesture cum choreography, line, costume, decor, lights—above all, the lights. Wilson is nothing if not a lighting genius. He is a painter manqué (he studied painting in the 1960s, but became discouraged) who found his medium or "canvas" in the theater. A production by Wilson is always certain to yield the most sumptuous visual delights. The temporality of the theater, normally a drawback for anybody interested in making pictures, has become, in Wilson's hands, an asset, for by slowing down his action to glacial tempo, the full impact of a "picture" is deployed, and the image is allowed to change as well. In Wilson's theater the action is integral to the backdrop (lights and all special effects), forming a unified pictorial field: the action doesn't stand out against its decor as in conventional theater. Both decor and characters move slowly enough not to disturb the integrity of any single picture, which may last for some time before dissolving into a new frame. But Wilson's characters do speak and play parts, and the text and the "drama" of his work have consistently proved resistant to integration.

During 1984–85, Americans had two major opportunities to check out the Wilson oeuvre, which has been performed and developed largely in Europe since the early 1970s, after the staggering success of *Deafman Glance* in Paris in 1971. *Einstein on the Beach*, seen in New York in 1977, was revived at the Brooklyn Academy of Music in 1984; three scenes from *the CIVIL warS* (a colossal multilingual conception six years in the making, projected as a twelve-hour performance in five acts, fifteen scenes, and thirteen entr'actes, or "knee-plays," and involving the contributions of innumerable artists from six nations) were performed in March 1985 at the American Repertory Theatre in Cambridge.[1] In addition, a relatively small work, *The Golden Windows*, first shown in Munich in 1982, appeared for a week's run in October 1985 as part of BAM's annual Next Wave Festival.

The Golden Windows as well as *the CIVIL warS*, or at least the three sections of the latter—lasting two hours—produced in Cambridge, indicates some altering emphasis or development in the dramatic and textual aspects of Wilson's work. In *The Golden Windows*, Wilson's text is more prominent than it has ever been. While it makes no "sense," it is spoken by four actors—an older man and woman, a young man and woman—as if it does, or should. The piece is a "play" in three parts or acts, including a

prologue, lasting nearly two hours without an intermission. The three parts take place during the evening, at midnight, and in early morning—in other words, in the dark. Wilson alters the basic "picture" of the piece three times to suit the three acts or time frames of the unfolding night. There is a "house"—which looks like a sentry box or telephone booth—sitting on a "hill" or the peak point of a raked stage, against a starry sky. Downstage right there is a bench. The older man sits on it to speak the opening lines. For the first part the little house is situated stage left, for the second in the center, and the third, stage right.

There are several dramatic events in *The Golden Windows* with no necessary causal connections among either them or the characters. The only reliably causal event is the brilliant emission of light from the door of the "house" whenever it slowly opens to embrace or exude a character. The beauty of the scene—night blues and stars and half-moon and shafts of gold and geometric/architectural purity—is abraded by a jumbled and incoherent text. The pictorial integrity of the scene—its naturalistic relation of parts that remain consistent throughout—is contradicted by characters who speak apparent nonsense in loaded emphases or inflections, who appear to have almost nothing to do with each other. They speak nearly exclusively to themselves or the audience. Their isolation from each other, supported by the non-sequitur nature of the text, is the most striking aspect of the play.

There are three "meaningful" interactions among the four characters: the older man hands the older woman a gun; the older man embraces the young woman; and the older woman for a period of time regards the young man as he hangs by the neck on a rope from the flies, though her lines as she stands there regarding him have no necessary connection with him. It's impossible, however, not to feel that it's he who may be the object of her amusement as she laughs and laughs for perhaps forty seconds, intermittently looking up at him. Certainly it doesn't seem "nice." And some of their lines at this point suggest "meaning." As the boy or young man is lowered on his rope, the first thing the older woman says is "listen to me don't you know that you are in my chamber and you are wanted in the observatory at once." Then in the lines that follow, spoken by the boy, it's possible to hear a "son" talking to his "mother":

come here they had no evidence you are just attending to

your duties they are right under my nose o.k.? i will be back
tomorrow afternoon yeah outside outside line so what i just
want to warn you east top of zooooo in state cigarette i do
not get it look oh boy yeah i am sorry come on let us see here
we are is everything alright is something wrong i told you
nothing i do not want to go to bed what is the matter

Or these lines contain bits of dialogue between the two. All the
monologues appear to double as interior dialogues. According to
Wilson, he made his visual book separately from his text, and then
put them together, much the way John Cage and Merce Cunning-
ham collaborated on their audio and movement scores, or Lee
Breuer has developed his animation pieces with Mabou Mines.
There are a number of lines or monologues in Wilson's text for *The
Golden Windows* that could be just as suggestive for that particular
moment in the drama as the lines quoted above. At any rate,
because there is no dramatic continuity, story line, or character
development (let alone portrayal), any apparent connection among
the characters or with their environment is purely fortuitous, ran-
dom—not *meant* by the author, but left for the audience to
associate freely in the vacuum created by an "unstructured" plot.

The text of *The Golden Windows* is like many tiny pieces of a
puzzle cast out of a barrel onto a gorgeous and coherent set. For
there is certainly a "picture," or plot, in the text, a narrative that no
amount of "free association" on the part of the audience is going to
put together. Even an audience that might conceivably be adept at
seizing "key" lines repeated throughout the text, following them
the way one does bits of thematic material in a concerto, disregard-
ing the "weather," as Wilson has characterized some of his texts
(cliché phrases, trivia, mundane observations, etc.), disentangling a
kind of web of attributions or rematching the lines to give them to
whomever they *really* belong, will be unable to (re)construct the
plot that inheres in a puzzle like this. Only the author can tell us.
And in *The Golden Windows* he doesn't want to. He makes this
plain in his typescript: "don't tell anybody joe is in trouble"; "i've
got a secret a big surprise . . . i won't tell you"; "well as long as you
do not say what it is about." Later: "i've got a secret a big surprise i
still will not tell"; "one is for sure i have no memory"—a line that
Wilson finishes this way: "which saves me from being sentimental
and can make what i say more poetic afterwards." If Wilson has

"no memory," he may himself not know what his plot is. Here is another line also clearly about his work, this one ending in a kind of plea: "excuse me i have no comment i have offered you hypnotism in my work please i i i ah i need your help." There are ironic comments: "i am going to figure this character out," or "just yesterday i was thinking it would be a good story."

Something big does happen, however, in *The Golden Windows*: there is a murder and/or an accident and an earthquake, the latter somehow symbolizing the former. All the commotion occurs in the middle, or midnight scene. The first line in this scene is "after murder" repeated seven times. So we know the murder has already happened. Who did it and how, where or why, and so on, remain mysterious. Indications are that perhaps the No. 1 character, the older man, is the culprit, inasmuch as No. 2, the older woman, says, "i can smell you are a real killer" when they both happen to be on stage at once. She and the daughter figure, the young woman, together say "please you are a murderer . . . it is obnoxious"— lines spoken during the same evening scene. But during the midnight or calamity scene, after the young man has been lowered from the flies on his rope, after he has spoken a number of lines and has been raised again out of sight (his boots dangle a while in the shadows above), the older woman/mother figure comes clearly into possession of the (or a) murder weapon, a silver handgun given to her by the older man as he exits the "house" in the expected shaft of golden light; all this is accompanied by a voice-over singing quietly "happy birthday . . ." The older man says "make a wish may not come true" when he hands her the gun; holding it, she slowly and protractedly scans the area and the audience, pointing the gun all around.

Wilson's female "murderers" are well known in his work. His prototype was a Medea figure dating back to *Deafman Glance* who took forty minutes or more to stab two children, a boy and a girl. The gun toter in *Einstein* is Patty Hearst. This one in *The Golden Windows* who doesn't kill anything that we can see becomes party to the natural catastrophe of an earthquake. As she stands there holding her gun, the raked stage splits apart into a lit crevice the shape of a lightning bolt, steam exudes from the jagged chasm, the moon falls from the sky and lies on the ground, enormous boulders tumble very slowly to earth, and a voice-over whispers repeatedly, "after murder." Is this the "accident" referred to throughout the

text? Perhaps it is. The accident, like the murder, is never identified, but rather surrounded by disclaimers. "It's nothing more than . . . ," or "what happened you name it . . . " The accident may never have happened, and references to it may simply be ironic allusions to the sort of thing one expects to happen in classic drama or the naturalistic theater.

Many dismal things are spoken of in *The Golden Windows* besides the murder and the accident: night sweats, being driven from home, being lonely, sorry, embarrassed, depressed, worried, confused, accused, persecuted, needing love, and so on. And at least three "dire" things occur—a man hangs on a rope, a lady points a gun, an earthquake alters the set—but nothing really happens because no context has been established. Whatever plot there is has only been alluded to. The audience is asked to behold beautiful pictures—indeed they are beautiful—and to listen to words and look at gestures that *stand for* different states of being or feeling. The words are invested with feeling as spoken; the gestures are also "heavy"—further emphasizing their disassociation or dislocation. Certainly the audience is being distanced from the possibility of identifying with, or understanding or feeling anything for, the characters and their apparent plight. An audience may amuse itself trying to guess what it's all about. The author may be amused at setting up a kind of guessing game. The author could be embarrassed to say anything directly or straightforwardly—i.e., concretely—about the general human condition, or his own personal situation or background. Beautiful pictures obscure terrible stories. Life is terrible—who wants to know about it? Life could be just a beautiful picture, dreaming through the night. This is the way to make life better. *The Golden Windows* is a very interesting "play." In a way it is a play about wanting to be a play. It contains all the elements, presented raw, as if crying for an author to take responsibility for them. Near the end Wilson has his older man say, "i will not rest until i have gotten to the bottom of these terrible events"— a desperate sort of irony.

In the spirit of this line I approached Wilson several times like a detective. This is not easy because (1) he is as busy as a campaigning politician, his global wall-to-wall appointments made for him by a team of office workers; and (2) he is, as might be expected, quite evasive. No doubt the two circumstances qualify each other. At first he seemed happy enough to see me. He brought flowers and

candy and lots of literature about his work, and he stayed very late consuming wine and discussing enthusiastically his preoccupations with style and effect. Gradually I believe it dawned on him that I was interested in biographical data. I had not accepted his work at "face value." I was not "against interpretation."[2] I had failed to choose or construe my own meanings. The "pure, untranslatable, sensuous immediacy of [the] images"[3] had left me cold. I might want to replace the work with something else. I might want intellectual revenge. I might have a certain contempt for appearances. I could want to tame the work, make it manageable and comfortable, and so on.[4] But no, this last would be impossible. Wilson's work is itself quite tame. Then I might want to expose something wild and savage that the work clearly contains. I could understand my motives being suspect. I tried hiding them. I wasn't sure what I wanted in any case. I am only sure that some knowledge of biography can enrich the appreciation of works of art, help provide access to those that are densely veiled or opaque to meaning.

Wilson is a charming guy, eager to please, irrepressibly good humored. Sometimes he whoops and shrieks with laughter, a very contagious explosion. I've known him since the 1960s, but in the most superficial way. We have a number of mutual friends. In the early 1970s, we introduced people to each other. Quite a few people I knew had become "Byrds." (Wilson established his Byrd Hoffman Foundation in 1969.) I saw *Deafman Glance* in Paris in 1971 but missed the production of *Einstein on the Beach* in 1977 at New York's Metropolitan Opera. What particularly struck me about Wilson's work as I heard or read about it, and then began seeing it in the 1980s, was its identification with huge mythic characters: Einstein, Edison, Stalin, Freud, Queen Victoria, the king of Spain, and most recently Frederick the Great, who is the "hero" of a section of *the CIVIL warS* produced recently in Cambridge.

In Wilson's oeuvre there are three types of heroes: the (male) child, the disabled, and the fabulously great. These three must be aspects of the same person. They certainly are personas with which Wilson himself closely identifies, though the "disabled" aspect has permutated considerably since the days of his *Deafman Glance*, which starred Raymond Andrews, a deaf-mute black boy from Alabama whom Wilson legally adopted, and early work featuring Christopher Knowles, a boy who was reputedly brain damaged.

The "disabled" hanging boy/young man in *The Golden Windows*, for instance, is a professional actor. Anyway he is the "hero" of the piece, if only because of his striking "condition"—assumed during the prologue and during a prominent part of the midnight section. Wilson has made no secret of his own early difficulty with speech. Until he was seventeen he apparently stuttered badly; and it is well known that he worked with handicapped children in Texas and New York. Of his deaf-mute adoptive son, Raymond Andrews, Wilson told me he was "born deaf and had grown up with people who didn't understand that his problem was one of not hearing." In the early 1960s, Wilson was a consultant in New York for special education, offering programs for children with severe learning disabilities. His disabled boy-child turns up most recently in his *the CIVIL warS* as the "child" (in a family of seven) and as Frederick the Great, the latter played by a (well-disguised) woman in the Cambridge production.

Seven figures represent a "real" family: child, father, mother, aunt, young man, young woman, and grandfather. The actors in these roles also double as other characters, for example, Frederick the Great, Katte (Frederick's friend and lover, executed by his father), and Sophie Dorothea (Frederick's mother, sister of George II). They all first appear in Act III, Scene E, in a large car that traverses the stage left to right after an ensemble of eighteen Civil War soldiers (played by Harvard students in Cambridge) has emerged (at dawn) from their tents to dress and prepare for battle, accompanied by a voice-over humming the tune of "My Merry Oldsmobile." The figures become ever so gradually more distinct as the light comes up and the soldiers with their guns move into formation to march offstage—everything of course in Wilsonian slow motion. The "still" of the great car with its passengers disappears stage right as the soldiers "march" off in the other direction.

This whole scene is like an overture to what follows, Act IV, Scene A, in which "the family" along with Frederick, Katte, Sophie Dorothea, and others, and the eighteen young men, now playing "scribes" or "men with poles" or "furniture movers" or "polar bears" or "submariners," enact a number of pictures. These are classical Wilson, in the tradition of his *Einstein* and *Stalin*: breathtaking theatrical effects. For special results, Wilson relies here on a huge screen suspended to the viewer's left, upon which are projected wonderful clips of animals and landscape and scenes of

destruction. Life-size projections of Frederick or "the family" duplicate their actual appearances on the stage below the screen to the viewer's right. They could be live or on film (no floor or other support is visible beneath them), but in actuality they are on film. Frederick appears standing with his cane amid a huge scape of ice floes, then against snowy mountain peaks. But juxtapositions of live action below and screen images are no less spectacular, for example, Frederick staggering (slo-mo) off stage as the filmed statue of a man on a horse falls down over and over again. Later, stunningly, Frederick emerges live from a trapdoor on his horse, a life-size, wooden, white facsimile made from paintings and constructed by the Cambridge Rep people.

There are two other trapdoor marvels, in particular the appearance of a pair of polar bears who emerge after a great big silver bullet or rocketlike thing has descended over the hole (having first slowly traversed the stage horizontally)—the effect as a whole suggesting an outrageous hair dryer closing down over a white-haired lady crouching at a table (over the hole or door). The object then emits smoke, in a burst of Handel. It's hard not to cheer when the bears appear.

The text for these two sections of *the CIVIL warS* is by both Wilson and the East German playwright, Heiner Müller. Wilson's text is played in voice-overs for Act III, Scene E—typically his "weather," interspersed with lines indicating affect ("it is terrible" or "more hunger") or seemingly appropriate to the action ("it is a terrible war" or "it's reported he's in the hospital")—delivered in this case in a matter-of-fact tone. Along with Müller's own text for Act IV, Scene A, Müller selected fragments of texts by Frederick the Great and his father, by Shakespeare (*Hamlet, Timon of Athens*), Empedocles, Racine (*Phèdre*), Goethe (*Erl-King*), Kafka (the letter to his father), and Friedrich Hölderin and Maita di Niscemi.

In Heiner Müller it seems Wilson has found a collaborator as important to him and his work as composer Philip Glass was to him in the 1970s—or more significantly, perhaps, his two handicapped friends, even earlier, Raymond Andrews and Christopher Knowles. Müller was born in 1929 in what used to be Saxony to a working-class father who was a political activist and small functionary in the Social Democrat Party during the Weimar Republic after World War I. Wilson says Müller has changed his life. In Cambridge, where I saw Wilson for another long evening, sans flowers and

candy, he asked me several times enthusiastically what I thought of Müller. Act IV, Scene A, of *the CIVIL warS*, featuring Frederick the Great in vignettes from his life, contains words by Müller that give Wilson's disabled protagonist an emotional weight and substance he has perhaps never had before.

Wilson himself was born in 1941 in Waco, Texas, to a comfortable middle-class family. His father was a successful lawyer who became a "town father." He was a district attorney as well as acting city manager, and he held office for a time in the state legislature. Wilson describes his paternal grandfather, a successful businessman, as "this very powerful man" whose eight children were crippled by him. Wilson's mother, he says, was a very silent, remote woman who never expressed any emotion—dominated by her husband, yet "quite powerful in her silence." Wilson says his father was probably afraid of her. She had been raised in an orphanage after her father died and her mother was unable to care or pay for her six children, so she farmed them all out.

A disappointment to his father, who was a regular guy, Wilson describes himself as an outsider to his family (he has a younger sister), spending his time alone and staying up all night in his room on his various "projects"—stuffing the opening between door and floor to hide the light. He still stays up all night. He likes to say it's because he's afraid he'll miss something. Several lines in *The Golden Windows* (which occurs, of course, at night) reveal his involvement with the night as a time to create his own world: "the night is for dreaming," and "i told you i do not want to go to bed," and "you are not normal you have got to go to bed," and so on.

A charming and sad passage in Louis Aragon's open letter of 1971 to André Breton—the letter that virtually made Wilson's reputation in Europe and described Wilson's *Deafman Glance* as the "miracle" they had all dreamed surrealism might become, as "more beautiful" than anything in the world he, Aragon, had seen since he was born—connects a father's tyranny with a child's drive to create. Aragon refers to a book called *My Life* by Jerome Cardan, a mathematician, who wrote, says Aragon, "about his childhood dreams, when his father forced him to stay in bed until the third hour of the day and he had time to notice cities, animals, horses with their cavaliers, grass, trees, musical instruments, theaters . . . soldiers, crowds, forms he'd never seen, prairies, mountains, forests."

When Wilson was eighteen or twenty and living temporarily in Waco, perhaps during a college vacation, his father came to see a play put on by his son, the delinquent kids with whom Wilson worked serving as performers. The kids were all nude in the play, and his father's comment was that it was "not only sick, but abnormal." At a rehearsal in Brooklyn for *The Golden Windows*, Wilson showed me admiringly the silver gun he would have his "older man" hand to his "older woman" during the play. He said it was a German Luger. I guessed that his father owned guns and hunted animals. Wilson replied that, indeed, he did, and that along with football and the other "manly" sports, hunting was something that failed to interest Wilson himself, though he tried to please his father nonetheless. For instance, Wilson majored in business administration at the University of Texas before going on to Pratt in New York to study architecture.

Of all Wilson's mythic great men, Frederick the Great may offer the richest parallels to his own background and aspirations. A brief biography of Frederick was included in the Cambridge program for *the CIVIL warS*:

> He despised the despotism of his predecessor, his father, but he imposed it throughout Europe with an iron will . . . Frederick's youth was one of constant battle with his father . . . Resentfully the boy learned his parade-ground drills, but against his father's will he learned Latin, cultivated his French, and assumed the manners of a dandy. His father abused him publicly, caning him, kicking him, forcing him to kiss his boots, calling him "a cringing coward, so effeminate . . . that he can neither ride nor shoot." . . . Frederick learned to play the flute and with his sister Wilhelmina cultivated a love for plays, operas, and ballets, which [his father] considered "godless things increasing the kingdom of the devil."

In Act IV, Scene A, of *the CIVIL warS*, the father/son violence at the heart of Frederick's story is much muted, and as is usual in Wilson's work, really transcended by pictorial splendor. Frederick, who became a great tyrant like his father, is depicted in his glory, posing on his horse; with his cane in dramatic land or waterscapes; attended by costumed courtiers at his death; and so on. One small

event clearly represents a father's humiliation of a son. The old man or grandfather knocks over a bunch of blue blocks that the "child" has been playing with. Heiner Müller's text makes Wilson's father/son theme emotionally vivid. What is all allusion or reference or avoidance in Wilson's own text and imagery becomes real in the words of Müller and his collaborative sources.

This may be because Müller aggressively or consciously connects his texts with his own father story. In 1958 he wrote that his father, in 1933, was arrested while still in his bed:

> I woke up, the sky outside the window black, noise of voices and footsteps in the next room. Books were thrown onto the floor. I heard my father's voice. . . . Through the crack of the door I watched as a man hit my father in the face. Shivering, the blanket up to my chin, I lay in bed when the door to my room opened. My father was standing in the doorway, behind him the strangers, big, in brown uniforms. . . . I heard him call softly my name, I didn't answer. . . . Then my father said "He is asleep." The door was closed. I heard how they took him away.

Müller has said, "That is my guilt. I pretended I was sleeping. *This really is the first scene of my theatre*" (my italics). His experience of "Fascist brutality" and of his first "treason" in the face of it became the trauma of his life and work. Müller's father was eventually released from prison, and father and son became estranged. His text for Wilson's *the CIVIL warS*—spoken by actor No. 6, the "child"—includes bits of his story about his father: hearing him taken away by strangers in the night; later seeing his father through the wire mesh of the prison camp gate; later still, when his father was living in West Berlin and Müller had "defected" to East Berlin, seeing his father on either side of a glass door in a hospital. "We stood, the glass between us, looking at each other." Actor No. 1, the "father" (played in Cambridge by a large black man), speaks the first lines in this act, taken from a letter to Frederick from his father, the king:

> Thy headstrong wicked will, which loves not thy father! For if one does all—if one loves one's father over all—then all is done to please him, not only when standing over you but when he turns his back. Furthermore, thou knowest well I

cannot stomach an effeminate fellow without manly inclina-
tion, blushing like a girl, who cannot ride nor shoot, and at
the same time cuts an awkward figure—hair brushed like a
fool's, not properly groomed—and I have reprimanded you
a thousand times upon the subject, but in vain, no improve-
ment seems forthcoming.

The lines are spoken during the first part (of twelve) while the
family of seven are seated at table.

There are many dinner-table scenes throughout Wilson's work.
Wilson told me that when he was young his family had "formal"
dinners three or four times a week, and he would have to wear a
coat and tie. Once, when he was about fifteen and late for dinner
(he says he was always late for everything—certainly he was late
for our several appointments), his family was knocking on his door,
and he crawled out a window and came in through a back door to a
sitting room adjacent to the dining room; he had put a stocking
over his head and had a flashlight (relating this, he giggled) shining
on his face: "very theatrical." He slowly and carefully opened the
door; his father was seated at the other end of the table. Here
Wilson yelled, imitating his father's reaction. I asked him what his
mother did. He said she turned around and said, "Oh, it's only Bob."

Especially affecting in Act IV, Scene A of *the CIVIL warS* is the
part called "Frederick the Great," in which Frederick crawls down-
stage with his throne-chair on his back while the text of Franz
Kafka's famous letter to his father is spoken by seven characters,
together and in alternation:

Very efficient, at least toward me, your never-failing rhe-
torical means of education: reprimands, threats, sarcasm,
sneering and, curiously enough, self-accusation. I don't
recall your directly hurling verbal abuse at me. It wasn't
necessary, you had so many other means at your disposal. . . . I
was almost numbed by it, thinking, of course, it was aimed
at me. . . . You even resorted to threatening violence—and
it terrified me—for example: "I'll slash you open like a
fish."

Wilson told me his father was "afraid to get close" to him. "It
was a strange thing to me, Jill. . . . I was a strange creature in the
house." A critic described the 1969 production of *The King of*

Spain ending as the King of Spain "sings a little dirge and rises slowly from his chair . . . grotesque, beastlike . . . raising his huge and misshapen puppet head to confront the audience as the curtain falls."[5] In his Kafka letter text for *the CIVIL warS* Wilson incorporates a number of growls. "I (growl) recall your directly hurling verbal abuse (growl) me It isn't necessary you had (growl) . . . " and so on.

Wilson's tale of how his father died includes a wonderful, and as it turns out, specifically theatrical, growl. Incidentally, there is a dog in Frederick the Great's story. Part 10 of Act IV is called "Dog's Death." Frederick plays with a dog, and later shoots it. What's more, a portion of Part 5 calls for actor No. 2, the woman, to growl continuously. In any case, when Wilson was twenty-five and living briefly at home, he entered a mental hospital, which released him six months later. He'd been wearing a long robe, had let his hair go long, and whenever his parents spoke to him, he had barked back at them like a dog. There had never been any significant contact between himself and the other family members. His mother, he says, never even touched him until he was leaving for college, when she kissed him on the cheek.

Anyway, Wilson was in Cologne in 1981 while his father was dying. He was about to do a performance to a sold-out theater at the opening of the World Theater Festival. "The mayor was there, the international press and I don't know who all . . . and everyone was after me: they were supposed to start at seven o'clock, the Germans are very punctual, I told them the show wouldn't be ready until nine, there was no way I could finish the technical work. I had five calls that day from Waco, Texas—emergencies, my father was dying of cancer—so finally at about five to nine I called him at the hospital. I said, 'Hi Dad, how're you doin'?' He answered, 'Oh I'm doin' pretty good; how're you doin?' and I said, 'Well, you know, Dad, I wanna talk to you, but I've gotta do this performance now, I'm in Cologne, Germany,' I said, 'Listen to this.' I turned the loudspeaker up where you could hear the audience, I was in my dressing room [here Wilson made sounds like a pack of growling dogs, imitating the audience; then he laughed]. 'I have to go out and perform for that German audience,' I said, 'I'm two hours late.' And he said, 'You're two hours late? *What the hell are you talkin' to me for.* . . . ' And he died right then."

When Wilson walked out on stage after the phone call, the

audience was furious. He just stood there. He'd told the stage manager not to start until he moved. He said to me, "You know somethin', Jill? You have to *hate* the audience; if you don't *hate* 'em, you'll never win; you have to hate 'em, you say fuck you. . . . And I walked out, I just stood there, they can wait an hour. I waited till it was very quiet, then I started." The piece was called *Man in the Raincoat*, and Wilson had slides of his father in it.

Possibly the most traumatic event in Frederick the Great's life was the execution of his friend and lover, Katte, by his father.

This event is handled by Wilson and Müller in *the CIVIL warS*, Act IV, Scene A, by means of a curious superimposition of genders and character. The part is called "Frederick and Katte." Frederick, already played by a female, now plays Phèdre; and Katte, also played by a woman, doubles as Hippolytus, both from Racine's tragedy, *Phèdre*. So the models for the story, two young men, played by women in disguise, are further removed or masked by having one play a woman, Phèdre, and the other play a man, Hippolytus. Müller's betrayal theme (Katte/Hippolytus is sacrificed by Frederick/Phèdre to the wrath of the father, Theseus) dovetails with Wilson's more hidden deception-and-mortification motifs, solved mythically, impersonally, grandiosely by the hero's accession, accompanied by intimations of the hero's mortality. *A Tree is Best Measured When it is Down* is the subtitle, or epigraph, to *the CIVIL warS*. When Wilson was in second grade he was asked what he wanted to be when he grew up and he said the king of Spain. Wilson's father/betrayal theme (i.e., not following in his footsteps) is reflected in his successful rebellion and rise to preeminence in the theater.

Before his father died, Wilson made sure to corral him somehow and bring him into the arena he had conquered. This, he told me, was not easy. He invited his father to see *Deafman Glance* in Paris in 1971. His father declined. Several years later, Wilson called from Paris again; he was doing *A Letter to Queen Victoria*. It was 1974. Wilson's mother had died two years earlier. His father did go; Wilson had him picked up at the airport and driven to the hotel, and then had a car take him to the theater. The next morning his father returned to Texas without saying a word about the performance. But three weeks later Wilson received a letter from his father that said, "Son, your play, a *Letter to Queen Victoria*, had great poetry." Wilson laughed uproariously as he told me this.

But in Wilson's estimation the nicest thing his father ever said to him was after the performance of *Einstein* at the Metropolitan Opera in 1977. First his father remarked that Wilson must have made a lot of money—"you must be a wealthy *ma-an*." And Wilson said, "No, I'm not. I produced this, and it cost a million dollars." His father replied, "Ah, that's a lot of money"; and Wilson said, "Yes, it is, and I only raised nine hundred thousand, so I'm a hundred and twenty five thousand dollars in debt." There was a long silence. At last his father delivered his encomium: "Son, I didn't know you were smart enough to be able to lose a hundred and twenty five thousand dollars."

Wilson describes himself as the weaker, backward son to his father. He says Stalin, the Shah of Iran, Frederick the Great—they were all weaker sons, and that Stalin became stronger after the death of his first wife. The Stalin play, *The Life and Times of . . .* , was centered on this single incident, portrayed as causing a fundamental change in the dictator's career. Wilson presented this play the year of his mother's death (1973).

The last words in Act IV, Scene A, of *the CIVIL warS* are from Goethe's Erl-King: "The father shudders, riding wild,/ In his arms he holds the gasping child, / Swearing, racing home to bed; / In his arms the child lay dead."

Nothing seems so meaningful to Wilson as the death of a child, or two children. Years ago he saw a movie made by an experimental psychiatrist, Daniel Stern, showing mothers lunging at their crying infants, who would recoil in what looked like terror. The film had been slowed down to illustrate what "actually" happened. This impressed Wilson tremendously. One time after recounting the film to me he said, "In some societies the firstborn is killed." At some point he described his father to me as "terrified" of his mother. Giving directions to the woman who played the role of Medea he said, "You don't know that you murdered the children." The mothers in Daniel Stern's film, he says, were surprised and horrified to see their aggressive reactions to their infants' crying. His voice was very low, almost a whisper, when he confirmed that his own mother never expressed any emotion: "Never, never, never . . ."

It would be hard not to see Wilson's "disabled" hero as this dead child: his mother (Stalin's wife?), his father ("terrified" of his mother), himself the firstborn (and only son), his sister (a shadow

figure in my interviews). Wilson, the grown man, "town father" of an international theater, "holds the boy in arm . . . clasps him tightly, keeps him warm."

If his stories mean anything, his texts and pictures must, I surmise, contain an unexpressed wish—that the culprits, as well as the victims, in his family scenario, might experience/express their feelings, and come to terms with themselves. The glorification and embalmment of the hero (father and son), along with the preservation of the "mother," precludes this process. Wilson has cast this "mother" (and her "daughter") in many caricatured forms, incidentally, as well as in her more straightforward guise. In *The Golden Windows* Wilson's characters are, presumably, ordinary people, a "family" of four, but they are as dead as his grand and mythic figures. They have all *arrived* someplace, and assumed certain postures in a picture. Their origins, and the process by which they got there, are mysterious. What's more, the places at which they've arrived may, to some audiences, not seem appropriate or desirable. What contemporary audience, for instance, remains willing to accept the stereotype Wilson projects of the female murderer—a figure we can easily recognize as the all-culpable mother? Or the female victim (e.g., the Patty Hearst facsimile in Wilson's *Einstein*) who deserves what she gets, having turned, after all, into a gun toter? (One thing she "gets" is to look absurd and ineffectual with her gun.)

But the stereotype of the male superhero—the weakling male child who conquers all and wins his rightful throne, place, or whatever—is equally at issue in contemporary (sexual) politics. Both figures, the weakling male and the castrating mother—a classic twin archetype—are subsumed in Wilson's work. And yet, with Müller as collaborator, Wilson appears to be humanizing at least the male half of this pair.

Müller's text for Frederick the Great provides a kind of "interpretation" of Frederick's past and present situation. Critical interpretation may further help to provide an understanding of the author/hero's dilemma: namely, *the inhibition against connecting his past with his work.* "In some cultural contexts interpretation is a liberating act. A means of revising, of trans-valuing, of escaping the dead past."[6] The cultural context itself requires interpretation. What is it in the culture that militates against forging direct links between history and the work of individuals?

In Wilson's oeuvre the sex-role stereotypes are so fully embodied, so completely assumed, that they are no longer recognizable as human; their suffering individuality becomes opaque. What is it in the culture that forbids examination of parental sex typing? And what is it in the culture of the art world that particularly operates against this line of questioning?

With his discovery of Müller, and current involvement in the classics (directing *Alcestis* in Boston, March 1986, *King Lear* in Hamburg, September 1987), it seems possible that Wilson's heretofore muted "family romance" could erupt in the contextualized drama he has till now held in contempt, or at the least be supported by an emotional texture that could de-mythicize his figures—and bring them alive.

1986

Notes

[1] The Cambridge production drew from the Cologne section of *the CIVIL warS*—specifically, Act III, Scene E; Act IV, Scene A; and the Epilogue to Act IV—and it ran from February 27 to March 23, 1985. Plans for a full production of the work have twice fallen through for lack of funds: it was originally scheduled for the 1984 Olympic Festival in Los Angeles, then rescheduled for Austin, Texas, in October 1986. As of this writing, there are no current plans to produce the piece in its entirety, although Act V, the Rome section, was performed at the Brooklyn Academy of Music on December 12–30, 1986. In addition, during the fall and winter of 1986 the thirteen "knee-plays" (which together constitute some two hours of performance time) toured American cities, including New York.
[2] The phrase is Susan Sontag's, and it is the title of the essay that makes that argument (Susan Sontag, *Against Interpretation* [N.Y.: Dell, 1969], 13–23).
[3] Ibid., 19.
[4] Ibid., 17 et passim.
[5] Calvin Tomkins, *New Yorker*, 13 January 1975, 38–62.
[6] Sontag, *Against Interpretation*, 17.

Jigs, Japes, and Joyce

The New York premiere in October 1986 at the Brooklyn Academy of Music of the hour-long work by John Cage and Merce Cunningham, called *Roaratorio: An Irish Circus on Finnegans Wake*, marked a very special moment for John Cage in his long career. Born in 1912, an avant-garde composer by the mid-1930s, he grew up in a generation of artists who loved the writings of Pound, Stein, Eliot, Cummings, and James Joyce. Now he says that he's still devoted to Pound, Stein, and Joyce. *Finnegans Wake* in particular was an epochal event for an artist like Cage. He thought of it as the most important book of the century. And like so many other enthusiasts, he never read it. His professional involvement with the book began in 1976 when he was asked to write something about it. Typically, Cage set out to colonize the work, turning it into an artifact very much his own. (He had already done this with another great favorite of his: Thoreau's *Walden*.)

Using a method called mesostics—a form of acrostics—which means literally "a row down the middle," he went through the 626 pages of *Finnegans Wake*, reducing it at first to 120 pages, and later in a final version to 41 pages, by organizing the text around the two

words: JAMES JOYCE. Beginning on Joyce's first page he selected the first word with a J in it that didn't have an A, because the A would belong to the next line for JAMES, and so on through the entire book, making a path or vertical line down the center of his own text consisting of the ten letters of Joyce's name, and utilizing his time-honored chance operations to determine how many of Joyce's words surrounding the mesostic word proper would be included on each line. Not very many. So that Cage's text looks visually like a minimalist concrete poem, or like a poem by Cummings or Apollinaire, especially as Cage lower-cased everything but Joyce's name, and eliminated all punctuation.

In 1979 Cage read the text he had made on German radio. At BAM, he gave the same reading, but many other elements had been added, including choreography for fifteen dancers by Merce Cunningham (premiered in France at the Festival of Lille in 1983). And since Cage complicated his aural score by adding five musicians (flute, fiddle, two bodhrans, and uileann pipes), and sixty-one tapes containing hundreds of sounds collected from all over the world, perhaps five percent of what he read could actually be heard, or made out. Yet his guttural singsong, a most unusual "emotional" delivery for Cage, who has always read his texts as if they were news reports or amusing party vignettes, had a binding effect, like a basso ostinato, on the whole score. The sense was mostly obscured, but the voice kept rolling and burrowing along. Overall, the three components of the score—musicians, tapes, and recitation—created an overpowering density, a multiplicity and simultaneity of effects, each element independent of the other, and a going nowhereness, for which Cage is famous. Cage and the five musicians occupied the three tiers of boxes on either side of the stage.

In an unprecedented format for his choreography, Cunningham matched the ethnicity of Cage's various plays on Joyce (the musicians and their music were all Irish, and the sounds of the sixteen tapes were either collected in Ireland or from a large selection of the 2,462 places around the world mentioned by Joyce in *Finnegans Wake*) with an unmistakable jig or reel motif—hopping, coupling, smiling, etc.—which opens the dance, and recurs so frequently in variations throughout, that it binds the dance action much the way Cage's recitation glues all the sound. Minimal decor (by Mark Lancaster) soberly and elegantly counterpoints any sense of ethnic

celebration carried by the leading jiglike movement theme. The background is neutral, and a bunch of stools are used by the dancers to sit and rest on, move about, and drape discarded pieces of costume on (sweaters, shirts, pants, leg warmers) as they exchange them for others—all in bright, variegated colors.

Cage and Cunningham have turned Joyce into a happy man. *Finnegans Wake* was of course ready-made for Cage, who would find in Joyce's masterpiece of wall-to-wall puns and neologisms a reflection of his own love of the incomprehensible. However, Joyce really was writing a story, many stories within a story, and stories are things that both Cage and Cunningham have been dead set against, that is, as vehicles for either movement or feelings in their work, or as narrative forms suggesting logical continuity or dramatic coherence. Cage believes Joyce didn't mean *Finnegans Wake* to be understood, but that seems doubtful. More likely Joyce wanted to make it difficult to be understood. Cage himself perhaps doesn't wish to be understood at all. He has said many times in different ways that he enjoys things as long as they remain mysterious to him, and that when he understands a thing, he's through with it. He quotes a line of Joyce's in *F.W.*: "Confusium hold 'em." And indeed, scholars and students may be kept busy for a long time parsing and interpreting Joyce's reinvention of the language. Cage is hardly one of them. His own interest, as he has boldly put it, has been to open up "the possibility of doing many things *with* the book . . . rather than trying to find out what the book is *about*." In other words, it's been a wonderful object for him to colonize and exploit, not to understand.

Cage's use of Joyce draws attention to a couple of great curiosities hidden in Cage's oeuvre, theory, and lifestyle: the contradictions between his abrogation of choice (use of chance procedures) and his prejudiced, finally choice-ridden pursuit of certain singleminded ways of doing and perceiving things; and between his avowed inclusiveness (Here Comes Everyone, or let all the sounds in, everything is equally important, etc.) and his very hierarchical and obsessively structured designs (James Joyce in mesostics is not exactly Everyman).

With his "homage" to Joyce in *Roaratorio* (the title word, by the way, appears in *F.W.* on page 41), Cage is not very sly in his identification with the great writer (though how conscious he is of it would be hard to say). Anyway, John and James, like the brothers

Shaun and Shem in *F.W.*, sound pretty close. And John and James both have last names that consist of one syllable. But the work fulfills another collaborative ambition. Cage was eager from the start to have Cunningham, his partner of over forty years, do the choreography that might be performed together with the score. Cunningham is half-Irish, and one of the characters in *F.W.*, Cage has pointed out, is "poor Merkyn Corningwham."

Nearly one-sixth of *Finnegans Wake* is ostensibly a great feast held in the tavern of HCE, the father of the book. Here one has to imagine Cunningham's hour-long dance taking place, though Cunningham may not be any more conversant with the book than Cage. Anyway, dancing, singing, and merrymaking would take place at a great feast in a tavern, and Cunningham's dance is dense with partnering between the men and women. They dance together, frequently with hands held, arms crossed over, in the jig and reel motifs, and they do a waltz together, as well as promenades and strolls, and the usual lifts or occasional contact familiar from his choreography in general. The dance is essentially a kind of "social." As might be expected in an ethnic performance (which this, strictly speaking, is not at all), the men do lots of the energetic, fast, airborne movement while the women generally are slower and more lyrical. But this difference is typical of Cunningham's recent choreography overall, and here it is perhaps just more noticeable. In this, as in other respects, Cunningham conforms in his own way to the ballet conventions. Cunningham's men never take the stage in the obvious virtuosic displays of the male ballet soloist, but there is the same assumed strength and aggression and expansion of gesture, and for the most part he chooses his men for their size, to contrast with his more diminutive women. Cunningham himself was once a virtuosic performer, though the solos for which he is famed were distinguished more by character than by technique.

In the 1980s Cunningham presented a profile of extremes. His iconoclastic approach to choreography (launched in the 1950s in collusion with Cage)—the dance and music coexisting in a common time frame, but otherwise independent of each other; the application of chance procedures to the movement itself; the defocusing of the space in an allover look, no element supposedly more important than another—is still state-of-the-art work. And where Cunningham sees examples of work by younger choreographers in which dance movement is measured in meter, to the music,

or in which movement appears to represent anything other than itself, he will characterize it as nineteenth-century work. In the 1950s, and even in the 1960s, Cunningham's own nineteenth-centuryness could hardly have been apparent, if at all, because the deep, or a priori, structure of the work, the gender-given aspect, still went unquestioned and was therefore invisible.

Conscious gender play has in the meantime entered into the choreographic considerations of a number of younger artists (among them David Gordon, Mark Morris, Steve Paxton, and Lucinda Childs). But Cunningham himself clearly continues not to question this "deep structure." Most apparent, and most boring, in the range of male/female breaching in his work is the predictable lift. *Roaratorio*, with its extensive social partnering, has more than the full complement of lifts to be expected in a Cunningham dance. Again, he inherits this convention from the ballet, yet generally the way his men lift or carry or place or drag his women is much more like a vestigial echo of the ballet than anything resembling the no-nonsense support of the ballerina for the purpose of exposing her line and "sex" and sweeping her through pedestals in the air. Although Cunningham's manipulations of women are compara-tively matter-of-fact, frequently like an afterthought, en passant really, they still appear to affirm, if only perfunctorily, the assumed dependency, weakness, helplessness, and so forth, of women. Cer-tainly his women remain armless this way, except in the conven-tional decorative sense. But Cunningham would no doubt say that lifting is, simply, along with leaps, jumps, turns, and so on, part of the raw material of his medium, something that bodies can do on stage, and to which he can apply his chance operations, obtaining the most interesting variations in rhythm and sequence.

Roaratorio, like all of Cunningham's dance, brims with the most wonderful changes in speed, direction, rhythm, dynamics, group-ings, as the whole piece moves stage left to right, in a linear action (not, incidentally, like the circular structure of *Finnegans Wake*) finally exiting to the right as the dancers carry off the seven or so stools that accompany them as they traverse the space. But the one variation you won't find is in the lifting of women. Men always lift women, or "girls," as Cunningham calls them throughout *The Dancer and the Dance*, the excellent book of interviews with him by Jacqueline Lesschaeve. And these days, no doubt because Cun-ningham, in his late sixties, has lost even a hint of virtuosity in his

own dancing (he essentially walks and gestures), the vigor and expansiveness in his work are all projected through the males in his company.

At one time, say as late as 1972, when Carolyn Brown quit the company, Cunningham's men and women were at least technically somewhat closer together. He had more mature women dancing with him then, not only technically accomplished (Brown was of *prima* quality) but with interesting character as well, and he and the men also of course were nearer in age. Now there are great gaps in his demographics. He is sixty-seven, one of his men is forty, the rest are in their early thirties and twenties. His men are fun to watch, his women are good, certainly attractive, but only Cunningham, immobile and arthritic as he is, carries the weight of character, of presence, of the necessary eccentric factor that makes any company great. The general impression is of a marvelous gaunt grandfather tree, craggy and leafless, weathered and patinated, amazing in its knotty configurations, its sheer endurance, sticking way up over a band of brightly colored acorns dancing at the foot of its trunk.

There was a certain perfect reverberation between Cunningham, on stage, and Cage, in his box, in *Roaratorio*. Cage delivered his Joyce text like some hoary old poet; Cunningham appeared on stage like some ancient satyr. And the panoply of noise along with the explosion of movement that surrounded them invoked that great line of Dylan Thomas: "Do not go gentle . . ."

Cage and Cunningham, John and James. Behind Cage's concept, unheard in his reading, itself difficult to make out in performance, is a monumental inscription. Cage has destroyed Joyce's narrative (he would like to think there isn't one), replacing it with his particular "roar"—and erection to a Name, his paean to Shem (Joyce), the brother in *F.W.* who stands for the misunderstood, rejected (and hopefully exalted, at last) artist. The other brother, Shaun, stands for the establishment, which now enthusiastically applauds the avant-garde composer in his old age.

1987

The Punk Princess and the Postmodern Prince

S ome artistic collaborations are Events, others are esthetic accom-
plishments. Happily, occasionally they are both. The premiere
of *The Mollino Room* on May 15, 1986, by American Ballet
Theatre, with choreography by Karole Armitage and sets and cos-
tumes by David Salle, was definitely an Event. It brought together a
heralded young choreographer/dancer, who has been called a
"reigning queen of contemporary chic" and "the punk princess of
the downtown scene," with Salle, a painter hailed as a new "young
master"—an established rising star of the art world. It brought
them together under the aegis of the American Ballet Theatre, at the
invitation of artistic director Mikhail Baryshnikov, for whom
Armitage created the lead role, and under the awesome establish-
ment roof of the Metropolitan Opera House. It attracted a capacity
audience of art world luminaries and suburban bankers or whoever
they were in their tuxedos and jewels, with wild satisfied looks of
feeling they were at just the right place that opening evening in
Manhattan.

Esthetically, *The Mollino Room* was a kind of coup for David Salle. The proscenium space was converted for twenty minutes into a gallery, if you will, for showing five of Salle's images, displayed at gargantuan size on backdrops. The action on stage, whether seen close or far away, was that of colorful ants put through certain well-known human paces. It was really hard to see the dancers—except for Baryshnikov, who would be a gorgeous and magnetic ant viewed even against the Taj Mahal or any of the world's Seven Wonders.

Salle's first painted backdrop consisted of glossy male footwear in black, three pieces ranging from shoe to low boot to higher boot, lined up in profile on a ground of broad vertical green and white stripes. Less competitive with the stage action was the next drop, a luminous cinnamon-red monochrome field. His second realistic image was a giant tea set in black and white, tilted in perspective. His second abstraction, dropped toward downstage, was a large red rectangle and a smaller black one to its right, set on a white ground. Finally there was a giant black fishing reel on a light copper ground.

The score for the ballet included two pieces by Hindemith—the first movement of *The Mollino Room* is set to the first movement of Kammermusik no. 5 Concerto for Viola and Orchestra, and the third movement of the Quartet no. 3, Opus 22. The ballet's second movement is accompanied by recorded speech: a dialogue by Mike Nichols and Elaine May called *My Son the Nurse*, dating from the early 1960s.

Karole Armitage is known for her intense combines of classical ballet with modern and erotic distortions, wild street rock accompaniments, and punk hair and clothes style. She danced for a year, back in 1971, in a Balanchine-dominated ballet company, the Grand Ballet of Geneva, and from 1976 to 1981 was a conspicuous feature of Merce Cunningham's company. Her long legs and generally attenuated physique, the force and thrust of her delivery, and her sexual theatricality have drawn plenty of attention here and abroad, particularly in France. Her first large-scale piece, *Drastic Classicism*, dates from 1981. The Paris Opera commissioned *Slaughter* in 1982. *Paradise*, a ballet in three acts, dates from 1983. In 1984 Nureyev commissioned *GV = 10*, for the Paris Opera Stockhausen Festival.

Baryshnikov saw her dance in 1985 at New York's Dance Theater Workshop when she premiered her *Watteau Duets*. In 1984 Armitage met David Salle, whose appropriation of images and styles from both the recent and historical past in art is often spotlighted by his women: recumbent nudes; photos of soft-core pornographic models; girls engaged in domestic tasks; and so forth. One critic has written that the "men in his work are basically heads or mind . . . women are usually bodies." *The Mollino Room* is not Salle's first stage design: he did sets and costumes for the Richard Foreman/Kathy Acker *Birth of a Poet* at the Brooklyn Academy of Music in 1985.

Armitage and Salle together bring a certain traditional, and reactionary, trend in the culture of the 1980s into focus. With their considerable skills they service a prefeminist worldview, projecting sharply demarcated sex differences rooted in the male gaze and the female as object. This is a worldview preeminently represented by the classical ballet. The support of the ballerina by a male partner for the purpose of displaying her beauty is the sine qua non of this traditional art form. Armitage works with strict classical elements modified by an aggressive, erotic approach. In her *Duets*, at least, she embodies an imperious ballerina dependent on her partner for the effects she creates, including extreme extensions sometimes performed in stiletto heels. The very personalized partnering in her *Watteau Duets*—with overtones of the challenging temptress who will be a kitten when you tame her—was nowhere in evidence in *The Mollino Room*.

Armitage herself did not dance in *The Mollino Room*, and her choreography for the "corps" of ten dancers—five women and five men—was decorous and conservative. It showed both Balanchine and Cunningham influences—the movement and patterns of the former, the spatial deployment of the latter, and the partnering of both: the woman as already tamed. This theme, cultural and deeply assumed as it is, was echoed in Salle's little-girlish costumes for the women, and especially in a revealing gender display during the third movement—the men wearing white tops with red dotted *i*'s printed on them, the women's tops bearing applied exterior breast forms, each breast in different color and/or design.

Overall, the sheer size of Salle's set paintings, looming titanically over choreography that was fairly bland, despite the luster of Baryshnikov and the vigor of the ten ballet dancers, signified an

unequal collaboration. Merce Cunningham has employed vast back-drops for his work, and even some stunning set pieces (Warhol's silver helium pillows floating in the space of his *Rainforest* of 1968 come to mind), but they have never upstaged and have usually enhanced his choreography. Conceivably, Armitage's choreography for *The Mollino Room* would look more interesting on its own. As it was, whatever was choreographically distinctive seemed reserved for her glamorous male soloist, Baryshnikov.

Armitage said she saw the dances as "a sort of fantasy about Misha's solitude, the awe-inspiring talent he has, the responsibility he has to shoulder, and the suspiciousness aroused by that amount of talent and power." To illustrate this idea, Armitage had Baryshnikov perform in relief against the group, never partnering and almost never dancing in unison with the others, his costume itself—sky blue tights and a darker blue T-shirt with a gold oval decal on his chest—unlike the others, standing out in its simplicity and never changing. The nucleus of his movement was conventionally balletic, and what was not would have been simply coy and quirky—at best intriguingly angular and off center, with nice sharp directional shifts—on the body of another.

Baryshnikov's elegance transcends all commonplaces. During one bit of business, however, he could have been anybody: As Salle's third drop, the giant tea set, consumed the proscenium, Baryshnikov was required to walk on stage, stand dead center against the drop facing the audience, mime drinking a cup of tea, and walk back off stage. The general audience was much amused. In such an Event, where a number of incongruous elements are brought together, the sudden startling realism uniting action and picture can evidently induce great relief.

Audience reaction to the dated Elaine May/Mike Nichols dialogue was curiously mixed. The subject of the dialogue, a kind of prolonged joke, was clear: a Jewish mother and her son discuss his future in rapaciously ironic tones; they are cloyingly collusive. The punch line, accompanied by gales of rasping laughter, repeated several times after several repetitions of the conversation (an adagio between the couples transpiring under the tea set), is that the son wants to be a registered nurse. The audience responded with a blend of obligatory and real laughter, embarrassed silence, and an underwhiff of hooted disapproval. Possibly the joke was brought in to illustrate some idea of questionable taste associated with the

dance's title. Carlo Mollino, a Turin-based architect and designer, was a seminal influence in a trend to estheticize vernacular forms. Yet plays on old sexist jokes, if that's what this was, go way beyond plays on levels of taste, occupying the civil realm of the reactionary.

Salle may fit some broad definitions of postmodernism in art, but Armitage is definitely outside the mainstream of postmodern dance as identified in a line from the great Judson period of the 1960s. Armitage's exhibitionism and female posturing are at least two outstanding elements that were purged from the Judson esthetic, which produced a purist choreography, cool and minimal, expressive and repetitious, at core gender neutral and egalitarian. A contemporary of Armitage's, Molissa Fenley, is an exemplar of postmodernism, her punk looks and technical drive subsumed by her more abstract choreographic intent. In the partnering department, even ex-Judson choreographer David Gordon has his women shift off lifting his men. Two other Judson veterans, Lucinda Childs and Trisha Brown, while their men and women, especially Childs's, tend to have indistinguishable roles and sizes, are having some problems adapting their work to commercial scale. Like the Armitage/Salle collaboration for *The Mollino Room*, Brown has been overwhelmed on two occasions by Robert Rauschenberg's set designs. And Childs has succumbed to a certain exhibitionism—a queen bee flavor recalling the heraldic Martha Graham.

But modern dance—a specifically female-dominated American idiom—has a matriarchist tendency. Armitage perhaps thinks of herself as a ballet choreographer, and her partnering and posing and deference to the male certainly place her in that transplanted European tradition.

1986

Intimate Moves

A nne Teresa De Keersmaeker, the Belgian choreographer, made
her second appearance in America at the Brooklyn Academy
of Music's Next Wave Festival in November 1987. In 1986, in a
company of four women including herself, which she calls Rosas,
she presented *Rosas danst Rosas*, a work she created in 1983 when
she was twenty-three, and only the third dance in her repertory.
Elena's Aria, the work seen here this season, was the fourth, and it
was choreographed in 1984. Three more have been seen in Europe.
Elena's Aria adds a fifth woman to the performing group, and like
Rosas danst Rosas, deploys a number of chairs as functional props,
and proceeds without intermission for nearly two hours, causing
impatience and abandonment on the part of some audience mem-
bers. Reportedly, pandemonium broke out at the Paris Opera this
year when a number of people didn't just walk but stormed out.
The work is certainly very demanding. De Keersmaeker takes her
time developing her themes, beginning in cocoons of dim light with
distant (upstage) and minute action; then gradually, quite gradu-
ally, accumulating momentum and enlarging the scale, letting all
her action mature.

Elena's Aria differs from *Rosas danst Rosas* in its use of mixed media: texts read aloud, a film, an electric fan, taped selections of various eighteenth- and nineteenth-century composers—all serving to point up a theme of malaise over love betrayed. With these extra elements, the dance seems to sprawl much more than *Rosas*, which was propelled all of a piece by the Reich-like repetitive score of two Belgian composers. But both works are driven by De Keersmaeker's precociously evolved movement vocabulary and phrasing, and a structure permitting great variation within a cumulative, repetitive framework. Her vocabulary is intensely intimate—a lexicon of expressive and recognizable gestures. Her structure is minimalist and reductive, with incremental or flowering developments. She hangs the intimate gesture (and dancerly elements, I should add) on a serial and repetitive armature. The result is a most unusual tension between form and substance. The impact of her gestures is strong; they are so discretely and precisely rendered. At the same time, we're distanced from them by our awareness of how the structure, particularly the unison and repetition, carries them along. There is no story line, so we're not compelled to identify with the gestures in any contextual way. They command our attention and our kinesthetic involvement because they're performed extraordinarily and caught in extraordinary configurations or captured in relief in striking frozen moments. Their "meanings" keep shifting according to their emphasis in any particular phrase.

De Keersmaeker is clearly a postmodernist, a choreographer with links to the American Judson/Cunningham gene pool. She studied for a semester in 1981 at New York University under Valda Setterfield; her second work, created in 1982, was *Fase, Four Movements on the Music of Steve Reich*; and she has expressed admiration for the work of Trisha Brown. Beyond this, her phrasing is distinctly reminiscent of an older American who is a founding mother of the modernist dance tradition, Doris Humphrey (1895–1958), whose work is most probably unfamiliar to De Keersmaeker. Humphrey's style was rooted in a breath-phrase that pulled the body off center into a suspension and fall, followed by a recovery to the stable upright or horizontal. To this she applied a number of classic principles—both theatrical and musical—of variation in design, rhythm, and dynamics.

De Keersmaeker shapes her phrases in a surprisingly similar way, especially the dancerly ones, though any sequence of expressive

gestures is marked by shifts in accent, size, and design that Humphrey would also have understood, however puzzled, possibly scandalized, she might have been by their lack of (dramatic) context and their aggressively repetitive treatment. In *Elena's Aria*, three of the five women, who all wear the same sleeveless sheath dresses and high heels, begin the dance upstage in an extended trio advancing along the horizontal row of ten evenly spaced chairs (the other forty chairs in this work are at first scattered about in the dim light stage right, used by the "inactive" dancers to sit and rest on), occupying every other chair as they move. They cross their legs slowly and sit still, they let their arms flop down at their sides, they slump suddenly and let their legs spread awkwardly; they pull themselves together and slowly stand up, then move behind their chairs, execute a slinky falling stepping pattern around the chairs, and end up sitting starkly in profile, very upright. In a key "chair theme," the women turn or spin low and fast (hunched over) as they move from one chair to another, two in unison, the third in some counterpoint, apparently being "chased" off her seat by the other two. This short episode suggests musical chairs, and is possibly the only humorous passage in the dance. A typical phrase reveals dynamic changes in speed and energy, direction and position. Movements run a gamut of extremes from decorous to awkward, limp to fully extended, uninflected to sharply accented, still to swirling, and encompass all sorts of symmetries and off-balance suspensions.

In *Elena's Aria*, the action on the chairs is ultimately brought together with the action on the floor. After the "chair trio," one woman initiates the "floor theme" in front of the row of chairs, moving along a large, chalk-drawn circle. She crosses one leg over the other, folded tightly, leans forward and slowly hikes her dress up over her thighs, turns, stutters backward along the white circle line, pitches forward, turns and walks along the line. She is then joined by a second woman, and then a third, who perform in unison. At some midway point in the dance, a number of the scattered chairs at stage right are moved toward the center, one at a time, obliterating the chalk circle, as it were, and signaling a point where the various chair and floor themes (including the dancers lying down on their sides, with rolls, sits, scissors kicks, crawls, stands, and falls) are merged, and the action swells and moves downstage.

De Keersmaeker punctuates many of her phrases with memorable poses. One of them—from an initial "chair theme"—is an extreme example of the class of gestures used by De Keersmaeker that one could say is stereotypically female. The women finish in a pose holding onto the seats of their chairs while bending over, legs arrow straight, on their toes, feet turned in, backs to the audience. In their sheath dresses and high heels, the "exposure" or "presentation" looks pointed. A David Salle female might spring immediately to mind.

A host of gestures signifying world-weariness, concession, failure, or inconsequentiality belong to De Keersmaeker's repertory. Her slumps, in particular, are outstanding. They occur violently, and the dancers look wonderfully eccentric as they fuse into resistant slabs, torso and thighs in one piece, legs akimbo, an elbow angled up, chin piercing the sternum. And in the coda to *Elena's Aria*, which is accompanied by a Mozart selection, the five women, seated downstage in a row in front of the lowered curtain, perform in unison a small lexicon of De Keersmaeker's "feminine" gestures: crossing the legs (ladylike), crossing the arms over the chest (not so ladylike), dropping the arms suddenly so they flop at the sides, tapping a knee with fingers, shaking the head slowly, swinging feet off the floor (like little girls), making a fist, pointing a finger, biting a wrist, turning away and "hiding," then looking over the shoulder at the audience, pulling the skin on an arm, wiping the mouth with the back of a hand, holding the dropped head in a hand and fooling with strands of hair, running both hands through the hair over the top of the head and, of course, one of the illustrious slumps.

It's the inwardness of all these gestures that suggests the private and female. *Elena's Aria* is pervaded by the dramatic mood of loss and defeat traditionally characteristic of women in their romances with men. If *Rosas danst Rosas* conveyed much of the same feeling, De Keersmaeker evidently decided it wasn't enough, and that for her next piece, *Elena's Aria*, she would add a number of dramatic effects to make her statement stronger and perhaps clearer. This included dressing up. The outfits worn by the four women in *Rosas* were schoolgirlish by comparison—loose polo shirts, skirts, socks over tights, sensible shoes. For *Elena*, it looked like these "schoolgirls" had raided their mothers' closets to play dress up. In fact, they were "dressing up"—to play the part of Elena, the heroine of Verdi's opera *I vespri siciliani*. *Elena's Aria* is what she sings before

dying, in a story of love and betrayal, foreign occupation and political uprising, involving the French and Sicilians.

For her two-hour work, De Keersmaeker collaged a number of elements suggestive of death, loss, and destruction. A powerful fan is turned on three times and directed at the women on stage, making their hair fly somewhat and making them look as if they were being blown about. A small movie screen is lowered twice, stage left, to show excerpts from a publicity film for a demolition company—endless silent sequences of buildings falling, bridges blowing up, a sign reading "Wreckers." Three dancers, one at a time, at different points in the dance, walk to a chair in the downstage left corner, turn on a light over it, and read passages from Tolstoy, Dostoyevsky, and Brecht. The Dostoyevsky selection is from *The Idiot*—a letter to a prince about waiting for him on a green bench in the park in order to talk to him about an "exceedingly important matter." The Tolstoy selection, from *War and Peace*, is another letter, which begins, "Dear and precious friend— what a dreadful frightful thing is separation," and goes on about "our hearts . . . united by invisible bonds . . . in spite of the distance . . ." and "a certain secret sadness . . . felt deep in my heart ever since we parted," and so on. A taped speech by Fidel Castro is about international politics and was more or less inaudibly presented (when I spoke to her, De Keersmaeker would not reveal its identity or content).

Caruso was heard singing three songs—very distantly at first, later at raised volume—"Vieni sul mar," "Santa Lucia," and "O sole mio," all conveying a sense of sorrow and something missed. And in the Brecht-Weill song "Surabaya Johnny," a woman keeps telling a terrible, abusive man how much she loves him and what pain he causes her. The atmosphere on stage—gloomy, dimly lit, sallow—together with the dancers—not when dancing, but when sitting slumped in one of the chairs scattered around stage right, backs to the audience—evoke a deserted, run-down dance hall, a musty abandoned old European space. In this setting one long passage in which the five dance in unison, using the floor a lot with rolls and sitting poses, strongly suggests a lamentation.

Yet the audience is not coaxed into identifying with this five-headed Elena and her problems. The dancers are not individualized; De Keersmaeker herself doesn't stand out or perform as a star. Throughout the dance, the delivery is deadpan. The dancers are

simply executing intricate phrases with great precision, rendering the dance a sort of study in isolation and tedious femininity. No "pity" or "terror" is being evoked or cathected because the work's structure stands out too clearly, transcending role and character—in the Brechtian sense drawing attention to itself constantly. The dancers show us that they're dancing, sculpting out space, rather than conveying specific emotions or bodily states or a tale of loss. The way De Keersmaeker frames her movements, isolates gestures, brings phrases to full stops, often in exhausted poses, makes you think the dancer has stepped out of "character" for a moment, sitting around waiting for the next passage, then slowly recovering to "rejoin" the dance; yet all the stops, rests, and slumps (including walking from one "performing" spot to another, sometimes moving a chair) are of course part of the dance. De Keersmaeker has built the dancer's weariness or time off into the structure of her phrasing, stylizing it in great-looking slumps and other still moments, specific and sculpted.

With the distance De Keersmaeker gets from her emotional images, which we associate with female behavior, it's easy to imagine that a feminist commentary of some sort is lurking in the work. But this apparently is not the case. She's bored with feminist questions about her work; she says she's definitely not a feminist, but that she cannot deny being a woman, therefore (she implies) her gestures will naturally be feminine ones. She says her next dance will feature seven men and seven women and that the men will naturally do "masculine" movements. But in the style De Keersmaeker has so trenchantly evolved in her brief career, her choreography for men will doubtless strike many people similarly—as both demonstration of and commentary on masculine-type movements. This would be an accident of style, then, rather than any indication of purpose.

There is no sexual exhibitionism in De Keersmaeker's work. None of the gestures for women, even at their most suggestive—as when the women in *Elena's Aria* hike up their dresses to reveal more leg (freeing them actually to move more)—show women as desirable objects per se. The most one can say is that certain attitudes associated mainly with women (e.g., the grief of Elena over love betrayed) are uncritically displayed, but presented in such an objective style as to *appear* that some commentary is taking place.

1988

Hardship Art

On July 4, 1983, Tehching Hsieh (formerly Sam) launched his fourth consecutive one-year performance at 111 Hudson Street, in the loft where he had lived for seven years. This time, however, he had a collaborator in Linda Montano, a performance artist who has sought religious disciplines in her work that made Hsieh's rigorousness attractive to her. For his part, Hsieh no doubt wished to experience a certain model of togetherness that was eminently lacking in his previous three one-year works, and perhaps by implication in his life in America, where he came as an immigrant, from Taiwan, in 1974. For his first one-year event, 1978–79, he lived alone in a barred cell that he had constructed inside his loft, without radio or television or reading and writing materials and without talking, serviced by a friend who brought him food and removed his trash. During 1980–81, he punched a time clock in his studio every hour on the hour, both day and night. His third one-year performance consisted of living outside entirely, never entering "a building, subway, train, car, airplane, ship, cave, tent."

Hsieh's collaboration with Linda Montano, which ended July 4,

1984 at 6:00 P.M. precisely, one year to the minute after its start, was characterized by the same harshness and deprivation as the earlier work, despite, or perhaps because of, its conception of intimacy. Hsieh and Montano were tied together at the waist with an eight-foot rope for the duration of the piece. Their statement read: "We will stay together for one year and never be alone. We will be in the same room at the same time, when we are inside. We will never touch each other during the year." As in Hsieh's three previous marathons, or endurance tests, the event was framed by ritual performances marking the beginning and the end, with at least two days during the year specified for display. Typically also, heads were shaved for the opening, then hair was allowed to grow, its length at the end a noticeable measurement of time spent. Hsieh is a meticulous documentarist, approaching legalese in his scrupulous concern for providing evidence of meeting his own set terms. Thus, besides the evidential offering involving hair, the ritual opening performance on July 4, 1983, centered on the rope binding, a padlock at each waist, hammered and inscribed by two witnesses (a man for Montano, a woman for Hsieh) who reappeared a year later before quite a large curious audience to testify that the rope—with seal—had remained intact. During the year, the bound couple documented the event by taking a photograph of themselves every day, sometimes appearing with friends, maintaining a scrapbook of the photos, and carrying a tape recorder at all times to record every conversation—tapes that Hsieh would seal, planning to consign them to some private archive.

In work so broadly inclusive of life, so removed from the witness of audience, except for the two framing rituals and the two open houses during the year, documentation becomes the art object: the traditional representation. No doubt the term *Documentary Art* has been used to describe this life/art genre—a means of making known the intention to frame an experience, and derived or descended at least from the heavy kind of documentation of Earthworks that has composed gallery shows. But Hsieh's work is most closely related to the life/art enterprises of the Englishmen Richard Long and Hamish Fulton, who have both shown maps and photographs of specific walking tours around Great Britain. What actually happens on these tours—what is seen, heard, experienced, etc.—beyond what is chosen for documentation, is in some important sense (the sense of the audience, at least) not part of the art

object. What may be imagined to have happened is as vital to the object as anything imagined while beholding a traditional land-scape. What else did the artist do that day? And so on.

Hsieh himself expresses little interest in what he has done or experienced all year long during the extraordinary time span of his events. His great attention to detail, the exactitude of ritual, com-mitment to finishing the work as announced, adherence to its rules, and documentary fervor, including very excellent publicity posters and flyers, seem to occlude any consideration of the experience framed. Nor does Hsieh express interest in his motivations for doing the work. This may be because its nature as *rite de passage* is all too obvious. One might wonder how many such hardships he feels he must endure before America seems less hostile or more welcoming, and/or he registers acceptance in the art world, the latter perhaps his condition for belonging. Certainly to be more than a Taiwanese oddity, even of surpassing interest (media doll that he is), he must establish the seriousness of his form.

If form, substantiated by documentation, is Hsieh's strength and preoccupation, content (experience) became the domain of his part-ner in this fourth art/life tour de force. Montano's ambitions as an artist are much less defined than her avowed interest in learning how to live better through lifelike artworks, of which she has done a number of her own since 1965, for example handcuffing herself to a man for three days (1973), making a video document of the event for ten minutes of each day. Montano has made a book, published in 1981, documenting her art events alongside comments about her life that she deemed concurrently relevant. Until her collaboration with Hsieh, nothing she had done had been even remotely as extreme, in terms of time—except, curiously, in certain realms of her life. From 1960 to 1962 she lived as a nun in a convent. From 1970 to 1975 she meditated daily in a Yoga center. Beginning in 1980 she spent two years in a Zen center. And she studied karate for two years. The prospect of doing a year-long piece with Hsieh (motivated in part by her depression at the end of an eight-year relationship) seemed perhaps like the ultimate com-bination: the rigors of religious seclusion and discipline united with an art form of impressive breadth and structure and publicity potential.

While preparing to do the work she told a friend she was going to do a "one-year meditation retreat." For an audience interested in

the *experience* of the work, the interstices between documentation and public ritual, the liminality of the event, Montano was clearly the one to consult. Hsieh is not unwilling to discuss such things—things he has learned about himself and human nature, etc.—but his objective is really art, and the images he creates so far as he's concerned are symbolic, not biographical or personal. The most he wanted to say about the work's relevance to life was that his central image of two people tied together symbolized people's survival (dependency) needs. The rule not to touch (they documented all the times they touched accidentally) was meant to make it clear that the work was not about a couple, but about two people, and not individualized people at that.

Problems of living together that arose during the year, often intense, occasionally erupting in violence, were for Hsieh directly subsumed under concerns for the survival of the work. Nothing should obstruct its completion. Montano, on the other hand, while also eager to get through it, was interested in the power structure of their relationship *within* the work, the morality or quality of the alliance, issues of character, cooperation, compassion, and her *personal* survival in the face of danger and violence. Hsieh greatly opposed any reading of the work in sexual/political terms. For him, it was not about a man and a woman but two people, equal before the law of the work. Yet Montano had joined him, agreeing to do his piece, accept his terms, live in his loft, in effect take his name, much the way any woman joins a man as his wife. Much of what then transpired was, from her point of view, a struggle to make herself an equal partner under those unequal conditions. Hsieh was perhaps not prepared for an insubordinate accomplice. Montano, while no feminist per se, had been doing her own work for a long time; she is nine years older than Hsieh, and she had a large stake of her own in the event. At any rate, this struggle between them (e.g., Montano pressed for equal control over the documentary process—for a month Hsieh did the sound, she the pictures, then they would alternate), unrevealed by the documentation, constituted a core aspect of the structure *beneath* the structure of the event.

Montano's anticipation of a "one-year meditation retreat" was transformed through conflict into a parade of insight about her emotional life. She said the piece surfaced a lot of her "suppressed

rage," providing access to realms of feeling that could give medita-
tion new meaning. "What this piece has done, for me, is to exhibit
what I need to purify. . . . it's been a good *preparation* for medita-
tion." At such close quarters, she was forced to express needs and
wishes that made conflict inevitable, giving rise to concessions
fought for and won, but also to appeasements and appeals for
mediation outside the alliance—the latter two ploys stereotypically
female. One way Montano fought feeling engulfed by Hsieh's domi-
nance as author of the piece was to engage at the outset in bitter
fighting—mutual criticism and insults, much of it about each
other's (historical) work. This would serve the additional purpose,
more critical no doubt, of placing a greater distance between them
than simply no touching afforded. The daily battle over priorities,
most pronounced in their plans for excursions outside the loft—to
restaurants, movies, friends, places of work (she did some teaching,
he carpentry), etc.—shaped up into a major impasse by midwinter.
Expressions of discontent culminated in dramatic withholding meas-
ures. Montano refused to go to Chinatown, where Hsieh liked to
eat at least two or three times a week, and Hsieh wouldn't walk
Montano's dog, Betty, or would cause the dog to suffer by waiting
an inordinately long time before agreeing to take her out.

Friends counseled making contracts over food and the dog.
Montano said the dog was obviously an extension of herself, and
she suffered with her. Problems of privacy, its lack, erupted around
Montano's extensive use of the telephone to talk to the outside.
This climaxed in May when Montano submitted to an interview by
phone about her own work; Hsieh strenuously objected, then tore
the phone out of the wall. Montano yanked him down the stairs to
the street (yanking had become the main way of expressing anger)
to a phone booth where she called friends nearby who came to
mediate for several hours. Conflict also rose over Montano's greater
ability to communicate in general (Hsieh's English remains poor),
and Hsieh's refusal to let Montano help him when they went to his
carpentry jobs.

It was hard for them to say how much of their year together was
spent quiescently or enjoyably, though Hsieh was the one who
liked to stress positive aspects. As for Montano, on the anniversary
of D day, June 6, she presented a friend with a tearsheet of an old
Life magazine spread featuring a two-year-old girl who had
learned the Houdini-style trick of freeing herself from rope binding

her wrists and ankles while submerged in a pool. At any rate, they had their full share of the crises that typically mark any middle stage of both social drama and *rite de passage*, the metaphor of life transit itself between birth and death. The "birth" and "death" ritual performances that framed their event were also classically inverted in mood and design.

The "birth" of the piece meant, of course, their death to the world, which—in the form of an interested group of friends, well-wishers, curious folk, and art world cronies—watched them somberly undergo the "initiation" of rope binding and padlocking, heads shorn, the two witnesses geometrically in attendance. And the "death" of the piece was heralded by the same group, greatly expanded to include media people holding television and video cameras, jammed into Hsieh's long narrow loft space, gladly welcoming the couple back to normal life. It was quite an emotional, joyous occasion. Lots of people cried; everybody cheered. The two clasped hands, then happily embraced. Hsieh playfully pretended to punch his partner out. Their independence from each other mirrored their earlier separation from the world, two July 4 events. And as at the end of all such dramas, the status of the initiands was, at least momentarily, elevated and redefined. For Hsieh, a Taiwanese immigrant, this holds high significance. For Montano, as for any woman (herself "outside" the mainstream, exiled from patriarchy), this should also be a promising development, whatever her priority of dragging things she's learned back into "life."

(Postscript: After the second July 4 performance, Tehching Hsieh left his loft on Hudson Steet, and is now renovating a new loft in Brooklyn. Linda Montano went to stay with her parents in Saugerties.)

1984

Remembering Charlotte Moorman

Charlotte Moorman died on November 8, 1991, in New York from the cancer that had afflicted her since 1979. In another ten days, she would have been fifty-eight years old. I never knew Charlotte personally, except the way one knows everyone who shared a historical scene, and I saw very few of her performances; so my first thoughts of her must be pretty standard. I see her playing her cello, dressed only from the waist down, hauled off by the police, tried and convicted for "partial nudity," released with a suspended sentence, and flying or floating in a helium balloon over one or several of the avant-garde festivals that she organized.

On February 9, 1967, Charlotte was arrested by two police officers while performing the cello topless at the New York Film-makers' Cinematheque before two hundred invited guests. Her condition of undress was called for by Nam June Paik, the composer of the score she was playing—titled *Opera Sextronique*—a "mixed-media work in four arias." Paik was arrested with her, then released and not charged. One of Judge Milton Shalleck's

remarks, in a long, insulting opinion indicting Charlotte for "inde-cent exposure" and an act "born not out of a desire to express art but to get . . . [men] to be aroused," put his victim in the proper gender perspective, though he could not have intended to. The judge said he "doubted if Pablo Casals would have become as great if he had performed nude from the waist down." The comparison helps bring the history of a cellist like Moorman into focus, and may explain the curious transition she made from classical musi-cian to avant-garde cultist and rebel.

In 1962 or 1963, Charlotte had become bored playing Bach and Kabalevsky, et al., on the cello, and someone she knew suggested she might like to play a piece by John Cage: "26'1.499' For a String Player" (1955). That was her introduction to "different music." She had been a student of the cello since she was ten, had received a master's degree from the University of Texas, and had studied at Juilliard—she was a member of Jacob Glick's Boccherini Players and of the American Symphony Orchestra under Leopold Stokowski. She had also been married very briefly to a double bass player with the Buffalo Philharmonic. In 1963 Charlotte founded the New York Avant-Garde Art Festival, which ran through 1982 and drew in hundreds of artists from many countries to show new work. In this world—which a Pablo Casals would have viewed as if it were an asteroid seen through a Mount Palomar lens—Charlotte herself became a soloist and a unique entity, "the only avant-garde cellist in the entire history of performance art," as her friend and Fluxus archivist Barbara Moore put it.

But if a woman could never be a Casals, with or without clothes, in this new world of the free there was high price for a woman to pay for standing out. Until 1967 and the nudity trial, Charlotte appeared to be pulling off a double life. While organizing her festivals and performing outrageous works by Paik and others, she maintained her symphony orchestra job. Then, with the notoriety of the trial, she was forced to choose. The symphony people told her she could continue with them only if she renounced the avant-garde. Economic hardship followed, as she supported herself work-ing late shifts at a telephone answering service or playing in a balalaika orchestra.

But there was a more insidious, more dangerous price to pay for her choice. During the 1960s, as the so-called sexual revolution consumed our society and before the feminist movement had gained

any momentum, women were an easy mark for exploitation. Charlotte Moorman arrived in New York in 1962, ready and eager, it seems, to fit a conventional female role, not the one she knew growing up repressively in Little Rock, Arkansas, but the "liberated" one that awaited her in a city about to blow its gaskets. New York just then was a giant maw, yawning wide to receive such innocents from the provinces and gulp them into the churning entrails of rebellion. Her husband of twenty-one years, Frank Pileggi, says she discovered sex in the 1960s and couldn't believe what she had been missing.

In Nam June Paik, Charlotte found a collaborator made in seditionary heaven. They met in 1964, the year Paik emigrated from Korea to live in the United States, the second year of her avant-garde festival. Paik, too, had a classical background in music, piano primarily, and had met and fallen under the influence of John Cage. And he had by then been embraced by that old boy network known as Fluxus—a neo-dada movement of international proportions. Women were never excluded from Fluxus, but in keeping with mainstream social values, as creators they played token roles at best, and were used exorbitantly in their distaff functions. It was here that a woman like Charlotte shone. She was very enthusiastic about being used as a soloist in all the ways that flaunted tradition.

Although just a few of the two hundred or so works that she performed called for nudity, the icon of a woman in formal attire—wearing makeup, groomed 1950s hairdo, floor-length gown—seated with cello, exposing her breasts, would come to represent her position with perhaps unfortunate clarity. Here was a perfect expression of a girl from privileged Middle America "gone wrong." Here you might imagine a southern hostess, entering her salon, greeting her guests with the proper smile and sweetness (many people remember how sweet Charlotte was) and words of welcome, then shocking them to their booties by sitting down decorously to play her cello, *without her top*. Then she introduces her collaborator, Korean expatriate, New York desperado, smasher of culturally venerated instruments (pianos, violins, etc.), presenting a slide show of his and their work together. She might show the image of an early work of his—of a mangled, dismembered female dummy in a bathtub (1963). Surely she'll show the outstanding *TV Bra for Living Sculpture*, made for Charlotte after her trial, in which she

supports two miniature TV sets on her breasts, equipped with a foot pedal to scramble the images. Paik might close their presentation by saying, as he once did, "Someday entrance exams at Juilliard will be decided not by finger-technique but by the size of breast." The nice southern guests will have left by then, or called the police, or complained to Charlotte's mother and grandmother.

Charlotte, an only child, adored her grandmother, who died in 1969. After that, she was out of touch with her family. Charlotte once said that her trial in 1967 gave her grandmother a heart attack. Frank says she became "the fallen child." Charlotte had idolized her father—a wealthy real estate man with a hideaway ranch in Texas—who died at forty-six, when she was just twelve. For some reason, Charlotte's mother was left penniless after his death. She died in 1982, at a time when Charlotte's cancer was spreading to her bones.

If Charlotte's background and presentation of self seemed incongruous with her iconoclastic activity as an artist (though they meshed marvelously in the images of her work), there were mysterious points of agreement—not unnoticed by herself and others—between the trauma of her trial and the illness that at last overcame her. In 1979 she was diagnosed with breast cancer. Eerily, a few months earlier an artist had sent her a proposal for a work called "The Radical Mastectomy of Charlotte Moorman." That year her left breast was removed. Charlotte once remarked that some religious fundamentalists claimed she "lost [her] breast because God was punishing [her] for sinning." One repercussion of her trial was a law passed in 1967 barring female toplessness in public but allowing artists to appear topless in New York State. In a more personal repercussion, Charlotte sometimes presented herself mummified or overly clothed. She wore football gear in 1968 in another mixed-media opera; I remember her the next year, cello and self swathed in white gauze, a kind of nun-mummy, in an event of my own called *The Disintegration of a Critic*.

The last time I saw her, December 1988, she was performing Yoko Ono's *Cut Piece* at Emily Harvey's gallery. Audience members were invited to use a scissors lying before her to snip off pieces of her dress. There was great pathos there. I simply wouldn't cut the dress myself. I saw a valiant victim in Charlotte, ever a champion of the forces that felled her, and I couldn't participate in it. If Barbara

Kruger ever remade *Your Body is a Battleground*, Charlotte's image would surely be an appropriate illustration for it.

1991

A Fluxus Funeral

On Sunday, October 17, 1988, assorted remains of the great Fluxus clan met in Bangor, Pennsylvania, to celebrate the death of one of their own. The artist and teacher Robert Watts had died at his home near Bangor on September 2. The all-day memorial festivities took place there, on the land behind his house and at Watts's pond another two hundred yards or so beyond the house and into the woods. Watts himself had named the event—"Fluxlux"—and provided instructions for its fulfillment. It was, in a way, his last work and testament, bearing witness to the spirit of Fluxus, a movement in which works of art as property have been negligible compared to the idea of living as an art form and art as a way of life.

Fluxus artists since the 1960s have made the most ingenuously simple objects and events in the tradition of the Duchampian ready-made, combining the playfulness of Dada and John Cage—inspired chance operations with the minimal or the purely conceptual, to an end result of *épater tout le monde*. Fluxconcerts pulling together a wide range of individual contributions have been a regular feature in the life of Fluxus. But special also to Fluxus have been its

members' rites of passage: the "Fluxwedding," "Fluxdivorce," "Fluxfuneral" (there has been at least one of each), and other collective expressions marking cultural or personal events in a distinctively wayward style. In 1976 Fluxus friends and artists made a festschrift banquet for George Maciunas (the founder of Fluxus in 1962), who died in 1978. In 1970, Maciunas created a "Fluxmass" in the chapel at Rutgers University, delighting Flux-minded students and faculty, scandalizing church officials and legislators. Maciunas had been invited to Rutgers by Geoff Hendricks, a professor in the art department there and a Fluxus artist since the mid-1960s. Bob Watts was also a professor in that art department, retiring in 1984.

Watts had a kind of family of ex-students, some of whom participated in his Fluxlux memorial. One of them had taken the photograph of Watts that played a totemic role in the final events. Enlarged to life-size, cut out and glued to cardboard, Watts was carried at the head of a parade to the pond for sunset ceremonies by another ex-student, Larry Miller, a Fluxus artist since 1969, an organizer of the Fluxlux, and inheritor of Watts's land and house. Two months earlier, just before Watts died, Miller and other friends carried him out to his pond, which was like his church, Miller says, to watch the sunset.

Watts defined his Fluxlux as a "memorial ceremony" for his spirit, for "the spirit of deceased friends, and all living friends who care to join in." He said, "The tone of Fluxlux should be one of rejoicing—a party, with music and dancing, lights and banners, and good food and drink." He mentioned an auction "of small works of mine and others . . . if desired." And the "playing [of] my tapes of birds, water, thunder, clouds and other natural sounds" to manifest his spirit "in the tradition of Gurdjieff and Marshall J. Smith," his grandfather. Finally, "a few guns could be fired off." Three outcomes for Watts's ashes were indicated. Some were to be dispersed in his pond, some shipped to his remaining family in Iowa, some (a project conceived in 1975) to be scattered by rocket toward the constellation Gemini, preferably on the Fourth of July, from any location. His friends are working on this. Watts was as interested in guns and technologies as he was devoted to nature and art. His art, and his final event, Fluxlux, reflected all his interests.

Watts was born June 14, 1923, under the sign of Gemini, in Burlington, Iowa. In 1944, he received a degree in mechanical

engineering from the University of Louisville in Kentucky. Later in the 1940s he studied painting and sculpture at the Art Students League in New York. In 1953 he took up his position in the art department at Rutgers. Until 1958 he painted in the abstract expressionist style, then suddenly he stopped painting. Between 1958 and 1963, when he joined the Fluxus artists, he exhibited electromechanical works guided by random or quasirandom circuitry; became interested in film, photography, and tape machines; designed light, sound, heat, and motion devices for gallery environments; and investigated botanic and mineral forms as mediums. He worked closely with Allan Kaprow, George Brecht, and George Maciunas. Kaprow, Brecht, and Maciunas contributed pieces to Fluxlux, though they were not present themselves.

Brecht had sent three scores from Cologne, where he has lived since the early 1970s. One said, "Music is what you are listening to at this moment." Another was a more direct instruction: "Drive a nail in the wall, take a piece of string as long as you can hold between your outstretched hands, hang the string on the wall." String, hammer, wall, and nails were available all day inside Watts's empty, dirt-floor barn, about a hundred feet from the house.

Fluxlux began at 11:28 A.M. exactly, which was the time Watts died on September 2. It was a glorious Indian summer day, the best day of the fall. The kickoff event at 11:28 was a performance of a Watts piece called *Two Inches*. A two-inch-wide ribbon was stretched out and cut on the roof of the house outside the room where Watts died. Right afterward the window in the room was opened, and people let out helium-filled balloons all rubber-stamped with the words "Trace Bob Watts." This was Larry Miller's piece, meant to "contact" Bob, in part no doubt by invoking a number of Trace events created by Watts himself. In "Trace for Orchestra" (ca. mid-1960s) musical "scores" consisting of flash paper (used by magicians) sit on music stands and go up in a puff when lit with matches by the "musicians." The one I remember was "Trace for f-h" (French horn), performed in 1964 by George Maciunas at Carnegie Recital Hall. The curtain opened. Maciunas, dressed in tails, bowed formally, the mouth of the French horn under his arm disgorging a cache of marbles.

At Fluxlux, Geoff Hendricks performed the same work during the sunset ceremonies at the pond, except that Hendricks had filled the instrument with rice, which was discharged into the pond as he

stood and bowed deeply on the docklike wooden structure used by Watts to fish or dive from. Like Maciunas, and in keeping with one key dress code of Fluxus, Hendricks was in formal gear, however contrarily, to suit his idea of the place and occasion. With the familiar black derby (a favorite of Maciunas's), Hendricks wore a black coat that he had bought many years before in Vermont at an antique store. He said it had belonged to a farmer who had worn it only once—at a funeral of his brother.

Hendricks wore black rubber boots, and during the parade to the pond, as he walked along next to the photo cutout of Bob Watts carried by Larry Miller (in a tuxedo), he held a big black umbrella opened overhead, and had a Mexican death mask, made for Mexico's Day of the Dead, slung around one shoulder. Hendricks, a tall man with a salt-and-pepper beard, cut a very visible figure all day, a kind of mascot of the memorial and a reminder of its seriousness, despite the lightheartedness requested by Watts and natural to Fluxus. Hendricks's own contribution to Fluxlux was called *Death Cleans Up*. He took off his rubber boots, washed one foot in a white enamel basin, then poured dirt on his other foot in another enamel basin. He didn't announce the performance; he just did it, and a few people watched.

It was performed somewhere around Watts's barn during the afternoon. A number of events took place more or less unnoticed or anonymously like this. It was often uncertain, for that matter, whether an "event" was intended. The potluck lunch, for instance, served all afternoon on long narrow tables laid out in a square under a tent near the house, could have been someone's "piece." I recalled the salad made and served by Alison Knowles (*Make a Salad*) at the 1963 Yam Festival. But while we were eating and mingling, it was very clear that a piece *was* being performed when people came up to you and tried to plant a kiss on you with blue lips. This was a work by the Czechoslovakian, Milan Knizak, called *Blue Lips Prints*. The instructions were for people to paint their lips blue and print them on any object: on the ground, on people, on furniture, on mind waves. Robert Filliou, the noted French Fluxus artist, who died last year, was represented by three No-Plays, which were posted to be read. Some trees had messages posted on them by Rafael Ortiz, once famed for his work in destruction art. The name of Ortiz's event was *The Trees Speak of Bob Channeled through Rafael Ortiz*. Ben Vautier, great Fluxus Frenchman from

Nice (he met the others at the Festival of Misfits in London in 1963), sent a mailgram reading, "I suppose Bob went to heaven to prepare with others Fluxus concert with entrance piece *Two Inches* played by Saint Peter and Saint Thomas. Love to all present. Ben 1988." Hendricks made a poster of the words and tacked it to a side of the barn.

On a slope facing the barn a good number of the nearly two hundred assembled people sat down to participate in the auction of small works that Watts had asked to take place "in the tradition of Al Hansen and the Third Rail Gallery." (Hansen was well known for his Hershey's bar wrapper collages and his toilet-paper Happenings.) Funds were to go toward a Watts memorial scholarship at Rutgers. The auction was introduced by an amplified tape of phoned-in greetings from Munich by Al Hansen. The auctioneer was Fluxus artist and composer Philip Corner. Objects for sale had been on exhibit earlier in the barn. Corner's style was intimacy, bravado, and slapstick. Nothing sold for more than $250, as Corner pumped up trifles and things of value alike, and urged all Americans to outbid the Europeans.

Around 4:00 P.M., everyone gathered behind the barn on a grassy road to close ranks for the parade to the pond. The straggly procession was led by Miller bearing the cutout of Watts, Hendricks with his death mask, bag of rice (hanging nearly to the ground) and opened black umbrella, and Philip Corner making noises on the trombone. The "music" for the parade, called *Fourth Finale*, was Corner's piece. It included different noisemakers—bird whistles, New Year's Eve kazoos, pots and pans, and so on. This low-key cacophony had a dirgelike effect, stressed by the parade's slow pace. In addition to the dramatic, black-clad figures of Miller and Hendricks, there was also a tall man pulling a dead fish on a little cart on wheels. Yet this was not a procession that looked like it was going to a funeral. Various parade cutouts that bobbed along were bright and cheerful. Lots of balloons mingled with them. People talked and smiled, amused perhaps by the pose they struck, and still under the influence of a gorgeous day. Possibly, too, they looked forward to the "last rites" at the pond, knowing that Fluxus always promises humor, brevity, surprises, elegance, charming mishaps, and familial references to its own history.

The parade itself recalled Watts's love of parades and the Fluxparades he organized with students in California, when he

taught there in the late 1960s on leave from Rutgers. An airplane piece organized by Danish Fluxus artist Eric Andersen was a reference to a piece of Watts's for *Earth Day* (1970) in New York's Union Square. Watts had employed a skywriter to draw the word "sun" with a circle around it, downtown, and the word "moon," encircled, uptown. Now Andersen planned to do the piece for Watts—but with a plane pulling a banner reading "Moon," because no area skywriter could be obtained. As dusk approached at the pond, the assembly frequently scanned the sky, looking for Andersen's plane. Many wonderful things happened in the meantime.

A man called Charlie who had excavated the pond for Watts gave a little speech (heard only by a few) and showed people a Polaroid of the excavation. Larry Miller, standing on a dock across the pond from the main body of Fluxfriends, conducted a Maciunas piece called *Lip Farts*, in which everyone was asked to make a sound like a frog. Miller also conducted Dick Higgins's *Constellation for Bob Watts*, in which everyone said in unison "Bo-o-b Watt-s-s-s," drawing out the *s*. Takako Saito's small wooden fish—forty or fifty of them—which she had made and sent from Düsseldorf, were put in the water. Yoshi Wada (also from the important contingent of Asian Fluxus artists that includes Nam June Paik and Yoko Ono) played a lament for Watts on the bagpipes against the fading colors of fall to the west.

A small paper boat with a candle in it and a dream written on the paper, sent by David Behrman from Berlin, was launched. Alison Knowles traversed the pond paddling a small unstable rubber raft, pulling along a little solar-powered music boat (music plays when the sun hits the solar cells) by Joe Jones that turned upside down. When Knowles got to the other side of the pond, where quite a few people stood clustered on the bank, she threw out some beans and tomatoes that she had in the bottom of her boat. Later, Jones retrieved his music boat and set it upright. Jones was also responsible, along with Miller and Ben Patterson, for a small radio-controlled boat that pulled a little barge (each was perhaps ten inches long) containing the portion of Watts's ashes that were to be dispersed in the pond. As the boat moved forward, a paddle wheel in the barge was supposed to spread the ashes. This, too, failed to work, and Miller had to go out in a boat, turn the barge upside down and pat the bottom to get the ashes into the water.

Before this happened, seven Fluxus artists executed a twenty-one-gun salute. There were revolutionary war muskets, guns from Watt's own collection, and toy guns. Hendricks had one that shot out a plastic ball, and Miller had one with a flag inscribed "bang" that popped out. The guns were fired in sequence, each one three times, across the pond from east to west. The twenty-first shot was made by Ben Patterson, attired in a naval officer's uniform, from the cannon of his boat (perched on shore) called the USS *Robert Watts* (Watts served in the navy in World War II). The twenty-first shot sent off a firecracker rocket that crossed the pond and started a little fire in the grass. Patterson then launched his boat after trying to christen it by pounding it with a plastic bottle of seltzer water. When the boat hit the water, it capsized. In a final "salute," the black derbies worn by the seven gunmen were tossed into the pond, where they bobbed with the fall leaves and the wooden fish.

By this time Eric Andersen's plane was circling overhead, towing the red banner reading "Moon." Somehow the pilot made his last pass—directly over the pond and quite low—just when the performances seemed to be over. The pilot waved and everyone waved back, cheering.

Back at the house there was music and dancing and one last performance: Allan Kaprow's *What's Watts' Watts?* The amount of wattage in each room of the house was added up and of course the lights were all turned on while the wattage was counted.

Altogether, not a bad way to go.

1989

Between Sky and Earth

I am sure I met or knew Geoff in the 1960s sometime, but I have no clear memory of him until his "Fluxdivorce" in 1971, a striking event, the kind you don't forget. It was June 24. Geoff's wife Bici Forbes invited me to the event earlier that day when we saw each other at performances on the *Q.E. II* in New York harbor. I wrote about the Fluxdivorce, calling it "a beautiful event," and "a ritual of renewal on their 10th (wedding) anniversary." I found it edifying for several reasons, outstandingly that Geoff and Bici had recently "come out," and a number of gay people were there.

I had known gay men, assuredly, in the art world. But Geoff was the first male in our time to deal openly in his work with issues of sexual identity posed by the Stonewall riots of 1969. This is not to say that he participated in the riots or even became political per se. But because of the riots and the new gay politics, a consensus in America, in particular in New York at that moment, existed that made possible for the first time in human societies a passage of

Note: All italicized passages are quotes of Geoff's, catalog essay: for *Fluxus da Capo* 1992.

identity from the normative heterosexual to the hitherto secret and unnamed homosexual.

Geoff's work during the 1970s, beginning with Fluxdivorce, illustrated this momentous transition. At last, with consensus, people of same-sex preferences could be what they were, no longer be split between what they did or wanted and what they knew they were supposed to be, between action and thought, self and culture, desire and propriety. Fluxdivorce was a happy occasion because ties were cut that made other ties possible. In one event, Geoff and Bici were separated in a tug-of-war, with the men pulling on a rope secured around Geoff, the women on a rope secured round Bici, symbolizing (re)unions with their own sex. The halving of a number of objects—wedding documents, clothes, double bed, etc.—with knives, scissors, saws, and whatnot, likewise ritualized the separation and forecast a reconfiguration: *Common objects transformed.*

Halving furniture, in particular chairs, became a theme in Geoff's work, beginning at least by 1975 when in performance he cut a chair in half, reversed it, and lashed it back together. In his 1992 Weisbaden installation, he included an ensemble of a table that he quartered, then reversed, and rejoined (the four legs then coming together in the middle), flanked by four standard restaurant chairs, cut in half, and similarly reversed and bound together again. In such symbols, the restructuring of the artist's life is recalled and reaffirmed, and anybody can see in them the break points, the deaths and renewals of all sorts in their own lives. For Geoff—*I became an operative person as a gay person.*

Classic Hendricks, too, is the earth below (a pile of dirt under the table and chair) and the sky above (four watercolors of skies hung in different positions, showing the quartering of the moon cycle). Geoff first painted skies in 1965. He was turned on by Roman baroque ceilings, the subject of his master's thesis at Columbia University. He covered many objects with sky images—boots, car, sheets, shirts, chairs, etc.—and eventually he painted skies on the flat surfaces of paper and canvas. He never depicted skies traditionally, that is, in any landscape context; nor surrealistically (like, say, Magritte) as backgrounds for dream imagery. However, he has incorporated his skies, usually his paper rectangles of watercolor skies in their endless variety of cloud formation and moon position and light and weather aspects, as combine elements, into many of

his performances and installations. I see Geoff simply as a realist here. This is what's above me, the element I see (and admire) everyday, the atmosphere my head is in, the top of the world, he seems to be saying. *God, the sky is beautiful. And so still.* "The skies include an idea of physically unbridgeable distance," Henry Martin wrote of Geoff. But Geoff likes to bridge everything, often symbolizing this effort or attitude by including ladders in his work. Two ladders with skies hung on them appeared in the Wiesbaden installation. Geoff is very concrete. Where he isn't there in person, the ladder, I think, is his body, connecting what's above with what's below, as are the table and chairs, stuck between the sky (representations) and real earth. Geoff is a body artist. He covers his body—paint or makeup—with sky sometimes, and he immerses himself in earth.

Following Fluxdivorce, in November 1971, Geoff sat on a great mound of black earth, about six feet high, for twelve hours, in the exact center of the Sixty-ninth Regiment Armory in Manhattan, for the duration of the eighth annual New York Avant-Garde Festival. He called the performance *Ring Piece.* Buried in the dirt underneath him were relics from his Fluxdivorce in June, including both halves of his (severed) marriage certificate and fragments of his marriage bed. I was there. He didn't speak or move, except to write impressions and thoughts in a journal. A meditation, a bridge between past and future. *An act of mourning for the end of one important chapter in my life.*

Shedding his old life, and appearing newborn, in another ritual performance called *Body/Hair* he shaved his body from the neck down, and made relics of each area of hair as he removed it, storing it in bottles labeled "The hair of the left foot of the artist" and so on.

During the time moving toward the Fluxdivorce and actual separation, Geoff played mother and father to his two children. In 1971 Stephen Varble entered his life, his first postmarital and post-Stonewall relationship. In April 1974 he split up with Stephen. That June, celebrating the summer solstice, Geoff performed a ritual self-initiation on a mountaintop in Norway. *Norway the land my father's parents had left nearly 100 years ago.* A family reunion had been arranged by Geoff's eighty-two-year-old father. Geoff's two children, two brothers, sister, sister's husband, and their two children had gone to Norway for it. Alone in his mountain ceremony, Geoff cut off his hair and tied it to roots. He did

other things: made a bonsai fire, buried dirt from Vermont in a circle of black earth, put animal teeth and leather onto a ledge, tied trees to a cairn, made a cerulean blue circle in the snow, and naked, colored himself blue, washed himself off and bathed in a snow-edged pool. He went way back, you might say (*a journey to roots, to source*), in order to jump forward. He enacted a dream of the ancestors, collecting energy for what lay ahead. *In the morning on the very top of the mountain I read my chronology aloud. I placed my grandfather's picture under rocks in the cairn marking the top.* Geoff foreshadowed much of what is called performance art today—intensely personal, autobiographical.

I see his Norwegian rite of passage as the watershed event of his career. Geoff was forty-three years old. An urgency, perhaps, marked his work in the mid-1970s. In January 1976 he presented *La capra* in Italy, yet another ritual of metamorphosis, this one, however, relating pointedly to his identity as a gay man. A ladder was cut in half, reversed, lashed back together. Hair and signatures, collected from the audience, were attached to the ladder. Dreams were read, dipped in water, and tied to a table. Flowers were stuffed in his pants. Corn was poured into his shoes. A film of cows and slaughter was shown. Geoff performed naked with two other naked men. A goat was involved, Geoff dancing with it, and bound to it. *Dionysus represents . . . the liberation of natural emotions from the tyrannies of ideology and culture.*

In October of that year Geoff met Brian Buczak, a young artist from Detroit, and they were together for a decade, until Brian died of AIDS on July 4, 1987. Beginning in 1978, the deaths of friends and family have affected Geoff's life, and influenced his work, expanding his repertory of ritual-based and commemorative forms. Actually, the first important death in Geoff's life was that of his sister Cynthia, his older sister by two years, when he was just five. He feels the shadow of her death as an undercurrent in the imagery of his work from the start. His first adult encounter with death was when George Maciunas, founder of Fluxus, died in 1978. Before he died, Geoff performed with the Fluxus collective a ceremony called "Fluxwedding," the marriage of Maciunas to Billie Hutching. And after Maciunas died, Geoff constructed a program of events for a "Fluxfuneral." In the Fluxwedding, there was much cross-dressing and sex-role exchanging, for Maciunas himself was perhaps either gay or a gay hopeful. *Sexually I have been between homosexuality*

and heterosexuality, drawn to both poles, living in both worlds, living in each world in turn.

The following year, 1979, Geoff's father, a professor of English, poet, and founder of three colleges in Vermont, died. In 1980 Geoff included two terra cotta death masks of his father laid in a kind of bed, of newspaper and dried leaves, inside a produce crate that formed part of an installation in Naples. Geoff's father, incidentally, had once made a death mask of his mother (Geoff's grandmother) that was kept in a little valise. A few years later, Geoff donated the death masks of his father, along with a ladder with images of sky from day to night hanging on it, to the Sonja Henie-Niels Onstad Art Center in Oslo. *The word Sky in English goes back to the old Norse word Sky, meaning "cloud."*

After Geoff's mother died, May 1987 (two months before Brian), Geoff made a memorial book of her poems. Geoff is a documentary artist. He records many of his performances, installations, dreams, journal entries, and commemorative ideas, by publishing books of them, or of their pictures and descriptions.

I saw Geoff play a heavy role in Bob Watts's memorial service, titled "Fluxlux" and constructed by Watts himself before he died, in October 1988 at Watts's land in Pennsylvania. Geoff wore black rubber boots, a black coat and derby, performed an event called *Death Cleans Up*, and during a procession to Watts's pond, for the performance of some Flux rites, carried a big black umbrella opened overhead and a Mexican death mask slung around one shoulder. Watts had been a colleague of Geoff's for many years in the art department at Rutgers University.

I have considered the possibility that Geoff, amongst all his Fluxus friends, and other artists as well, may have the most heightened sense of the interaction and fusion of life and work, crystallized in rituals bridging the now and the hereafter, because of the crucial transition he once made in his sexual identity. *I spoke with Francesco about how I came to realize that the most personal meets the universal.* He isn't a perfectionist, or a formalist, as an artist. He collects objects around him, or around each other, that have deep meaning for him, that have numinousness from past associations, a patina they must give off in the recognition of old sources.

Geoff has made at least two memorial performances for Brian. On July 4, 1991, the fourth anniversary of Brian's death, and a day

that held special meaning for Brian as an American of Polish ancestry, Geoff performed *Cortile* with another man, Alberto, in Verona. Hair was cut, the two men got in a tub and covered each other with flour and dirt; they tied masses of flowers onto their legs and arms, they moved a moon back and forth; Geoff climbed a ladder and met Alberto high up in a doorway where they coated each other in blue makeup; they pushed a wheelbarrow through the audience with two chickens in one cage and two doves in another. A third person who had been blowing a trumpet lit a fire, then Geoff and Alberto released the chickens and doves and there were fireworks. *The past was alive for Brian and he saw himself as part of a continuum.*

Recently Geoff has been more overtly political, in context at least of certain exhibition auspices. For *Outrageous Desire*, a show at Rutgers University during the week of a gay and lesbian symposium, two condoms, one filled with sugar, one filled with salt, flanking watercolors of three nighttime skies, were hung on a wooden coat hanger.

The Wiesbaden installation included a music stand that surely resonates with such body imagery, and yet is more fully metaphorical in the Hendricks style: the vertical body suspended between sky and earth. On the stand are two semicircular pieces of watercolor paper, painted skies on both sides, with the four faces of the moon. A baton rests there also. A pile of stones appears on the floor underneath. And above the stand hangs a small bell. In a little box called *Ring Piece*, dated 1971, Geoff placed his wedding ring and ten small bells. I can imagine a silence of acceptance in all these muted bells. *John Cage speaks of how when you fight sound, it is noise, but when you accept sound it can be music.*

1992

IV

Walking into Art

Near the beginning of his book, *The Kingdom by the Sea: A Journey around Great Britain*, Paul Theroux writes that his "route was crucial. It was the most important aspect of travel. In choosing a route, one was choosing a subject." Then he goes on, "And so as soon as I decided on this coastal route from my itinerary, I had my justification for the trip—the journey had the right shape; it had logic; it had a beginning and an end; and what better way was there to see an island than circumambulating its coast?"

Similarly, Richard Long lays great importance on planning the walks for which he is so well known and admired in the art world. Unlike Theroux, however, any route that is Long's subject is brought under the most rigorous formal control. It is not just the route of a walk that is his subject but the conditions he lays on a route, or the condition he imposes on his audience for perceiving his route—conditions so narrow and strict that they turn his "subject" into much more, or much less, than what one is usually given in traditional travel literature. When you see a "four-day walk," which is in effect "described" by means of some dark lines drawn over a section of an Ordnance Survey map (beautifully framed under

glass), and with a text or caption underneath containing nothing more than "Dartmoor Riverbeds/A Four-Day Walk along All the Riverbeds within a Circle on Dartmoor/Devon England 1978," you know that you're looking at "art," not literature, and that the walk indicated is an idea, an abstraction, not a journey meant to be shared.

You can of course use your imagination to picture his walks and try to re-create them (especially by means of his evocative and picturesque photographs, each one clearly meant to convey some representative aspect or mood of a walk or of the landscape traversed). But Long really draws your attention *away* from the walk itself and directs it toward the object he uses to signify the walk. The memento or document is the thing, not whatever the memento serves to remind us of. By means of an eloquent object (I'm partial to the maps) that contains information about a trip—location, time, distance, and/or a simple activity whereby he alters something in the landscape—Long is saying "I've been there," and that, apparently, is all we need to know.

Long is a kind of souvenir hawker on a grand or high-art scale. But he's also certainly some kind of photographer, and a poet of sorts (his printed texts—words disposed architectonically on paper—can be as evocative of his journeys as his photographs). He's also, more importantly, a sculptor. Actually, he displays an impressive mastery of different mediums, all derived from, and leading back into, his walks. A fair representation of Long's work was on view at the Guggenheim Museum in the fall of 1986 in an exhibition curated by Diane Waldman.

The exhibition included four stone sculptures and one mud drawing made for the Guggenheim space, as well as over forty framed works—photographs, maps, texts—that spanned Long's career from 1966 to the present. The centerpiece of the show was the large slate ring occupying a good portion of the Guggenheim's ground-floor space. Long brought the many slabs of roughly cut slate in from a New York State quarry, then laid them out in a doughnut shape. He made both outer and inner rims perfectly circular by using a pencil and string to outline them.

Within this geometric containment were set the haphazardly cut quarry pieces, overlapping in two dense layers. Long puts them down to conform to some "all over" structural principle that seems dictated by the materials and the general shape of the piece. These

in turn were suggested by the architecture. Long likes to echo the spaces where he shows. However, he is always guided by a canny sense of proportion, adapting the size and density of his sculptures, whether made of stone or the various other materials he lugs in from the landscape (e.g., seaweed, pine needles, ash, sticks, mud, driftwood, brushwood, or firewood), to the dimensions and shapes of his interiors. Certainly the red slate ring in its form and placement at the Guggenheim seemed not only a perfect complement to the museum's strong cylindrical aspect, but exactly the right size as well. Three other stone sculptures equally well adapted to the architecture were laid out in gentle arcs curving along sections of the museum ramp.

Like his other mediums—text, map, photograph, drawing—the stone sculptures refer to Long's walks, though they do so only indirectly—even less directly than the lines indicating walks drawn on his Ordnance Survey maps. Both the indoor sculptures and the lines drawn on maps are analogues of the walks, though the sculptures obviously also have a very concrete, much more abstract, life of their own. Almost all the map works include texts or captions identifying the particular walk. One can infer Long's walk from his sculptures by noticing similar sculptures featured in some of his photographic pieces— arrangements of stones and other materials that he makes in the landscape during the progress of a walk. Arranged in a circle, a line, or the occasional spiral, the stones, sticks, driftwood, or whatever often represent the original trajectory of his walking.

Included in the Guggenheim exhibition was Long's prototypical, or signature, work: *A Line Made by Walking*. It was done in 1967, when Long was still at St. Martin's School of Art in London. Walking up and down a field along one track he created a "path" of flattened grass. Then he took a picture of it. The path or line is vertically dead center in the photograph, its width diminishing as it leads away from the foreground and disappears into a distant grove of trees. There seems to be nothing about Long's subsequent oeuvre that is not clearly suggested by this ingenuous image. Indeed, in light of what followed, it has the numen of a manifesto. R. H. Fuchs, in his finely written catalog for the Guggenheim show, says he believes Long's *A Line Made by Walking* to be of equal importance to Malevich's *The Black Square*, "a grand abrupt statement canceling all previous art—a conviction that something was over

and there's no need to hang on." Long must have seen the piece as a "vision" himself. So many of his subsequent photographs commemorating his walks contain a line of one sort or another, made by hand or by foot, by either accumulating or removing things. Centrally placed in the picture, these lines stretch away from the viewer and the foreground toward a horizon of exotic mountainous terrain—the future of potentially endless walks spelled out in the first "goal" of English trees or forest that "receives" *A Line Made by Walking*. The walker is clearly the line, and the line walks toward its unknown future, a terrain yet to be charted or traversed.

By now Long has walked everywhere. The main body of his work has been done in England, especially in Dartmoor, where he enjoyed walking as a child with his grandparents, and around Bristol, where he was born and raised. He has also made walks in Canada, Africa, Mexico, Lapland, Iceland, Alaska, Ladakh, Nepal, Japan, Bolivia, Peru, Australia, the Andes, Holland, Scandinavia, Switzerland, and parts of America.

Long walks for freedom. "Behind my work," he has written, "is the idea that I have seized an opportunity, won a fantastic freedom, to make art, lay down abstract ideas, in some of the great places of the world." But Long also walks for sale. Or at least he sells the by-products. Does he make art in order to walk, or does he walk in order to make art? No doubt both, although the great privacy of his walks, and the love for walking cultivated in his childhood, suggest the primacy of walking for the sake of walking, and art as a means of supporting it. He has said, after all, that he considers the journeys themselves to be works of art. Like many English people, Long is enthusiastic about his solitude in extended walks through isolated terrain.

Long has occasionally had a walking companion in Hamish Fulton, who was at St. Martin's School of Art with him during the 1960s, and who makes work in some respects very similar to Long's (Fulton does texts and photographs but not sculptures). But Fulton has accompanied Long only to the most faraway places and only on nine occasions. Recently Long has also taken his two small daughters out to walk with him around the Bristol area. While pondering this article, I wrote to Long asking him if he would mind taking me on a (modest) walk. He wrote back to say he thought it was "not a good idea, for various reasons" for me to undertake a walk with him, "for the sake of an article."

While it was "the *idea* of a walk" that originally excited me about Long's work (I saw a framed map piece with one of his straight lines drawn over the map's topography indicating the length of the walk—an inch to a mile—at the Hayward Gallery in London around 1980), when I saw more of the work I wanted to look behind the scenes. I wanted to know what happens out there— how he does it, what he feels and thinks along the way, and what sorts of incidents occur. I found I wanted more of Long the person, so artfully hidden behind one of the most esthetically developed systems—his works are both abstract and pictorial, both minimalist and sensual—of any contemporary artist.

Long's printed texts of course reveal different kinds of things than the highly edited or condensed photographic works. Yet what they reveal are indeed just "things." Laid out in line or circle forms exactly like his stones and other landscape materials, his word-pieces are lists of things seen on the journey, their pattern on the page often conforming to the shape of the walk itself. *A Straight Northward Walk across Dartmoor* (1979) is a centered vertical text of twenty-nine entities encountered on the walk: Stone Row, Bracken, Cairn, First Sun, Ponies, Red Lake, and so forth. For *A 2½ Day Walk in the Scottish Highlands/Clockwise* (1979), Long laid his words out around the periphery of a circle, and if you want to "follow" his walk you'll read them "clockwise," as the title says: White Owl, Deer, Red Stones, Am Meadar, Allt A'Chama Choire, First Night, and so on, in this case twenty-seven items altogether. Again, the words evoke the idea of the walk but do not convey the experience of it. The experience is Long's personal affair: the work is like an elaborately tooled door, locked to outsiders, meant to stop you right there and engage your mind and senses with its fascinating surface of numbers, words, pictures, signs, and geometries.

So what is Long doing out there, behind the door so to speak, besides just walking and "making work"? According to Fuchs, Long has a very unromantic attitude toward his walks, and toward the exotic landscapes where some of his walks take place. Fuchs says "Long's walking has nothing to do with an exploration of the hidden splendor and mystery of Nature, or with a romantic, elegiac longing for a purity forever lost to our urban and industrial present." And Long has written that "the purpose of the artwork is not to illustrate . . . beauty but to give, as purely as possible, the idea of

the walk." He may be overwhelmed by the places he chooses to work in, and he may enjoy the fabric of country life that he sees along the way, but the great sights or interesting artifacts he encounters are simply incidental to the work as idea. Yet both the maps and photographs show a concern with what Paul Theroux described at the outset of his travel book as "the problem . . . of perspective. . . . How and where to get the best view of the place?"

"A view" per se is something that Long obviously enjoys. He has recorded enough spectacular ones, and his photographs are consciously composed and highly structured in depth. He loves layered perspectives. But more important to Long must be the whole prospect of the land in its essential character. Beyond Dartmoor and other parts of southwest England, Ireland and the Highlands of Scotland also bear traces he has left during his walks: stone cairns or lines or upended slabs that resemble toy megaliths or henges—and which, like so many of the prehistoric remains that also stud these areas, might be stumbled over and considered to have no known purpose or origin. Long says, "So now the country is crisscrossed with different works, enabling me to perceive the same place (England) at different times from different directions and from artistically different points of view." He likes surveying his country.

Much earlier, Daniel Defoe, in his *A Tour through the Whole Island of Great Britain* (1724), quite another kind of travel book, by the way, than Theroux's, wrote something that resonates with Long's interest: "in the course of this journey I shall . . . call it a circuit, if not a circle . . . in the plural, because I do not pretend to have traveled it all in one journey, but in many, and some of them many times over; the better to inform myself of every thing I could find worth taking notice of." Long in fact has a lot more in common with a writer like Defoe than with a contemporary travel writer such as Theroux, or the less recent Hilaire Belloc or J. B. Priestley. (Long feels no affinity with these literary figures, but he wrote me, "If I had to name a literary parallel for some aspects of my work, I would say Samuel Beckett, although I am not a literary person.")

Anyway, Defoe was truly the observer; his purpose evidently was to provide information about his growing nation, the burgeoning seat of empire—its customs, manners, occupations, and so forth. The journey as an emotional experience that leaves the traveler

somehow changed may be implicit in literature like Defoe's or work such as Long's, but what they both convey is the great impersonal survey, signifying a possession and a kind of exaltation of the land. Remarks like Theroux's, "There was so much of it ahead of me that I sometimes had the urge to cut and run—simply to get on an express train and make a dash to Wales, or fly to Scotland and forget Ulster," or Belloc's in his *Path to Rome*, "[O]n this repast I jumped up merrily, lit a pipe, and began singing, and heard, to my inexpressible joy, some way down the road, the sound of other voices," are quite beside the point to a traveler like Long, except, I presume, to himself.

While the whole world is Long's studio and canvas, England is where he begins and probably ends. And Long's England is hardly Defoe's or any other travel writer's of recent or more remote eras. Long looks way back, to some glorious period far predating the rise, decline, and fall of his grandparents' empire, when the kinds of monuments that inspire his work—the cairns, dolmens, barrows, megaliths, menhirs, mounds, henges—were, according to certain renegade astro-archeologists, laid out along networks of sighted tracks or "ley systems" in an ancient technology that took account of energy on the earth's surface, and the artificial modification of the terrain to express their geometric relationships with other centers. Geomancy was employed to discover the most suitable and correct sitings for places of worship. Some people think the whole of Britain was once organized geometrically on principles of energy and divination. Long, who feels that "art should be a religious experience," could be a kind of reincarnated geomancer, leaving his post-post-neolithic marks of passage in power spots of his own.

In case Long's affiliation is not clear, he gives himself away, in Fuchs's catalog at least, with a photograph of himself, dated 1969, "Climbing Mt. Kilimanjaro" in Africa, next to, on the facing page, an aerial photo of one of England's great Hill Figures—a figure made by cutting away soil to expose the chalk underneath. This Hill Figure is not identified in the catalog photo, but it happens to be called the Long Man and it's located in Wilmington in Sussex. The Long Man is dated loosely between the first and seventh centuries A.D. He's 231 feet high; he holds a staff in either hand. A year ago while driving in Sussex, I spied the white outline of this figure and jumped out of my car to take a picture of it. I had no idea what it was. But by the time I wrote to Long, I had compared it to

the "self portrait" in the Fuchs catalog and seen it in Lucy Lippard's 1983 book *Overlay*, which juxtaposes many examples of contemporary land art with prehistoric remains.

It seems likely, though, that Long identifies even more with another Hill Figure, the Giant of Cerne Abbas, located in Dorset, a figure also featured in Lippard's book. This "Giant" is the "protagonist" of one of Long's more unusual map pieces, a work called *A Six Day Walk over All Roads, Lanes and Double Tracks inside a Six-Mile-Wide Circle Centered on the Giant of Cerne Abbas*. Long has documented this walk on the Ordnance Survey map with lots of meandering lines strictly contained inside the invisible perimeter of a circle, and he has included a black rectangle with the Giant outlined in white superimposed at the bottom of the map. The giant, 180 feet high, is more individualized than the Long Man— he has markings for eyes, mouth, nipples, ribs, and overhead he wields a serrated club, itself 120 feet long. He also has balls and a penis extending 30 feet up his torso from the crotch. A banked enclosure to the upper right of the figure was once the site of May Day celebrations. Lippard writes, "A siteline taken up the Giant's penis on May Day points directly to the sun rising over the crest of the hill and toward the Maypole that once stood in . . . [the] enclosure . . . where the revelers greeted the day after a wild night."

Long's England is largely untouched by modern industry. Almost all his sites and shapes and activities recall the residual traces of ancient habitation or worship. Usually, no living humans are involved besides himself. He has a one-on-one relationship with nature. It would be hard to imagine him doing anything remotely like the American land artists who become steeped in protracted negotiations with contractors, realtors, government agencies, and construction people in the acquisition of land and building of works. Long's work is way beyond the reach of public authorities. He doesn't have to secure anything except a passport, camping equipment, and the money to travel. Certainly he doesn't have to arrange public access to completed works, much less provisions for maintaining work into the future. American land artists such as Michael Heizer, Walter De Maria, Robert Smithson, Robert Morris, James Turrell, and more modestly Nancy Holt have been developers, engineers of large permanent structures that might survive the end of our civilization. Heizer has said that he's interested in making a work of art that "will represent all of civilization to this point," and

that he strives for as much permanence in his works as he can afford. Long has said that he wants "to do away with nuclear weapons, not make art that can withstand them." He acknowledges a kinship with American minimalist sculptors, such as Carl André and Donald Judd; he rejects any connection with American earth artists. Heizer and Long make the most interesting study in contrasts.

Heizer is an American cowboy, romping through the desert, buying up land, doing "brutal work" with mechanical diggers and heavy trucks, bulldozing tons of rock and soil, living in dangerous conditions, struggling with authorities, and so on. Long is an English recluse, walking around the countryside, talking to nobody, reliving a pastoral childhood, enjoying the landscape as it is, leaving the kinds of marks on it that will sooner or later be reabsorbed, not allowing visitors to his sites of work, and so on. Long is much more the Process artist, Heizer the Product man. Nevertheless, I think too much has been made of the differences between Heizer and Long, and between American and British land artists. After all, they both share a love for ancient mounds and prehistoric stuff, and for the earth itself; and while Long's actual work in the landscape may be "impermanent," the souvenirs or "documents" he hawks are obviously intended to be as permanent as any other artwork. But where the art of one is *moving through* the land, the art of the other is standing his ground and planting himself in it.

Heizer inherits the territorial instinct of a native whose land is still up for grabs. Long comes from the muted land of lost empire, a land from which he inherits a pastoral romanticism as meaningful to his work as his more archaic references. Long identifies the power he wants or gets from the land in religious terms. Heizer expresses himself more materialistically. Long may be just as acquisitive, but his style is naturally more symbolic. He possesses the land by surveying it, and by removing tokens of it to show the people back home. Heizer has also brought chunks of earth or rock into the gallery, though he's never systematically developed an interior display that relates to his land works the way Long has. Heizer and Long are both involved in establishing "places" in art history.

There is nothing mysterious about what Heizer does. Long, on the other hand, has placed a mystery between himself and the observer: the journey he has said is the work of art. But the work is not the journey, really; it's the highly selective evidence of it. In this

he has little in common with any of the earthwork artists, whose work may be difficult to see or find, but whose documentary presentations are not meant as (testimonial) primary forms. Long's use of the document as an art object in its own right constantly refers back to the huge absences that each document signifies. This throws the viewer back on the work as idea, and if that proves insufficient, a certain curiosity and frustration will cling to the documentary object, which is not worked enough to sustain interest in itself. The absences then take on an independent life.

My tendency to pull Long toward travel literature, with which of course he has nothing in common at all, obviously represents my interest in these absences. In an interview with Martina Giezen (MW Press, Holland, 1985) I found an exchange that fit my sentiments nicely. Long answers a question; there is a pause; then he says, "Next question!" The interviewer responds, "I like silences in conversation," and Long replies, "It means people are thinking. Silences are when people are making coffee, putting a log on the fire or watching it burn. They are part of the outtakes. Do you know what outtakes are?" And the interviewer comes back with either an intentional irony or a mistaken impression. She says, "When people make a film (or interview) they leave out the best parts!"

At the Guggenheim press conference before his show last September, Long told me a great story about Africa. He said he was reading a book by a stream in Zambia when six young soldiers with guns jumped out of nowhere, bundled him into a Land Rover with a gun in his ribs and took him to their chief of police. This very big police chief checked his passport suspiciously. Apparently it was unprecedented for a white person to be on his own in the bush. Long explained his purpose, and the chief believed him—that Long was an English artist walking through the country by himself. The chief wrote a letter on official police paper in "funny English" saying he was allowed to be there, and told him to show it to each local chief. A few days later more soldiers jumped out at him and he presented the paper. The next morning the same soldiers jumped out and read the paper again.

It's tempting to try to picture the chief's letter in one of Long's frames, behind glass, on a gallery wall. There are, out of the 254 works by Long illustrated in Fuchs's catalog, several personal emblems of his treks: a photograph of two washcloths (strung on a wire cable in Nepal), of a canoe and paddle (from a river trip on the

Severn), of a flattened area of grass near the edge of a lake where clearly Long's tent had been pitched the night before—*and*, wonder of wonders, the tent itself—shown on the Sierra Nevada in Spain, surrounded by upended slabs of stone, possibly a "sculpture" he erected to protect himself from something or other. (Long wrote to me that the first time he went to Africa, in 1969, walking in Kenya across the plains to climb Mount Kilimanjaro he had to wait two days for a pride of lions to move away.)

Anyway, I would like to see the chief's paper, and I would like it as an object under glass too. But rather than imagining the enlargement or adjustments of his "harmonic system" it would take for Long to accommodate this kind of image or information, I prefer to think of him going outside his system altogether and writing his memoirs. In lieu of that, and of the possibility of taking a walk with him, I might locate the route of one of his walks (one that goes in a straight line, of course) and take it on my own, hoping to stumble over his and other prehistoric remains along the way.

1987

Tracking the Shadow

In a 1987 show at the Castelli gallery of Jasper Johns's latest work—four largish paintings titled *The Seasons*, with a number of drawing and prints related to them—one detail eventually caught my attention, occluding all others. The most obvious feature in these four paintings is Johns himself, represented by his shadow, cast life-size onto the canvases, worked from a tracing drawn by a friend. The same silhouette, painted in rich grays, appears in each Season—*Spring, Summer, Fall, Winter*—tilting left to the same degree.

This four-part work is as literal as anything Johns has done. *Spring*, for instance, is marked by diagonal streaks of white paint crossing the whole canvas and indicating rain; *Winter* is dotted all over with white snowflakes and even has a stick-figure snowman in it. In *Spring*, birth is clearly signified by the centered shadow-form of a child (inside a rectangle) directly underneath the looming, tilting shadow figure of Johns. The child's head, cut off just above the ears, slashes across Johns's body right below the crotch, separated only by its variant gray color and the top horizontal of the rectangle containing and cropping the child's head.

172

Fall literally depicts a fall. Here Johns has cut his shadow length-wise in two; a portion of him disappears off the left edge of the canvas and reappears, as it were, on the right, both halves separated by a central vertical "panel" portraying a number of tumbling objects, including the ladder that elsewhere had held them all up and together by means of a rope and that has now broken in two.

The detail that eventually commanded my attention is one of these objects—the section of a painting appearing in each Season and referring to a series of paintings from Johns's 1984 show at Castelli Greene Street. This section, consisting of jigsaw puzzlelike shapes fitted together and made discrete by directionally opposed stripes, is contained by a rectangular frame; it is a section of one of Johns's own paintings, which appears partially obscured by other objects in every Season. The catalog essay to the recent show, by Judith Goldman, and reviews I read, identified it as a fragment from Grünewald's *Isenheim Altarpiece*. What fragment? I became curious to know. Barbara Rose, surely an authority on Johns, was more specific than most: she said it was a detail from the Resurrection panel of the Altarpiece.[1] At first, however, I was preoccupied by the two things that most clearly presented themselves in these new paintings: the shadow itself, said to be Johns's first use of the whole figure, and his various quotations, of himself and others.

Quotes of his own work constitute nearly all the objects in *The Seasons*, and these include not only his own past paintings or parts from them but other objects he possesses and has collected, such as his George Ohr pots, which have also been represented in past work. The two most readily recognizable images from his own oeuvre are the Mona Lisa and the American Flag. These would go back the farthest, except for the arm/hand imprint that inscribes a half-circle in each Season, which dates back to 1963 and is usually associated with *Periscope (Hart Crane)* of that year. In *The Seasons*, this image functions like the hands of a clock. The hand points upward in *Spring*, horizontally to the left in *Summer*, three-quarters down in *Fall*, straight down in *Winter*. Inside its circle, it weights each work like a big dark pendulum, partially visible as it "swings" from painting to painting.

The four *Seasons* represent Johns in his studio (or studios: he has four of them), a developing theme of his in the 1980s (e.g., *In the*

Studio, 1982), and here done up in spades, though not in a narrative context the way Picasso showed himself walking into his bedroom in *The Shadow* (1953). While the viewer can imagine a degree of environmental depth in the four *Seasons* paintings, Johns has really assembled himself and his belongings in collage style on a flat plane.

If the paintings are literal in many ways, they're still not naturalistic. As Barbara Rose has pointed out, Picasso's 1953 painting of himself as a shadow entering his bedroom was a totemic source for Johns's new work. Another source for Johns was Picasso's 1936 *Minotaur Moving His House*. Both Picassos represent the artist's possessions, outstandingly his woman of the moment—recumbent on her bed before him as he enters his door in the *Shadow* picture; and as a horse giving birth (said to represent his then mistress, Marie-Thérèse Walter), head lolling out of the cart he drags (himself as Minotaur) in the *Minotaur Moving His House*. From this picture Johns appropriated a number of elements, most conspicuously the ladder with a rope around it holding up a painting; and the yellow stars, more like flowers or starfish, actually, in Picasso's sky. Also, the wheel of the cart appears in a number of drawings and prints from the *Seasons* show, and at one remove as the "pendulum" in the paintings. A branch, also from the *Minotaur*, overhangs each of Johns's scenes: budding in *Spring*; bearing leaves in *Summer*; withering and broken in *Fall*; dead in *Winter*.

Prominently absent of course from the Johns paintings are the parturient horse and recumbent nude, though in *Summer* Johns painted a whimsical reminder of the former in a little sea horse, a rare species in which the male bears offspring. This information[2] points to the Johns shadow-form in *Spring* clearly parting from the child's shadow directly beneath him. But there are several images of women in the Johns pictures: the Mona Lisa (*Summer*), Queen Elizabeth (her silhouetted profile facing Prince Philip in profile and forming the image of a vase between them in *Spring*), and the trick double image of a lovely girl/ugly crone (also in *Spring*), which could seem to invoke Picasso's general exploitative use of women but was doubtless not intended by Johns to do so.

I saw Johns near the end of February 1987, while his show was still on; then I went to Europe. I asked him some questions and he told me nothing, really. I've known him since 1960, and this is the first true interest I've taken in his work. Which is not to say I

haven't liked and admired it, even wished to own it, or have it on loan. Anyway, I've known him much better than his work, and I hardly know him at all. There are people who know him a lot better than I do who might say the same. A typical critic's or interviewer's remark is, "Johns doesn't wish to confide . . . still less to confess." In my new role as "interviewer" I found him more guarded than ever, yet, as always, fun to be with. He was fun even though his back hurt and his right (painting) arm was in a cast. We laughed about silly things. Having just realized how involved his work has been through the years with various poets and literary figures— O'Hara, Crane, Stevens, Beckett, and Céline—I told him I don't like poetry. He smiled, knowing I was putting him on while perhaps also telling the truth. He said I suppose you don't like singing either and I replied of course not, except for Frank Sinatra. Then we laughed.

I asked him why he kept for himself his *Fall* painting from the group of four (I had read in several accounts that he did), and he said because there were two left and that was the one he was working on. I remarked on the, to me, amazing coincidence between the accident in which he broke his arm and the main detail in his *Fall* painting. In the central vertical shaft of the painting all his possessions are tumbling to the bottom, the rope that bound them to the ladder and the ladder itself having broken. And this is the painting in which his shadow is split lengthwise. Johns broke his arm in Saint Martin, where he has a studio, not long before his show opened; he was standing on a tall ladder pruning a tree, and a rope that had bound a branch to another tree loosened somehow, causing the branch to boomerang and throw him to the ground. He said he didn't make the association himself between falling and the *Fall* painting, but that others had.

In her catalog essay to *The Seasons*, Judith Goldman asks: "Johns as Picasso's stand-in?"—referring to Johns's self-portrait as a shadow—"This seems inappropriate for an artist who throughout his career has kept art and life separate." What must really be meant by such remarks is not that the artist has kept his art and life separate—how is that possible?—but that the artist has disclosed little or nothing to connect the two, either in the work itself or in commentaries about it. Johns is famously associated with the phrase, "Not mine but taken." To avoid the personal ("I didn't want my work to be an exposure of my feelings"[3]), he painted public icons

or found objects—targets, flags, numbers, etc.—with which the spectator has so many associations that the object becomes, in an important sense, meaningless. Conversely, and to the same end, he built up a self-referential body of work, subjecting the spectrum of public icons that he'd made his own to a variety of treatments, to interact with themselves in different mediums and to evolve in relation to each other over time.

Johns's strengths have been in his ever-rich and subtle handling of paint, the sensuality of his surfaces, and the intellectual plays he has conjured between what is seen and what is known. He asks, in his way, if you know what you see, or whether you have ever really seen it, or, perhaps, whether once seen you can ever forget it. Johns's flag, after all, is now almost as assimilated as the flag he copied. Here it is again, he seems to keep saying, in another con- text—new colors, sizes, settings, bedfellows—and though you might not see it anymore, you surely can't forget it. It belongs to Johns now. It's both America's and his—quite a coup. "Not mine but taken." The theme of his recent show appears to be a sym- phonic meditation on his possessions, which include of course his many complex references to those artists whose work he has admired and in certain cases—chiefly Duchamp and Picasso—would aspire to enter artists' heaven with. All "taken," even his shadow (in two senses: from Picasso, and from a tracing), all very easy to know (the ambition at least is wonderfully clear).

Except for that damned fragment from the *Isenheim Altarpiece*. Grünewald? Where does *he* fit in? There are associations in Johns's work with Leonardo da Vinci and Dürer, and the nineteenth-century American Peto, and with Redon and more recently Munch, but otherwise Johns has made his claim to the modernist tradition through the mixed and "proper" genealogy of Cézanne, Picasso, Duchamp, Magritte, and Pollock. The Christian reference (altarpieces?) struck me as practically neolithic; and while, once known, the reference was dutifully repeated, no critic had really touched it.

I flew to Europe armed with glossy black-and-white reproduc- tions of paintings from Johns's 1984 show, along with photocopies of all the reviews. I had not asked him about the Grünewald detail because it still seemed unimportant. Of the dozen or so reviews I had with me, I found exactly five specific descriptions of the detail in question. These were very brief, and in her 1984 *Vogue* piece,

not even Barbara Rose mentioned it. Then I decided it was impor-
tant. John Ashbery in *Newsweek* made the safest and in the end
most accurate (as far as it went) description. He said, "In *Perilous
Night* . . . there are . . . almost illegible outlines copied from the
drunken soldiers in Grünewald's Resurrection." John Russell in the
New York Times blended his data, imagining understandably but
mistakenly that what was in one painting was probably in others
that were similarly patterned. He said, "We could scan the painting
called *Perilous Night* quite closely and not guess that both there
and in *Ventriloquist* and *Racing Thoughts* there is an echo, faint
but distinct, of a figure of a sleeping Roman soldier from Grünewald's
Isenheim Altarpiece in Colmar, France." Similarly, Roberta Smith
in the *Village Voice* said that "details abstracted from the Resurrec-
tion panel of Grünewald's Isenheim altarpiece dominate the left
side of *Perilous Night*, *Racing Thoughts*, and an *Untitled* painting."

Jeanne Silverthorne, the reviewer in *Artforum* (Summer 1984),
was fanciful in another way: "In *Perilous Night* . . . while one of
Johns's two reworkings of Grünewald in this painting keeps the
sword of the stricken soldier in the resurrection scene in its original
position, the other (there are indeed two entire figures of the soldier
in *Perilous Night*, unnoticed by anyone else) moves it so that it
would, if extended, intersect with the risen Christ precisely at the
wound in his side."

Richard Francis, in an article in *Art in America* (September
1984), noted that "*Perilous Night* . . . carries a detail of an image
taken from Grünewald's Isenheim Altarpiece." In his book about
Johns of the same year,[4] he assumed, like Russell and Smith, that
this detail—the soldier—appeared in other works, however obscured
by cross-hatching.

In London I had no time to pursue the question, but in Copenha-
gen at the end of March I went looking for reproductions of the
Altarpiece to locate this soldier. Certainly without the original I
was unable to find him in the black-and-white photos I had with
me of paintings by Johns from the 1984 show, and I was missing a
reproduction of *Perilous Night*. The Academy of Fine Arts Library
in Copenhagen had no coherent rendering of the Altarpiece. I
ended up seeing a clear reproduction of the Resurrection panel at
the home of the art historian Charlotte Christensen, in a small book
dealing with Christian symbolism. I was lucky. One of my black-
and-whites, called *Untitled*, one of at least four *Untitled* pictures

Johns made in 1984, had mysterious figuration in it that could be compared to the fallen foreground soldier in Grünewald's Resurrection panel. There it was, very precisely delineated once you've located it. The soldier has just fallen, his right leg is still off the ground, his left arm is raised overhead, head turned toward the viewer, as he shields himself from the brilliant light of the rising Christ. Another helmeted soldier leans over him, about to fall across his body it seems, but he doesn't appear in the Johns tracing in *Untitled*. He does, however, appear in the two renderings of the Resurrection detail in *Perilous Night*, as Ashbery indicated; I didn't see *Perilous Night* till I returned to New York at the end of April. Now, in Copenhagen, I imagined my small search to be over. Like Russell and others, I believe I assumed that the soldier was depicted in these other works but in some fragmented, further removed way, making him quite illegible.

I was driving with a friend, south then west through Germany toward Paris, and I decided to make a detour and visit the Altarpiece in Colmar, a city in the Alsace-Lorraine region of France. The Altarpiece resides there in the famed Unterlinden Museum. Colmar is very pretty, and the Altarpiece is definitely worth a detour, but I found nothing further that would illuminate Johns's use of it. I took pictures and bought postcards and drove on to a town south of Paris to visit Teeny Duchamp.

I asked Mme Duchamp almost immediately if she had been to Colmar. She said she and her daughter Jackie had gone there to see the Altarpiece with Jasper in 1984—she thought it was 1984. Back home I discovered that *Perilous Night* was painted in 1982. I knew I had to see him again. Besides, I returned to Castelli's and obtained more reproductions along with all the reviews I hadn't seen of the recent *Seasons* show. The Isenheim detail, so-called, in the four *Seasons* paintings, does not resemble in its handling either the tracing of the soldier in *Perilous Night*, where it floats as a purple outline on or within a sea of black and white paint, nor does it look like the patterning of the soldier tracing in *Untitled* (1984), which is embedded in freely painted stripes that run through the figure all one way, broken into darker and lighter areas. The *Seasons* detail most closely resembles the jigsaw-puzzle patterning, areas with directionally opposed stripes (not technically, as was commonly noted, in Johns's earlier crosshatch style), that occupied the left-hand side of *Racing Thoughts* (1984). This was the side that also

contained the photo of Johns's dealer, Leo Castelli, as a young man (itself in puzzle pieces), and a rendering of Johns's pants (some saw a towel) hanging next to it. On the right side of *Racing Thoughts* appears the Mona Lisa, and a kind of logo from the 1984 show: the skull and crossbones with its warning, "Chute de Glace"—beware of falling ice, which was painted in variations into many of the pictures. Certainly the overwhelming impression from that show was of death and disaster. Anyway, the Isenheim update, if such it was, in *The Seasons* looked taxonomically related only to this expanse of jigsaw motif in *Racing Thoughts*.

Now I examined the jigsawlike motif in two of the *Untitled* 1984 paintings and found some shapes that had to be the same, and in identical relationship to each other in the three works, however much they differed in size or design. And in two of them you can see the same "eyes." In one, these eye forms surround the skull and crossbones and can be read as ghosts or scary night creatures. By now I had reproductions before me of two more of these *Untitled* works, one 1983, the other 1984, both included in Richard Francis's book. That made five altogether, and I was certain there was no soldier there. I got excited. I suspected I was on to something. This time when I saw Johns, I brought all these glossies, books, notes, reviews, and pictures and postcards from Colmar.

I met him at Da Silvano on lower Sixth Avenue. There's a dividing brick wall in that restaurant, and I arrived first and was seated on the far side as you enter the door. I waited and drank coffee. After a while the waiter came over and told me he thought perhaps the person I was waiting for was already there. He was. He was sitting on the other side near the door, in the same corner position against the wall drinking a beer. That got us off to a good start— laughing. Still laughing, he said, "*I'm* not going to tell you anything." But he did tell me he had been in Colmar *before* 1984, when he went with Teeny Duchamp and her daughter. And that a friend had sent him a big book with reproductions of the Altarpiece, which he loved. He sent a tracing of a detail to the friend and that evidently got him going. At length I threw my cards on the table— the glossies, pictures, postcards, etc.—and more or less demanded to know if these patterns in the *Untitled* works and in *Racing Thoughts* were variations on the soldier. He said no, they were not. I said well, what are they then? He didn't answer. I ran down the panels. I didn't think it would be from the Crucifixion or the

Annunciation or Nativity or Lamentation. Could it be from the Temptation of Saint Anthony? He thought it was. He wasn't sure. I had those two postcards at home: one shows Saint Anthony (Abbott, fourth century) in a long white beard talking to another old man, Paul, in the desert; in the other, Saint Anthony is being dragged by his scalp into the scene of his temptations—a Boschian phantasmagoria of monsters and devils.

At home I spent more than an hour trying to locate a detail in the two Saint Anthony pictures that might match the pattern in *Racing Thoughts* and the five *Untitled* works—the fragment in the four *Seasons* paintings still itself of course unidentified. I found nothing. These Grünewald pictures are teeming with details. As are the Johnses. I called Johns and tried to pin him down. He was irritated now. He was busy, he couldn't remember, and the information was in the country. I went for it anyway; I said, "Look, there's Anthony in the long white beard being hauled off . . ." There was a brief diversion. He remembered a Gertrude Stein line: "Stop stop I did not drag my father beyond that tree." I remembered the Stein title, *The Blood on the Dining Room Floor*, and he said he had that book and he never read it, and I replied likewise. Then I said, is that it, is it in that particular panel—Saint Anthony sprawled in purgatory? And he said yes, but it's skin. I thanked him and we hung up.

Skin! I spent more time looking, turning the glossies this way and that. I laid out the color reproduction of *Untitled*, 1983–84, in the Richard Francis book. The left side of it is consumed by the design, in purples, grays, and whites. I turned it upside down. I put the postcard right next to it. Johns is a very literal guy. The whole figure in the bottom left corner of the Saint Anthony Temptation panel took form in front of me like a picture in a darkroom being birthed out of emulsion, in the bottom left corner of the Johns jigsaw motif—as viewed upside down. I'd located it by concentrating on the outstanding feature in the corner of a three-pronged "claw." The figure is the only human in the panel besides Anthony, though he has an animal characteristic of webbed feet. He's a devastating creature. He has a long sort of fool's cap, his stomach is bloated and ballooned, all his skin (the *skin!*) is marked with pocks, an appendage or arm raised over his upturned head ends in a stump, he's clearly diseased and dying (according to legend, by the way, Grünewald died of the plague in 1528; the Altarpiece is dated between 1512 and 1516). I quickly found the creature in *Racing*

Thoughts, then in the other *Untitled* works (except that one with the soldier), and then as a fragment even in the four *Seasons*. The bent leg with pocks on it (the "eyes" I saw were the pocks on his stomach) is clearly visible in *Fall*.

I felt very sad finding this figure in the Johns painting. There's great pathos somehow in the carefully hidden and precisely copied forms of this dying creature-person, who appears as overcome by the scene before him—Saint Anthony and the monsters—as does the fallen soldier in the Resurrection panel, stricken by the "blinding" light of the ascending Christ. Then, if you turn the *Untitled* 1983–84 right side up again, you see, in the far right side of the painting, that double image of the lovely girl/ugly crone, the crone suddenly becoming the conspicuous one, assuming a compassionate role of guardian/seer/witness over the "tragedy" in jigsaw. And there she is again in two other *Untitled* works, also overlooking the scene, this time a mirror image of it, though still upside down. In *Untitled* 1983, the skull and crossbones in black on white is the opposing image on the right. That leaves *Racing Thoughts*, with the puzzle pieces forming a ground to Johns's pants and the photo of Leo Castelli as a young man. The Grünewald figure is in the same position, upside down, his distended stomach obscured by the pants, his female "guardian" to the right, here the Mona Lisa, half of the skull and crossbones visible off to the far right of the picture.

"Not mine but taken" acquires new meaning. What's been taken here is either meant not to be seen or meant to be extremely difficult to see. There's a striking sort of inversion here: in early Johns, the public icon (flag), known by all, is apparently divested of personal meaning and rendered highly visible; in recent Johns, another public icon (the *Isenheim Altarpiece*), unknown to the viewer off the street but charged with personal significance, is rendered invisible to an ignorant public. It's hard to equate "America's and his" flag with "Grünewald's and his" soldier and victim. Gone really is the play of confronting people with images so familiar that they've become invisible, then turning them into something visible (*familiarly his*) again.

Yet Johns's subject remains concealment. The nature of the concealment has changed a great deal. What was once a kind of game—an intellectual expose-and-seek with objects captured from the public domain—has become more seriously personal. Johns's use of the Grünewald masterpiece and much more symbolic

(however nearly obsessive) deployment of double or trick images in his work of the 1980s show an artist tantalizing both himself and his public with vivid subject matter. He might be nearly there (i.e., ready to expose himself), but his cover is still very important.

The shadow itself is a cover. Though all reviewers of *The Seasons* felt constrained to use the word "autobiography" to describe paintings featuring the full-figured tracing of the artist's own shape, which hovers over an obvious collection of the artist's possessions, and is hence additionally autobiographical, the surfaces of the works are no less compelling than before. That which meets the eye is a dazzling symphonic variation in four movements on the theme of time and property. The symbols are all in place—we recognize the appropriate signs of the seasons as well as the tokens of Johns's past work and the new form of self that endures this passage of time. But the mere projection of the artist's shadow along with his possessions, enduring a condition as general as the passage of the seasons, is not autobiographical per se; rather, it's the hint of the intimation of the kind of disclosures we associate with autobiography. A shadow is a figure still in darkness, sheltered and protected. It represents the *absence* of illumination. Johns has painted it beautifully—another beguiling concealment of self.[5]

Vying with concealment as a leading motif in Johns's work must be an increasing drive to express himself more openly. His recent association with Munch seems to signify this desire. His references to the human figure, foreshadowed in his *Weeping Women* (1975), after Picasso, and his *Between the Clock and the Bed* (two versions, 1981 and 1982–83), after Munch, indicate some conflict and pressure. Revealingly, Johns said to me, "I resent my continuing dependence on preexistent forms." He said this after I inquired about the "freely drawn" images in his new work. Obviously the "starfish," the branches, the tiny hummingbird are freely drawn. But only the hummingbird is "invented," the others having been "taken." Johns is a master of the secondhand. Entering art history through a milieu that encouraged his theft of the already used, and as an artist who was virtually self-taught, he finds himself now perhaps in a position in which he has made his mark and his fortune doing work that may no longer be adequate to fulfill his expressive needs. Directly after he said he resented his dependency on preexistent forms, I remarked, "Isn't it fortuitous that—" and he finished my

sentence, laughing uproariously, painfully I thought, "—that I would pick up tracing?"

His tracing in *Perilous Night* of the soldier from Grünewald's Resurrection panel was vitally new secondhand material. He tagged the work for meaning, opaque as it was to the general viewer in its submerged tracing, with his title, after a John Cage composition of 1945. In case the title wasn't enough to make the Cage reference clear, Johns incorporated into his painting a page, partially obscured by the hanging cast of a forearm/hand, from Cage's score, including a bit of the title itself: "The Perilou . . ." as well as the composer's name: "J. Cage." Cage has been quoted as saying that his *Perilous Night* was concerned with "the loneliness and terror that comes to one when love becomes unhappy." It was written the same year he separated from his wife of over a decade (Xenia Kashevaroff), and it represented a turning point in his career. He was dismayed by its critical reception. One critic, for example, writing that the last movement of the work sounded like "a woodpecker in a church belfry," prompted Cage to say, "I had poured a great deal of emotion into the piece, and obviously I wasn't communicating this at all. Or else, I thought, if I *were* communicating, then all artists must be speaking a different language, thus speaking only for themselves."[6] Within the next five years Cage would clear himself of such emotional dilemmas by placing his music insofar as possible outside himself. He became the original secondhand sound man, with influence far beyond the confines of music.

Johns met Cage in 1954, the year he met Rauschenberg, and for several years, Cage and Merce Cunningham, Johns and Rauschenberg were close friends and supporters of one another's work. Eighteen years older than Johns, Cage was a man whose authority, coupled with the earlier example of Duchamp, would be decisive for the modifications Johns and Rauschenberg would be able to make on the then prevailing and highly personal abstract expressionist esthetic. Between 1955 and 1960, Johns applied the gestural, painterly stroke of that school to subjects that were otherwise alien to it: the flag, targets, numbers, the alphabet, and so forth. It would be hard not to see Johns making a strong statement when he reached back, in 1982, for the older man's discarded expressive work in the instance of Cage's *Perilous Night*.

But as literal as he may be in his references, Johns keeps an ironic distance from his audience. There is a presumed irony in Cage's

title reference to the *Star Spangled Banner*, but Johns is clearly ironic himself in his submergence of a loaded subject, the smitten soldier at Christ's tomb, who was indeed a witness to the outcome of a certain (other) "perilous night."

Johns scoffed at me when we were having lunch at Da Silvano, when I made, I suppose, the mistake of telling him what I saw in two other paintings of his that he tagged by the use of another man's title: Munch's *Between the Clock and the Bed*. He had already told me the Munch work moved him. He once told someone that he sees a thing and then paints it, and other times he paints a thing and then sees it. He saw the crosshatch motif that he had used throughout the 1970s in the patterning of Munch's bedspread. Johns transposed the motif to his own works after the Munch, placing it in the same lower right-hand corner as Munch did. In the Johns it seems like a signature, in diminutive strokes, conspicuous on a highlighted ground yet overpowered by the broad striation of hatching that covers the whole canvas, and that is very similar to his 1975 *Weeping Women* (after Picasso), also done in three flush vertical panels.

It was his division of the work into three distinct vertical forms, light areas alternating with dark, that made me say I saw the three distinct shapes in the Munch work abstractly in his own (Munch's full-length self-portrait with his paintings behind him on the wall, flanked by a grandfather clock on the left and the bed and its spread on the right). "Well, Jill," he said, laughing hard again, "if that's what *you* see . . ." So much for his audience. He isn't inclined to help by either denying or affirming, and he enjoys teasing. But more interesting here no doubt was what originally moved him. He did say he was struck by the coincidence of finding his own motif in the bedspread. Perhaps that induced him into the Munch painting's subject: the very affecting self-portrait of the artist as an aging man, tired and resigned yet erect and heroic, standing before representations of his work.

Johns's first painting after Munch was done one year before *Perilous Night*. Once the soldier in the latter is "read," what might have seemed the arbitrary element of three forearm/hand casts, dangling across the top right of the picture, might now also be "read" in relation to the smaller tracing of the soldier, appearing in this case right side up, and being nearly touched by the fingertips of two of the cast forearm/hand parts. The same is true, for me at

least, of the relationship of crone to victim, once the victim has been "read"—in the *Untitled* works. And in *Perilous Night*, because Johns has taken his soldier out of context, retaining the other falling soldier, who leans over his recumbent one, the falling one who leans over could be imagined as attendant and concerned, and not falling at all. So there are two hovering, caressing elements over the smitten soldier: the one who "falls" on him and the fingertips just above the latter. And one set of fingertips, with its hand and arm, is tellingly laid down across a representation of a Johns (crosshatch) painting, the other across the silkscreen of the Cage score, flush to the Johns. Then—how could you miss the symbolism of the handkerchief nailed to a stretch of paling or wood graining below? Johns's source in the Cage score becomes more cogent: a death (of some sort) or a separation was perhaps involved too.

A similar connection between art and biography has been made concerning Johns's 1961 painting, *In Memory of My Feelings—Frank O'Hara*. In a provocative 1984 essay about Johns, two Englishmen, Charles Harrison and Fred Orton, drew what might still be considered unseemly personal inferences.[7] They noted that Johns and O'Hara were friends until 1966, when the latter tragically died, that the O'Hara poem, *In Memory of My Feeling*, written in 1956 and not published till 1967, was dedicated to the painter Grace Hartigan (one of two women, they said, that O'Hara, a homosexual, loved), with whom O'Hara fought in 1960, and from whom he became irrevocably estranged. Harrison and Orton speculate that Johns used the O'Hara title to express feelings of his own over his estrangement from Bob Rauschenberg during 1960–61. They quote Calvin Tomkins[8] on the breakup. They describe the O'Hara poem—an "inventory of feelings, and an assertion of the need to express them," and "images of death" recurring "throughout the poem." Then they ask, "So can we connote death from Johns' painting?" and conclude, "It seems so. The words 'DEAD MAN' appear in the lower right of the canvas." But these words are impossible to see. With magnifying glass I can just barely find a trace of them in reproductions myself. However, they are there.

I asked Johns about the words, mentioning the essay by the Englishmen, and he cast me one of his long, suspicious glances, saying, "How did *they* know the words are there?" They did of course note that the words are "veiled, camouflaged by busy grey

brushstrokes." To me the words are spooky, given that the painting was done in 1961, five years before O'Hara died. Anyway, it was not the objective of Harrison and Orton to expose lives, but rather to bring forward expressive aspects of Johns's work that have been overlooked. "To discuss the vivid surfaces of Johns' work, we suggest, is in itself a relatively uninteresting pursuit. What is significant is that they seem to show how a vivid surface—as the apparent technical 'arena' of the Modernist dynamic—can carry vivid subject matter while, as it were, pretending not to do so." And in sympathy for Johns: "We might say that the ambitious artist of Johns' generation (and since perhaps), who knows his or her Modernism and understands what 'American-Type' painting has to be in order to succeed as Modernism, has a real problem if he or she wants to express and to deal with subject-matter and to express feelings as subject matter."

It's a long jump from *In Memory of My Feelings* of 1961 to *Perilous Night* of 1982. Harrison and Orton rather quixotically say that Johns returned, "after years with numbers and letters," to "human figuration" when he painted *In Memory of My Feelings*. But of course the figuration there is wholly allusive and symbolic. The weight of feeling implied by the title was carried by the loose gray/dark (i.e., stormy-cloudy-overcast-murky) paint surface.

If his surfaces earlier carried the burden of expression, Johns's emerging figuration, now literal and embodied (however unavailable), could place him in a tradition linking him legitimately or convincingly with Picasso, Munch, et al. Yet it's easy to see that he might abandon these tracings as experimental. He has perhaps the sense that what he "takes" could be difficult or impossible to convert into expressive available currency. He might then have to "give" something he won't, or can't. More daunting, no doubt, is any prospect of drawing the figure freely. As things are, the use of puzzle pieces is itself revealing. The direction he might take next could be a puzzle to him. Yet we may also imagine that Johns has obtained a private pleasure here, turning public and critics into fools. He's like a jewel thief who makes a spectacular heist and who then reads the papers day after day, basking in the public's tremendous interest and ignorance, and the police's unsuccessful pursuit of clues. It's a type of onanism—a public exhibition of a masterful facade, concealing some intimate design or activity. It's also the act

of a great magician. Altogether, *nine* of Johns's pictures have featured this incredible little person (victim) in the Grünewald Saint Anthony panel, five of them prominently, and he has made at least three explicit renderings of the soldier from the Resurrection panel—and perhaps more that we don't know about.

In his recent show, he has given us his shadow to contemplate, his possessions and his tricks (double images) and surfaces to admire. And while the "Isenheim fragment"—the Saint Anthony creature—is in there, it or he has now been rendered quite unreadable as well as contextless, except in structural or formal relation to the other elements in the work. The emotional connection or moment is over, for Johns and for us, though differently for each. It must have been meaningful for Johns; and we never got it. Yet his (private) moment, surely something far richer for him than the mere pleasure suggested above of relishing the public's ignorance, must be somehow seriously qualified by his refusal or inability to be more direct. Johns has a relationship with his work that is exclusive, or that leaves out a great deal in its final embrace with the public. I remonstrated with him when I saw him, identifying myself as just a spectator off the street (i.e., how am I going to get it?). He protested in turn that I was *not* just a spectator off the street. I said but I was, and I had to go to a lot of trouble to decode this mystery, and I still had not done it (we were talking in the restaurant). And then after a while, he registered his final complaint—in a tone of triumph, I thought. He smiled and said, "But you *aspire* to privilege." There was a slight pause. Then I replied, "Well, yes, I do" (which he laughed over deliciously)—and I can't remember what I said after that. But later I thought he'd made a gilt-edged remark. Privilege, certainly, means everything in relation to his work. He isn't giving himself away to just anybody, and the privileged information that some critic or other obtained in 1984 (perhaps Rose, for a start) about the *Isenheim Altarpiece* easily turned into a Rashomon botch of things. This may be interesting in itself; it may also serve to divert attention away from the artist's own feelings, toward which any substantially accurate information will, in a case like this anyway, lead us. There was no way to appreciate all that "religious" (or personal) subject matter when it was not clearly identified.[9]

While Johns keeps his public at bay, he toys with it as well. He offers suggestive subject matter, which he short-circuits with tricks

and deceptions. His ambivalence seems extreme, though conceal-
ment still reigns over its opposite. If this is a problem, it inheres in
the tradition of detachment that surrounded his formative years as
an artist. The masking of feelings, especially uncomfortable ones,
was a goal at the core of the neo-dada esthetic led by Cage and
inspired by Duchamp. Nor did the modernist esthetic offer a vehi-
cle for the personal. Yet in Johns's use of the Grünewald figures, we
can perhaps guess that he found some grief difficult to share. If this
is true, it represents the autobiographical content that we were
unable to see in his 1984 show, and that has gone underground in
The Seasons. I read *Perilous Night* as a scene in which one man
gently attends the plight of another. I read the Saint Anthony
creature as a projection of both victim and witness (e.g., the artist),
overcome by death, or by dark forces. This figure elicits a sense of
horror and compassion. It's too distinctive, too particularized, too
human not to imagine that the artist made some strong emotional
identification with it. But equally evident, in retrospect, at least, is
Johns's interest in concealing, or not sharing, his involvement with
his subject matter. What we can share, perhaps, is a special moment
in an artist's career, as we watch him poised between his use of
"preexistent forms" and some aspiration to break way from them,
or to risk their deployment in more available modes, if that seems
possible.

1987

Notes

[1] Barbara Rose wrote a detailed and very informative article "previewing" the
Castelli show, "Jasper Johns: The Seasons," that was published in the January
1987 issue of *Vogue*.
[2] Ibid.
[3] Riva Castleman, *Jasper Johns: A Print Retrospective* (New York: Museum of
Modern Art, 1986), 18.
[4] Richard Francis, *Jasper Johns* (New York: Abbeville), 1984.
[5] Johns's images, cast with attributes of the four seasons, are uncannily like some
images or scenes in the four suits of the Tarot deck. The number 4 itself represents
the points of the quaternity: an ancient symbol of the self, or of wholeness. Many
symbols in Johns's paintings can be found strewn through any Tarot deck: the
cups pentacles (as stars), the child, hands, animals of course, the death's head,
snowdrops, and other seasonal signs, the "Wheel of Fortune," the plummeting
objects, and so forth. The Tarot, like other fortune-telling vehicles, symbolizes the

changes we go through in the course of a day, a year, a life; and Johns similarly indicates the cycle of things, while camouflaging autobiographical particulars.

[6] Calvin Tomkins, *The Bride and the Bachelors* (New York: Viking, 1962).

[7] Charles Harrison and Fred Orton, "Jasper Johns: Meaning What You See," *Art History*, March 1984. See also Marjorie Perloff, *Frank O'Hara: Poet Among Painters* (Austin and London: University of Texas Press, 1977), which is referred to by Harrison and Orton as well.

[8] Calvin Tomkins, *Off the Wall* (New York: Penguin, 1980).

[9] The *Seasons* paintings show a kind of fallout of this subject matter from the earlier work. The Isenheim fragment from the Saint Anthony panel is further detailed, and cast as a souvenir. The death's head, appearing only in *Fall*, is partially obscured and likewise remaindered. The soldiers are gone, but the figure of Christ so dominant in the Grünewald Resurrection panel and so spectacularly absent from Johns's traced details from the same, is now in some poetic sense rigged up in the form of the artist—a "floating," featureless shadow figure, a clear representation of the totality of self. The hands of the "clock" pointing upward, downward, and to the side may indicate the points of the Cross. Within the hand imprints are marks (perhaps left by the hollow of the palm, but Rose calls them "pinioned palms") now inescapably resembling stigmata. The ladder itself recalls the ladder depicted in many Crucifixion scenes.

There is another curious parallel between the Grünewald Resurrection panel and a prominent feature that occurs in all the *Seasons* paintings. Johns's very large black half-circles, bearing a striking central highlight from which the arm/hand seems to emanate, could be read almost as a displaced negative image of the great aureole around the risen Christ with arms and hands uplifted. Coincidentally, Barbara Rose's 1984 *Vogue* article noted that *Perilous Night* "contains . . . a passage of a burst of light taken from the central panel of Grünewald's Isenheim Altarpiece of Christ rising in glory and radiance at the moment of the Resurrection." Johns himself disclaimed this connection when I raised the question with him.

Trafficking with X

During 1990 Jasper Johns began painting a series of untitled pictures whose source is presently unknown. I first saw the image October 2 in a transparency at the Castelli Gallery. I asked Leo Castelli what it was and he said the artist told him, "You'll find out." Later in the month a good friend of the artist told me he bought one of these images and that the artist had said, "Nobody will find out [what it is] this time." That sounded strong. And I wondered why anyone would buy such a specific image without knowing what it is. It's impossible not to suspect that the new image in the 1990–91 untitled pictures is a very specific representation. Even the virgin viewer, without knowledge of Johns's camouflaged images of the 1980s, will see that something is hidden in or by this design. It's blatantly both explicit and mysterious. I'm calling the image X because the artist has made a big deal about withholding the identity of its source.

Counterpoised to X in Johns's recent work is another series, also consisting mainly of untitled works, that features an image whose source Johns made clear soon after he began using it, back in 1984. From Picasso's *Straw Hat with Blue Leaf* (1936), Johns lifted

details to make a peculiar frontal face. *Straw Hat* is a still life with a book, a vase, some leaves (on the hat), and a bald head in profile consisting of two eyes, a mouth, and three rounded protuberances. Johns has used the image as a whole and in part in many different ways and settings. He likes the Picasso for being "more than one thing"[1] and has said, "It's informed with sexual suggestion and very complicated on that level."[2] Johns transplanted the eyes with their prominent lashes to the perimeters of a rectangle, transforming Picasso's nose/mouth into a decorative arabesque, that serves as a nose, and adding a mouth—invented or from another source. A surrealist tendency is very pronounced here, as he carries over the weird, metamorphic design of Picasso's head to his own face-image. Simultaneously Johns went in two directions with Picasso's *Straw Hat* picture: he continued using the whole Picasso image and, with the transplanted eyes and added mouth, pursued his rectangle-face as a specific image of his own. At some point he created a veil-face as well—the defining outline of the veil, like the rectangle, fixing the boundaries of the face.

Artists don't generally tag their work to identify references. Yet artists' works in a way consist of nothing *but* references. This aspect of art has long provided critics their bread and butter, identifying influences, exhuming sources. But Johns, of all contemporary artists, has fetishized this presumptive nature of art. The burial of two bodies in his work of the 1980s has given source hunting a new meaning. People at large can't see or identify the bodies—don't even know there are bodies there to see. Only their outlines—traced from Grünewald's *Isenheim Altarpiece*—describe them as bodies. Otherwise, they are striated, patterned areas, interlocked like flat pieces of a jigsaw puzzle. Nonetheless, once you know they are there, they jump at you as you go from painting to painting: mirrored, upside down or right side up, doubled, obscured in parts, detailed or cameoed, filled in with an endless variety of striping or hatching or set afloat on clear grounds in naked outline. Johns has said that once something is established in his mind as an image, he goes to great lengths to reproduce it by whatever means.

Sometime in the early 1980s, after launching this buried-body project, Johns identified one of the bodies himself, telling a few friends that the mysterious lines in the left portion of *Perilous Night* (1981) delineated Grünewald's fallen soldier in the foreground of

the Resurrection panel. Still, his secret was largely kept because it was mentioned only in passing by just a few critics after his 1984 show. From what they said and from lack of specific indicators to match up the Johns images with the Grünewald originals, it was not possible for people to see them anyway. Certainly the issues raised by the use of a religious Renaissance masterwork, and by the fetishization of appropriated material in highly challenging concealments were left unarticulated. But after Johns's 1987 show of *The Seasons*, when the other body, from the Temptation of Saint Anthony panel—the dying half-human or hybrid figure covered with sores—was not only found and identified but later discovered in great profusion on many sites (canvas, paper, etc.) in a mass burial, you might say, the subject was opened up.[3] And now, with X, Johns has again distracted his critics or upped the ante by posing a new challenge.

Before, we didn't know at first that there was anything concealed at all. We set out for a walk and discovered a body on the side of the road. Now an all-points alarm has been sounded: a body is missing, and we might want to go out and look for it. If we care deeply enough we can join in the search. Critics could mobilize like a mob of neighbors and police out to find someone. Or a critic might want to go it alone, hoping to be recognized or rewarded for outstanding spadework or luck in locating the burial site. A clear choice seems indicated: should we run after this thing, spend hundreds of hours in libraries, jump on planes and trains to follow vague clues or hot tips, call strange people in foreign places with urgent, inarticulate questions (what can be asked about a body you can't identify?), consult specialists known for their encyclopedic memories of images, wearily pulling out our wrinkled Most Wanted poster featuring a rectangle with an X in it, and so on? Or should we mind our own business and pay attention to the many interesting ways the image (already) has been presented or mutated?

A third choice is indicated for critics who are still curious—but who may not want to degrade themselves by chasing a stick thrown into the center of a whirlpool. We can stay comfortably in our houses, not building up phone bills, simply wondering what has driven the artist to his act.

Naturally we want to know the identity of the body. Johns now plays openly on our curiosity. He can count on being a big enough artist to make people care. And a precedent has been set. Very

interesting bodies—with great pedigrees (art historically), and signifiers (biographically)—that have already been discovered make us think X might be interesting too. Anyway, *knowing* something is concealed—being told by the artist himself—is a terrific summons to action, a gauntlet thrown down in the art ring. It's like Gary Hart challenging reporters to find him in flagrante delicto. Johns held no press conference, of course, but he let it be known that X is a mystery image.

X seems to have features that are unmistakably human or animal-like, especially in the horizontal central element. These features seem at the same time ambiguous, incomplete, and contextually dislocated. A tall, irregular shape, suggesting a figure, is broken into ten or so compartments, like map areas, and is interrupted in its middle by the fat horizontal shape that crosses it. We associate X with its predecessors by its outlining—we assume it's been traced—and its familiar demarcation into puzzlelike pieces, many of the colored-in patterns evolved from his familiar crosshatch design. But its predecessors, the camouflaged Grünewald figures, are typically integrated into the pictures where they're featured. X, on the other hand, is written against the sky, so to speak.

Johns's hide-and-seek games, for his and his critics' delectation, have here reached an apex in his treasure-hunt-type ploy for attention. The identity of the image concealed is surely biographically important, but the act of concealment itself is biographically more significant. And what would the artist be concealing if not his biography? Sometime in 1990 I asked Johns a number of questions, and he answered only one with any concern. I wondered if the "public accessibility" of figures he's traced, such as the Grunewalds, interested him. He answered by asking, "If something is a tracing . . . does knowing [what it is] affect your perception of the work? . . . And if you don't know what it is, do you see it completely differently . . . or not?"[4] Here perhaps lies a clue to his current concealment drama. He is interested, it seems, in finding out what or how people see when they know that important information—which can be biographically (mis)leading—is being withheld. Not for nothing do Johns's recent works feature big prominent eyes. He wants to know what we see. He's looking at us from the canvas to try to find out. We stare back at him, wondering what he wants us to see. We want to be polite, not see more than he's willing to let out or suggest. But we don't want to miss anything

either. And we may decide to risk being rude, admitting that we see more than appears to meet the eye.

Things perhaps got out of hand for Johns during the 1980s. For six years he traced and filled in his Grünewald plague victim without being disturbed by outside knowledge of its identity. His Resurrection soldier was reasonably protected in the same way. Such a programmatic concealment was unprecedented (as far as I know) in his career. He had never painted a whole body, either, nor anything so psychologically loaded, except perhaps for the skin-imprint drawings he made of his face and hands in 1962, or his cast body parts of *Target with Plaster Casts* (1955), or his *Untitled 1972* work, with its huge panel containing impaled body fragments. His arm and hand imprints in *Periscope* (*Hart Crane*), *Diver*, *Land's End*, and *Hatteras*, of the early 1960s, were dramatic, but without the impact of a full body in an expressive disposition. The Resurrection soldier hasn't quite hit the ground, as he turns his torso violently away from the brilliantly encircled risen Christ, at the same time shielding his eyes from the "blinding" light. The victim in the Temptation of Saint Anthony panel is likewise stunned by the scene before him. Both figures are foreground witnesses, mediating the scene stretching above them for viewers and the artist. The Saint Anthony victim evokes great pity and fear because of the signs of death upon him—the bloated stomach, the pocked greenish skin, the amputated left hand. He has already half joined the terrible purgatory of monsters in conflict before him.

By extracting these figures and placing them in his own environments and painting them again and again, Johns has tamed them, decathected them, turned them into emblems. Yet he's created "scenes" of his own in which they perform expressively. He's moved the dying Saint Anthony figure around virtuosically, situating him in little "plays" in which he is a kind of "chorus"— commenting on other elements in the picture—or emblematic protagonist, in turn commented upon. He's "figure" or he's "ground" or both, in boundless permutations. There are at least seventy renditions of him. By means of concealment, Johns created something like a private therapeutic room in which to work out his feelings about, and for, these figures. Even now, most of the viewing public remains none the wiser—it's impossible to see the figures without prior knowledge of them, a knowledge not easy to

come by. In context of these concealments, Johns's interest in how we know what we know, or how what we know affects what we see, takes on new significance. How much privacy does he still have, he might ask himself. He could accurately imagine that the public will leave him alone. His critics and friends though—that small but affective community called the art world—know what he's up to. And I surmise that X is a response to that understanding.

Besides providing the artist new expressive material to deal with privately, X sends a message to Johns's critics about the problems of concealment. X focuses attention on the act of concealment itself. Presumably, Johns wants to tell us the identity of the image isn't important; it's what he does with it that matters. He does amazing things with his images, it's true, marshaling them in surprising combinations, coloring them in with a tremendous range and subtlety. He's a classical composer, creating large compositions of groups of pictures relating to powerful themes. Pictures in every group can be moved to other groups where they also play well. The crossbreeding is intense. A 1990 *Untitled* drawing (watercolor, charcoal chalk, and pencil) is made up of parts from three different series, uniting a part of X with the frame/face eyes and mouth on a ground consisting of the disguised Grünewald plague victim. We know the source of two categories of the imagery, but what is this X? Johns is playing for time as he fools around with it and with us in our ignorance. He's given away a lot with the Grünewalds. And he tosses us other bits, hoping perhaps to placate us, to take the edge off the curiosity he's created.

Here is *Montez Singing*, for instance, a very large painting that belongs to the frame/face series. Not only do we know the source of the image, in Picasso's *Straw Hat with Blue Leaf* (he's coupled the Picasso and the veil or rectangle frame/face of his own often enough to make that clear), we also find a very personal title, along with private-seeming details. For Montez is not Lola: Montez is the first name of Johns's step-grandmother, the second wife of his paternal grandfather, with whom Johns lived, for the most part, until he was nine. The "singing" part of the title is illustrated, metonymically, by a little red sailboat situated upper center of the face, where a third eye normally appears. The little boat is painted on a small veil or white square that is nailed trompe l'oeil to the "forehead" of the face. Above the boat, still within the veil or square, is a minute sun on a horizon, with rays, and below it a wavy

line indicating water. Johns has kindly added to his scanty (public) biography by telling inquisitive people like myself that Montez used to sing *Red Sails in the Sunset* while playing the piano. Montez is happy looking, as these faces go. Some of the faces in the untitled work are pretty angry looking. They are all walleyed and/or cross-eyed, with schematic lashes and a caricature Monroe sort of mouth—the only feature not appropriated from Picasso.

Johns retains Picasso's vertically disposed profile eyes as well as Picasso's positioning of them at different heights. Then, in his many repetitions of them, Johns goes to work with eyes and mouth, especially the eyes, to vary the look of the faces greatly. The eyes come in many different colors. The lashes take various forms; they may be painted to resemble nails, or, in several works, sperm—swimming, say, toward the eye-womb. In one picture, the eyes have a lower extension forming large teardrops. Most of the "twin-peaks" mouths suggest a piece of landscape along the "horizon" of the painting's bottom edge.

The veil paintings present a special case. In them, Johns has apparently conflated several different images. For one thing, he probably associates the veil with the handkerchief in Picasso's *Weeping Women* (1936), which Johns used in *Perilous Night* (1982) and subsequently in other works. In addition, there is surely a reference to Francisco Zurbarán. In December 1987 Johns told me he had been impressed by paintings of the veil of Saint Veronica in the 1987 Zurbarán show at the Metropolitan Museum, and he said that he wished Christ's face had not been on it. In his own paintings of a blank veil, he returns the veil to Veronica, if you will, by showing it framed by his Picassoid female features.

Johns's frame/face Woman is generic and stereotypical. Using the "empty" internal area of the paintings as a receptacle for various objects, Johns at length evidently got the idea of filling up the center with his new X image. Not all, but many, of his X pictures are framed by the eyes and mouth of the rectangle-face. The eyes now work even more surrealistically than before, looking as much like suns (their lashes as rays) as eyes. These are pictures framed by the organs of sight and taste. Parasitic on the frame, eyes and mouth hold the pictures together, set them apart from the world and present their central or featured X images as a kind of balloon of cranial contents.

Some of his faces have within them or attached to a painted

border or frame a realistically painted watch hanging from its strap. Another childhood memory, this one involving his father, may be invoked here. There's a story that Johns's father promised him his watch when he was grown up. Soon after, Johns decided he was grown up, went to his father's house and took the watch, and his father came and took it back. Johns said, "I guess I wasn't grown up at all."[5] *Ein Schwert verheiss mir der Vater*—My father promised me a sword. How about *the time*? Johns has clearly taken the watch (for good) at last. Does this mean he thinks he's grown up now? He began painting it as he approached the age his father was when he died. We speculate impertinently, with nothing but an old story and a painted watch to go by. All we know for sure is that time is important for Johns, as it is for the rest of us. With enough time, Johns can control the space that's really crucial to him, fighting off critics, friends, and the public (nobody will find out what X is, he said—until he's ready to tell us, we could add), protecting the sanctum where self-knowledge is negotiated and where the artist feeds (on) himself, getting what he needs in the style to which he's accustomed, from his own productions.

One picture in the Saint Anthony group, which also belongs to the Picasso *Straw Hat* group, shows the artist literally feeding himself, or feeding his picture. The bodies painted by the artist must be (aspects of) the artist himself. If he buried them, there must be something wrong with them. There's definitely something wrong with the Temptation of Saint Anthony figure. He's dying, he's deformed, he's turning into an animal, he's helpless before his fate—he's not facing a great future. Johns has embraced and adopted this figure, *rescuing* him in a way, bringing him "home," giving him playmates, often a twin, enclosing him in amniotic situations, further protecting him with "guardian" figures such as the old crone who forms part of a trick double image (a young lady is her double), allowing him to fly or swim and most important of all establishing him as a kind of basso ostinato to a whole body of work. In an untitled picture from 1988, a largish watercolor and ink on paper, Johns has painted the victim as he is in the Grünewald— sitting upright in the lower left foreground, occupying the left side of a veil that is nailed together with another veil, in trompe-l'oeil fashion, to blue sky and clouds. Upside down and mirrored on the right-hand side veil, the victim is twinned, though largely obscured by the bald Picasso head from *Straw Hat*. The head is flopped, and

the artist has ingeniously slipped its lower protuberance, capped by an eye, "behind" the left-hand veil so that its eye, now easily read as a nipple, rests against the chest wall of the upright Grünewald victim. Surpassingly painted—a classic example of Johns's late surrealist style—it's also amusing, unexpected, and moving.

In another watercolor and ink on paper, painted two months later (in 1988), the Grünewald is depicted similarly, but without the Picasso head. Instead, Johns has restored the Picasso painting to its original form and placed it, much reduced in size, so that, split in half, it flanks the central veils. The two paintings can be read as a text or a story. A sick and prostrated figure is nourished by the "breast" of a big head while flying in the sky. The one who was fed is better now; he flies along on his own. His supplier is out of the picture but appears as a reminder in the margins, on the outside of the "flying machine," ready to provide services again and to make sure the victim is doing okay. The victim in this case is not just twinned but Siamesed—an extra feeding precaution, you could say. Doubling, mirroring—devices used repetitively by Johns throughout his career—embody a principle of nourishment. When he Siameses his victim, as in these two pictures, he simply joins up their outlines, blending the lines from one with the lines from the other.

If you don't know the identity of this Grünewald figure, you won't see its key function in a picture Johns also painted in 1988, for an auction to raise funds for AIDS treatment and research.[6] It forms the ground of the left side of the picture, painted in greens and yellows/tans/oranges, accompanied by a superimposed small rectangle containing the Picasso *Straw Hat* still life. You will know the subject by essential signifiers on the right-hand side: the skull and crossbones and part of its warning, *Chute de Glace* (Beware of Falling Ice), from paintings of the early 1980s, two joined images of the American flag and a copy of part of the front page of the *New York Times* of February 14 (Valentine's Day) 1988, with a headline reading "Spread of AIDS Abating but Deaths Will Still Soar." Johns's ambivalence is clear here. He demonstrates support and sympathy for an embattled cause, and at the same time withholds vital information that could convey his message more expressively. Yet it would be most uncharacteristic of him to bring his victim out of the closet, so to speak, after painting him incognito for so long.

For one thing, the figure would then be esthetically unrecognizable. And Johns himself would look like a different artist.

Not surprisingly, his ambivalence is compatible, psychologically speaking, with his strategies in art. He's been queried about his Grünewald victim and its connection with AIDS. He appears to accept an association he didn't originally intend (in 1981 when he began painting this figure, nobody knew that an AIDS epidemic was underway), while staying true to his policy of being noncommittal. In October 1988 he told me he had heard recently that food poisoning was the plague in Grünewald's time. In August 1990 I asked him about AIDS: When did you register AIDS as a phenomenon—when someone you knew died ? Have you lost many friends? And he took the fifth. Then when I mentioned his AIDS auction picture, asking him about the use of the Grünewald victim, he accused me of concentrating only on this one aspect of the imagery, thus seeing the work less clearly. He said, "I'm blaming you for directing attention away from the work." I would say, in turn, that whatever is concealed in a work is what will naturally become a focal point. Especially when the concealed subject so strikingly embodies the theme of the picture at hand.

Constructing X, Johns evidently intends to make his point about our attention very strongly. As he stares at us from his canvases, he wants to know how we might get stuck on one way of looking at something. He may even determine his next moves not just according to internal dictates of form and structure but in response to what he thinks we see, to elude any particular identifications.[7] He wants us to see the work—the manipulations of parts, design, color—and stop being distracted by identifications. At the same time, X is a great distraction. Johns is saying he has a big secret, thus he clearly wants us to discover what it is. The strategy is bold. He would like to fool us anew. He could catch us looking silly running after X to try to identify it. Or he can have us where he has generally had his way with us: preoccupied with structure and the way things are painted, pondering various formalist issues. He can also watch us vainly struggling to make out X on our own, speculating on its identity with no clues to its source. It seems to me he can count on a superficial response to this maneuver, a response congruent with modernist questions of expressive content versus structure and form. If he can fool us into dealing with X at this level, we won't look further—at the psychology of concealment, at

the extreme ambivalence underlying the work of this major artist. There is probably only one good counterstrategy for trafficking with X, and that would be to ignore it.

Having said that, and having already demonstrated my interest, I would also say that there can be good fun in the games artists play. Certainly X had people buzzing in London when I flew there for the Hayward opening of Johns's drawing show and an exhibition at the d'Offay Gallery in November 1990—my one plane trip on behalf of X. Someone speculated that X is a couple sleeping together. A British person saw a map of England. A well-known British artist (Richard Hamilton) said "it would be impertinent to ask Jasper anything about [X]." An American man working at the d'Offay Gallery announced fervently, "This is my goal"—to find the source of X. An American woman said it must be something from Cézanne because he's been so interested in Cézanne. And she saw a child in swaddling clothes. Another American woman saw Alice in Wonderland walking along carrying a baby that turns into a pig. The American printmaker Bill Goldston, walking into d'Offay's with his wife and baby, who was sleeping in a stroller, said X is unquestionably a Madonna and Child. This seemed to be the consensus, in fact. The English critic David Sylvester saw the Virgin holding the Christ child in the Annunciation panel of Grünewald's *Isenheim Altarpiece.*[8] But he also mentioned Leonardo's drapery studies, shown at the Louvre recently. The American man so determined to find out what it is said he thought there were drapes in the picture, too. Angels floated in and out of conversations—a pink angel of de Kooning's, for instance; and an inhouse title, *Green Angel*, seen on the back of the December calendar drawing.[9] I dutifully wrote down information about X conveyed to me. I was even told that if I felt like getting on another plane, I could find out in Basel what the image is. On good intelligence, I learned that in April 1990 Johns had sent for a reproduction of X from the Kunstmuseum there. This meant that Johns had engaged a confidante in his scheme, and I knew that even if I had the time and funds to enplane for Basel, I would not get past this confidante. The image might not be hanging in the permanent collection galleries, and three-headed dogs would bar my way elsewhere.

Johns has already put X through many familiar paces. For a start, I believe he is presenting the image upside down, and it's

frequently mirrored. Also, it comes in all different sizes and mediums, and he's colored it with his opposing striped patterns or plain but demarcated areas with the great variety and cleverness and wonderful texture that we've come to expect. Unlike the Grünewalds, the image is decidedly dyadic. The center element, lying horizontally, stands out and is evidently the part with which Johns identifies. It isn't usually colored in like the vertical forms that extend above and below it; it therefore is often silhouetted against the rest of the picture. Johns has also isolated this element to play roles in other pictures. It could surely be a hybrid animal/human. It has a human-looking "hand," and "feet" that look porcine. I think it's lying on a lap (of the vertical figure) because of the indentation along its "back" (if viewed upside down). It looks too big to be a child, in proportion to its vertical companion. Both right side up and upside down it looks like the horizontal shape is being carted somewhere—possibly through the sky. (But on a lap?) The whole thing is in the shape of a cross. A religious configuration seems indicated. *You* take it from there.

I trust, for Johns's sake, that whatever it is, it's good. If you find out what it is (in case it remains unidentified at this moment) contact the publishers of "Most Wanted" images, like *Art in America*, or contact me, or the artist himself, who has been known to reward the successful detective. I had some small satisfaction in London, slipping a pin of the Mona Lisa's face in puzzle pieces, bought at the Musée d'Orsay, into the artist's pocket.

1991

Notes

[1] In conversation with the artist, August 2, 1990.
[2] Amei Wallach, "Jasper Johns: On Target," *Elle*, November 1988, 152.
[3] Jill Johnston, "Tracking the Shadow," *Art in America*, October 1987.
[4] In conversation with the artist, August 2, 1990.
[5] Michael Crichton, *Jasper Johns* (New York: Abrams, 1977), 20–21.
[6] The auction, for the Supportive Care Program of St. Vincent's Hospital and Medical Center of New York, was held at Sotheby's, New York, May 2, 1988. Johns also donated the image for a poster that was sold in June 1990 for benefits against AIDS.
[7] Fred Orton and Richard Shiff have described Johns's elusiveness in the current semiotic lingo: Orton, in a dense paper uniting Johns and Derrida, says, "Johns's practice . . . can never be brought to a halt because of the relation between

signifier and signifier and signifier in pursuit of a signified which is always elusive, shifting and registered to a lack." Fred Orton, "On Being Bent 'Blue' (Second State): An Introduction to Jacques Derrida/A Footnote on Jasper Johns," *Oxford Journal* 12, no. 1 (1989): 44.

Richard Shiff has also written, "Since Johns creates conditions for the most active and inexhaustible kind of interpretation, the only dependable 'meaning' that his art signifies is interpretation itself." Richard Shiff, "Anamorphosis: Jasper Johns," in *Foirades/Fizzles, Echo and Allusion in the Art of Jasper Johns* (Los Angeles, CA: Wight Art Gallery, UCLA, 1987), 116. Shiff noted, in the same essay, by the way, that Johns has often expressed dissatisfaction with his own character.

[8] The Virgin has a vaguely similar disposition, but the infant doesn't at all.

[9] *Untitled*, 1990, watercolor, charcoal and pencil; one of twelve drawings reproduced in *Jasper Johns: A Calendar for 1991* (London: Anthony d'Offay, 1990).

The World Outside His Window

Someone asked me what I'm afraid of. You're afraid to die and you're afraid to live another minute.

—Robert Rauschenberg

T ry to picture Robert Rauschenberg in your mind's eye in his most characteristic pose. You might see him caught in a time loop, running eternally between two bases. He can't reach either base, and no one has tagged him out yet. Or he's been tagged out many times but he never returns to the bench; having made up his own rules, he gets up, dusts himself off, and continues, exhausted and depleted perhaps, yet ever reinvigorated by his cheering section on the sidelines. This is the artist's entourage, a devoted band of helpers who believe in the kind of base running their chief has established. Between the bases, Rauschenberg snares great images

with his camera and grabs other images from newspapers and magazines. Then he makes off with the images to his launching pad in Captiva, Florida, where he processes them in various ways, placing them on surfaces and adding paint and objects, to present as a record to the world.

Rauschenberg is an artist's artist—a man for whom that traditional space occupied by artists—the limen, or threshold—is very, very big. Long ago, in his best-known statement, he said it himself: "Painting relates both to art and life. . . . I try to act in the gap between the two." Acting in as broad a gap between art and life as he does, his art and his life have both suffered. Throughout the 1980s, art world pundits and others muttered about the thinness of his art. And while the life may look good—he lives on the beach in Captiva, has total mobility, and an excellent support system—it's a life that continually takes him away from himself. In so many words he has said that too. On a video accompanying his ROCI (Rauschenberg Overseas Cultural Interchange) exhibition, on view in summer 1991 at the National Gallery of Art in Washington, D.C., he announced "After the Washington show I'm gonna find out who I am and I'm not gonna find it in airports."

Four days after his ROCI opening on May 8, 1991, Rauschenberg was featured in a four-page foldout ad for The Gap denim jackets right inside the front cover of the *New York Times Sunday Magazine*. A portrait of Rauschenberg at his most glamorous and confident consumed the page you saw when you opened the cover. The cover itself showed a color caricature of British royalty. The contrast was supreme. Ugly, obsolete royalty, representative of America's distant past. Bright-eyed, eagle-visioned, open-palmed artist— symbol of the American future. The Gap ad included the words "For those who alter what's expected." Denied the magazine's front cover, a spot Rauschenberg told me he dearly felt he should have had at this moment in time, he collaborated with the Gap people to make a handsome consolation, and a kind of media miracle.

But how well does Rauschenberg really represent the American future, as artist and man? Is Rauschenberg as obsolete as royalty in his own way? With ROCI, has he actually opened up new ideas and territory? Or is he repeating himself grandly? Has he astonished people once again with his innovative flair? Does his art look better again, and does it matter whether he finds out who he is or not?

The apparent equation of art and life in Rauschenberg's aphorism about the gap between the two is misleading. Art is the fiction we all love. Life is the reality we inhabit and hope to transcend by our absorption in art. Rauschenberg has said so himself many times in different ways. I call them his Not-Me statements. "I don't want my personality to come out through the pieces. That's why I keep the TV on all the time. . . . And I keep the windows open. I want my paintings to be reflections of life."[1]—"When I go to work I have to feel invisible to get away from the inferiority that is attached to 'Bob.'"[2]—"I don't think about me that much. I have enough problems just getting through a day."[3]—"Listen, in the '50s, I already had a problem, it's been documented many times, I said if my work doesn't look more like that's going on outside my window, you know, then I shouldn't be doing it."[4]

Alcohol has been perhaps his best agent for escaping himself. Calvin Tomkins wrote that Rauschenberg told him "drinking filtered out most of the problems that distracted him from working, and that it also helped to get rid of the 'self' that he was determined to keep out of his paintings."[5] Rauschenberg, I've often observed, doesn't begin his day, around noon or later, without a glass of whiskey and water in his hand. By the evening, when he starts working, he's fine-tune pickled, as we can believe when he tells us alcohol breaks down his inhibitions and helps him work.[6] He certainly gets a lot friendlier as he seeps through the day and into the evening. He's said he loves to drink and he loves to work. It would be hard not to link the two as twin agents of both enhancement and escape. The life Rauschenberg is transcending is not what he sees out the window, the public world that stands there or passes by, but whatever lies within.

The life outside himself is what he has embraced since the 1960s. Beginning with the Silkscreens of 1962–64, his work often looks state sponsored, in its clear iconography of accessible, public symbols. There are monuments and official buildings, national fabrics, foods, street signs and traffic signals, construction sites and hard-hat workers, generic landscapes or decontextualized seas and skies, animals and vehicles galore. We also get *Family-of-Man*-type pictures of people, religious icons, heroes of the space programs or the athletic fields (anonymous men of action), and presidents or leaders of governments, as well as the fantasy women they all love—madonnas and whores, but especially the latter, as reflected

in many old-master Venuses (anonymous women of leisure). These may comprise the major thematic groups. The basis of appeal in a body of work dealing with such public imagery, apart from Rauschenberg's artistry, is the projection of a national consensus. The Silkscreens of the early 1960s, many of which were on view in 1990–91 at the Whitney Museum in New York, were patriotic documents, declarations of faith in the American dream. They were the perfect preview to the ROCI works, which feature parallel consensus images from the ten countries Rauschenberg visited in his great runs between the bases of international hot spots in the news during the 1980s.

No other contemporary artist has been so captivated by the panoramic view of life or moved to celebrate natural and cultural phenomena with such Whitmanesque pictorial litanies. Yet few artists, paradoxically, have done as much intensely personal, auto-biographical work as Rauschenberg has. Outstandingly, we recall his *Bed* of 1955, or the later work *Whistle Stop* (1977), dedicated to his father and filled with images of home. Within the ostensibly public work, much that is private intersects with the catholic and anonymous. As a man who came of age as an artist in the 1950s, and became political in the mid- to late 1960s (antiwar primarily, a bleeding radical generally), Rauschenberg has in his art remained personally subversive but publicly idealistic.

Though he often dismisses his personal history, it's been irrepressible anyway, surfacing quickly in his conversation if he's in the mood and asked the right questions. Actually he's usually a very upfront and open guy. My impression these days is that after the third or fourth whiskey, he'll say most anything. This didn't seem true in 1984 when I went to see him to ask him about his past for an autobiographical volume I was writing then.[7] Because he had played a certain role in my life during the early to mid-1960s, a period covered in my volume, I had the idea he might anchor a view I had of him by providing some facts. Mainly I wanted to know about his father. I had guessed that he had a violent, perhaps abusive father, and that he had lodged the experience in his upper back, where he carries a visible burden. At that time he seemed to confirm my guesses, but without really substantiating them.

Not long after that he began telling Mary Lynn Kotz a lot of things I wanted to know. She was then working on her quasibiographical book *Rauschenberg*, which Abrams published in

1990, timed to appear when the ROCI works made the final appearance of their tour, at the National Gallery. So when I approached him about his father again in March of 1991, this time with ideas related to his enormous images of Jack Kennedy from the Silkscreens of 1964, he was much more talkative. He doesn't relate Kennedy to his own father; in fact he sees no connection whatever. Yet his father's death occurred in October 1963, one month before the assassination, and it was upon the death of JFK that he pulled out the screens he had made, sometime earlier, of the president's image and began using them in new works.

You know the image: JFK speaking and appealing to us, his right hand extended and pointing at us, just like Uncle Sam in the recruitment poster. In some works Rauschenberg isolates the pointing hand, screening it as a detail, or highlights it by encircling it in gray or white paint. JFK was telling us we'd better ask ourselves what we could do for him, and not expect *him* to do anything for us. This is a demanding, even accusatory father, a father, moreover synonymous with country and government. JFK was extremely playful and youthful (and not much older than Rauschenberg), but we know enough about how demanding his own father was (in particular in regard to his sons) to see something darker behind JFK's disarming qualities.

Rauschenberg says he saw simply "authority" in his image of JFK. When he heard about the assassination he was traveling in a bus with some of Merce Cunningham's troupe (he was still designing sets and costumes for Cunningham) toward his mother's house in Lafayette, Louisiana, to make a pit stop. The story goes that he had qualms about using his screens of Kennedy for fear of appearing to exploit the president's death. Going ahead despite his qualms, Rauschenberg made his huge silkscreen paintings using the JFK images—alone, doubled within the same work or multiplied among various canvases. The resulting Silkscreen paintings were powerful in their timeliness, their appropriateness, their aggressive size.

One of my questions when I saw Rauschenberg last spring was "What do you think of JFK now?" I thought he might have joined many others of his generation in a revised view. He said he feels the same about Kennedy, "because there hasn't been too much competition since then." I said, "Not for looks anyway." Then I asked him if he didn't think Kennedy had been dangerous. He replied, "All meaningful people are dangerous." I liked the way that sounded

but had no idea what it meant, and he couldn't explain. Later on he said things about his father that could explain the comment very well. The most meaningful man in his life had been a "dangerous" father. He said his father had a "fantastic temper" and he beat him badly once. But evidently it was his disapproval that Rauschenberg feared the most. Growing up, he felt he was never able to do anything right.

When I tried linking Kennedy and his father he said, "The only thing that really bothered me about my relationship [to my father] was that it was just impossible to ever please him . . . but I certainly didn't have that feeling about Kennedy." He laughed here, I guess at the silly idea of pleasing a man you don't know personally. When Kennedy was inaugurated, by the way, Rauschenberg sent him a painting, which was never acknowledged, its whereabouts presently unknown.[8] Anyway, it's normal to find a connection between two such men absurd—the one relatively uneducated, son of a German immigrant father and a Cherokee mother, destined to become a lineman for the Gulf States power company in Port Arthur, Texas; the other an august, exalted personage—the wealthy, well-educated president from Boston, Massachusetts. Yet the coincidence of death dates and the image Rauschenberg had readied for use before the two men died—that pointing hand, with the exhortative message behind it, and the looming overblown face, stern and reproachful—indicate a segueing of identities and a kind of transference.

With his father's death, a son like Rauschenberg would now be asking himself what he could do for a man whom he was never able to please, who "died before I could make him proud of me," and whose last words to him on his deathbed were: "I never did like you, you son of a bitch."[9] Evidently Rauschenberg stuffed his anger (he told me he didn't have any). And he found a world on canvas of images that seemed remote from himself. It was with his Silkscreens of 1962–64, a time period in the very middle of which these two important deaths occurred, that Rauschenberg came out swinging for flag and country. And it was right then, first in 1963 with his retrospective at the Jewish Museum, then with his victory at the Venice Biennale in 1964, where he won the coveted first prize, that he had his first big popular and financial success.

In 1962 Rauschenberg opened up the skies and flew into them along with his beloved heroes, the astronauts. He left all those

closed, tight, densely packed, rectangularly collaged images of the Combines behind. In the Silkscreens, the images float free; they're absolutely aerated. They even look liberated within the familiar boxes and rectangles that often enclose them. Rauschenberg had a new luxury: a screening technique that allowed him to render his images with as much sfumato as his transfer drawings (though to different effect) and to achieve, through superimposition, great range in the sharpness or vagueness of images. Most important, this technique permitted the infinite repetition and rearrangement of images, all cast onto hugely expanded surfaces.

Through repetition Rauschenberg enhanced his Not-Me position. Now he could say with conviction, "It's *your* mind that makes it add up to something."[10] Scrambling his images by placing them in so many different contexts, both within a single work and from picture to picture, discouraged any reading of them as personal symbols. He had always said it was up to us to try to figure out what they meant, but nobody did—until Charles Stuckey tackled *Rebus* (1955) in *Art in America* (April 1977).

Rebus belongs to an earlier, intimate, more personal body of work. Yet the dechiffrage of Rauschenberg, begun with Stuckey, has never linked his images with his personal history, though this is more possible now, with Kotz's "biography." In the late 1950s his work was much closer to himself. *Rebus* is both a family picture and part of a "family group" that includes at least *Small Rebus* and *Gloria*, both from 1956. These Combine paintings appear to be meditations on received ideas of gender. Memories of life back home—in *Rebus*, Rauschenberg gives us comics, scribbles, sketchy drawings, a page of math homework—are overridden by images indicating the brutal consequences of adulthood: the female's loss of status and the male's destiny as conqueror, both still unquestioned in the 1950s. It was in 1956 that Rauschenberg's only sibling, his twenty-year-old sister Janet, got married. Rauschenberg had left home about a dozen years earlier, and was thirty-one in 1956. In *Rebus* his sister can be associated with a drawing of a girl in a crown to the far left; as a teenager Janet was elected Miss Sweet Potato at a state fair. A comic strip in *Rebus* is called *Sister*, and the work's central image is the Botticelli Venus, one of the really chaste Venuses in history. Directly below that are soaked-looking sections of maroon fabric and a mess of dripping red, suggesting oncoming womanhood.

The gender reading in these works can be extended further. A principal image in *Rebus* is a torn and defaced poster of a woman candidate for office (linked with the girl in a crown below her), who is clearly not going to make it. Two male runners facing her are overtaking her, and to the far right, as they break the tape, are about to "take" another woman, shown disrobing and baring her breasts. In *Small Rebus*, female victimization through marriage comes across with the conjunction of the image of the active male athlete and a detail from Titian's *Rape of Europa*.[11] Janet herself is featured in a photograph as a child of seven or so, posed with her mother and father.

Rauschenberg's own role in *Rebus* may be carried in another pair of male images: the reproduction of a Dürer self-portrait and a drawing of Dürer's brother. Following Rauschenberg's marriage in 1950, it was with brother figures—Cy Twombly, then Jasper Johns—that Rauschenberg found support and inspiration. Shadowed, biographically, in *Rebus*, is the history of his brief marriage to artist Sue Weil, who soon became lost—as far as Rauschenberg was concerned—to motherhood. In 1951, the year his son Christopher was born, Rauschenberg made a significant piece, called *Automobile Tire Print*, with the assistance of John Cage, who drove his Model A Ford across a 264-inch roll of paper, imprinting a single (inked) tire tread. Rauschenberg, who still owns the piece, had hitched his wagon to a star. The idea was to get someplace, to get away, and the symbolic tire print was made during the year sandwiched between his marriage (1950) and divorce (1952). Already, in the end-to-end line of the print, he showed his talent for travel, for moving continually, for endurance between the bases.

Yet he never got far away from himself in the 1950s. He moved on, but he wasn't flying yet. *Monogram* (1955–59), for example, is an obvious self-portrait (the piece bears his initials), showing the artist grounded (fixed to a heavy platform), stating his position directly, immediately—a (scape)goat mocked by a tire.[12] In *Canyon* (1959), a Combine painting that alludes to the Ganymede myth, Rauschenberg encodes the same-sex interests that can be read by indirection in various details of works throughout that decade. In her catalog essay for the Whitney silkscreen show, Roni Feinstein mentions "an extended series of Combines based on homo-erotic themes."[13]

Barge, the biggest of the silks (6½ by 32 feet), was done in 1963,

the year Rauschenberg lost his father and Kennedy. The artist's ascensionism begins most clearly right here, though he had done a number of silks by then and had indicated his direction with the first of them in 1962 showing repeated images of a baseball player hitting a ball out of the park. A barge is a capacious, slow-moving, flat-bottomed vessel used for carrying freight. The freight of *Barge* is nothing less than the story of mankind in America. But Rauschenberg was also "barging into" art history. That was his year. He was tremendously excited when he did *Barge*. He told Barbara Rose that he "got turned on" at Jim Dine's studio, making him want "to go out and do something fantastic." He ran to Rosenthal's "at breakneck speed" and bought "the biggest piece of roll canvas they had."[14] He finished the painting in less than twenty-four hours. Afterward his arms swelled up like balloons and turned bright pink, apparently of lead poisoning caused by some of the white silkscreen ink he had used.

Barge is a creation story. You can read it as a bulky sentence, much like *Rebus*. I read *Rebus* from left to right and *Barge* from right to left. The key that hugs the right edge of the picture inside a tall narrow rectangle gets us into the picture. The first "turn" of the key reveals dark images of a man regarding some birds in a cage, the wire grid of the cage crossing the man's visage as well as the birds. Rauschenberg has always identified with animals and sought to liberate them. His father was a hunter and according to one anecdote killed a pet goat that he had.[15] (In 1954 Rauschenberg even tried to liberate one of the marble cubes from the metal birdcage of Marcel Duchamp's *Why Not Sneeze?* when he visited the Arensberg collection in the Philadelphia Museum with Jasper Johns. As he reached into the birdcage a guard said in a bored voice, "Don't you know you're not supposed to touch that crap?")[16]

Superimposed on the upper right birdcage in *Barge* is the key proper to the painting: a family tale printed inside a slightly tilted squarish rectangle. It's about an Irishman called Edmund who married the daughter of an earl and emigrated to America along with two sons, Thomas and William. In a battle with the Indians during the French and Indian War, William had his head split open by a tomahawk. A surviving grandson had five sons and four daughters.

Life in America on the freighter called *Barge* involves some immigrant family such as this. A diagram of a box to the left of the

family-origins tale suggests construction to come; it may also refer to the "box" of the Venus who lies recumbent in the center of the canvas, as though giving birth to everything in the picture. This is the Velázquez *Rokeby Venus*, who appears in many of the silks. An organ of her insemination appears at the top in the form of a space capsule handled by four astronauts or technicians in white. Copulation proper occurs in the middle where the Venus reclines, screwed from below by the upward thrusting section of highway cloverleaf, and from above, more figuratively, by an army truck. She's boxed in also by the satellite package on her left known as a Venus probe.[17] The fires of this hot creation number are being put out, presumably, on the upper left by a tiny silhouetted fireman facing cascades of painted water, from which two men swim (actually the same man, printed twice) away and on toward the future: a football game, a photographer's umbrella, a building construction site, a cloudscape.

Now, one can always ask, what's wrong with this picture? There is generally something "wrong" with a picture, especially one that appeals blatantly to the public standard of ideal models. I read a high level of repression in this work, and in the Silkscreens generally—not so much in the many images of flight as in the two Venus figures: the Velázquez and the Rubens *Toilet of Venus*. Rauschenberg moved them both around a great deal, from picture to picture. We can assume he meant us to see his Venuses as women. Yet he pointedly chose nudes seen from behind and accentuated their asses in ways that suggest interests more sodomitic than coital, both highlighting them and designating them as receptacles in a number of works. In fact, the artist as ass-man[18] showed plenty of ingenuity in the ravishment of his Venuses. In *Transom* (1964) the Velázquez Venus's rear is encircled and also approached by one of four streams of white paint dripping down from a vaguely circular blob, oozing close enough to the cleft to make a perhaps random result look iconographically intentional. In *Tracer* (1963), a sign reading "Cafeteria," encircled in white paint, actually replaces the lower part of the Rubens Venus's ass—as if she's laying an egg and/or being identified as edible. Linked with the ocean in *Bicycle*, the Velázquez Venus "receives" a great pathway of red paint that cascades down from the ocean above.

The Rubens Venus often appears in the frame with JFK, who could be saying "I want you," as well as "I want you for the

country" with his pointing finger. Isolated as a detail, the hand and finger look as if Rauschenberg actually intended to phallicize them. Sometimes Kennedy's tie, linked to the wrist of the extended hand, is also emphasized with a paint job. JFK appears to play multiple roles in the silkscreens: the patriotic president (red, white, and blue are dominant colors); the handsome seducer of Venuses; and, his face often covered with washes of bloodred, the recent victim as well as the dangerous man—one who involved us in a war and an international crisis the moment he was elected. (Kennedy's war history seems to have been lost on the virulently antiwar Rauschenberg, in keeping with his avowedly idealistic stance toward the dead president.)

As to the ambivalent sexuality of the Venuses, this has been noted elsewhere. In his book on Velázquez, Jonathan Brown has noted that for his *Rokeby Venus*, Velázquez could have quoted or paraphrased from the classical sculpture known as the Hermaphrodite; the front view of the Rokeby Venus, which we don't see (except for her face reflected in the mirror), would have breasts and male genitals.[19] While the Venuses might appear to be about straight sexuality, more likely they descend directly from the boy-oriented erotica of the Combine paintings, a content most explicitly readable in *Canyon*, with its multiple Ganymede references.

Charles Stuckey noted the "eagle ride" of Ganymede (represented by a photo of Christopher Rauschenberg as a baby) in *Canyon* in 1977.[20] Andrew Forge had made the Ganymede connection as early as 1964.[21] Then in 1982 Kenneth Bendiner brilliantly associated each detail in *Canyon* with Rembrandt's *Rape of Ganymede*.[22] The myth of the boy snatched up by Jupiter disguised as an eagle and borne to the heavens, where he becomes cupbearer to the gods, represents a homosexual abduction and rape. On the most obvious level, this would seem to account for Rauschenberg's interest in the theme. On another level, with his paraphrase of Rembrandt's *Ganymede*, Rauschenberg would seem to have been commenting on his own difficult relationship with his father.[23] Ganymede's abduction can be read as a deliverance from ordinary family circumstances. Under the protection of Jupiter, a powerful paternal substitute, the boy is ushered into the company of gods— in the case of Rauschenberg, the immortal heroes of his medium.

In Rauschenberg's life, deliverers in the asexual mode are a matter of public record: he had three types of surrogate father by

the time he made *Canyon* in 1959. He's described John Cage as the man who gave him permission to think; Josef Albers was an intimidating, demanding teacher who "disliked [his] work exceedingly"; and Leo Castelli became his long-term dealer beginning in March 1958.

Rauschenberg's own father was left, paradoxically, in an ideal position—never questioned or confronted. His son could never identify, acknowledge, or expose his failings and wrongdoings. Rauschenberg continued to *believe* in the authority of the father. But he could take on the world, especially when his own father was gone. And that was what he did, late in 1963.

Before then, Rauschenberg was an apolitical artist; he didn't believe art could or should change the world, and he was part of a small group influenced by the detached and politically indifferent philosophy of Cage and Duchamp. The death of Rauschenberg's father coincided with events at home and abroad that politicized many Americans. After Kennedy's assassination, Rauschenberg became involved in the civil rights and antiwar movements. He became the father himself, demanding a perfect world. With art and money he could be the kind of father who helped to *rescue* sons from bad fathers.

Rauschenberg told me it's world events that make him mad. Late one night he saw a program about lepers and the medicine they needed to save them, and in the morning he wrote out a check for twenty thousand dollars to send to the mission. He's lobbied for artist's rights and has for a long time had a foundation, called Change, Inc., which helps artists with emergency funds; he's currently trying to figure out how to help the homeless; he has appeared at fund-raising events for AIDS research with Elizabeth Taylor.

Through the ROCI project, he developed his grandest save-the-world scheme. Countries with oppressive regimes, where tyrant fathers deny their people artistic and other freedoms, were favorite targets of ROCI. Chile, Cuba, China, Malaysia, Tibet, and East Berlin (before the wall came down) were high on the list.

In the ROCI works, Rauschenberg indefatigably pursues the world "outside [his] window." ROCI was designed in part at least because the artist ran out of real estate. He is quoted in the ROCI catalogue as saying, "I don't know the year but I remember the first time I announced that we were going to do an international traveling show dedicated to education and peace and familiarity and

social concerns. I was in Los Angeles having an exhibition at the Ace Gallery . . . and I was bored. I had had this idea [ROCI], so I just announced it."[24] That was 1977, the year incidentally of his big retrospective at MOMA. The ROCI project was not officially launched, however, until 1984. In Japan someone asked him what his greatest fear was and he said, "That I might run out of the world."[25] But he brought ROCI home after ten countries,[26] skipping thirteen others originally scheduled for the tour. Presumably he'd had enough.

ROCI was a huge logistical miracle. Reconnaissance trips by aides, extensive negotiations with authorities, byzantine arrangements for shipping and showing, and Rauschenberg's own forward surveys to get to know the countries and take photographs and collect materials—all were part of the art-and-media package called ROCI. The story behind the story was not apparent in the Washington show, except as glimpsed in the videos, which were installed in almost every gallery. Nor did the exhibition reveal what Rauschenberg might have accomplished by fulfilling his rationale for the project—to bring people closer together through cultural interchange. What it did reveal was the great continuing panache of Rauschenberg himself, his constant appetite for new things and places, for new techniques and materials.

Yet there was nothing particularly new in the work. This was vintage late Rauschenberg—I could see in it an aging peacock in resplendent color and vainglorious display. It was a very entertaining show, with dazzling mirrored surfaces, gorgeous fabrics, overpowering scale, and plenty to look at, all provocatively collaged. The catalog of images and methods of putting them together are familiar Rauschenberg. But one theme unique to the ROCI collection is the juxtaposition of images of poverty or scenes of ordinary life with icons representing official wealth—like a ROCI Cuba picture called *Cuban Night Vision* showing a street scene of local males beside a photo of caryatids on an ornate building. Yet the general extravagance of materials and surfaces in the ROCI work conveys more about the artist's delight in what he found in these countries than about his politics.

In one ROCI video he joked that he was on a "corrupt missionary mission." You can believe it when you see him walking around in Tibet in a very expensive fur coat, which he said the Tibetans

tried to barter off him five times a day. Slumming in downtrod-
den countries is a characteristic American media enterprise, and
Rauschenberg shows himself to be no exception here. He tells a
story in the catalog interview about meeting the Dalai Lama, recount-
ing his trip to Tibet to him, telling him how much his people miss
him, giving him a signed poster from his Tibetan show, and being
disappointed that the exiled spiritual leader wasn't more interested!

ROCI's exhibition format was highly innovative—conceived,
sponsored, and paid for by Rauschenberg himself. At some point
millions were promised by a donor, but with strings attached, so
Rauschenberg turned the money down. Having traveled with Merce
Cunningham, he could imagine a traveling roadshow of his own,
unlike any normal art exhibition that moves from museum to
museum. Works shown in one country would be moved to the
next, and shown alongside new works based on new local materi-
als, and so on. In East Berlin (the one overseas ROCI venue I
managed to visit), I saw German-made works alongside those from
Russia, Malaysia, and Cuba. Berlin was the next-to-last stop on
the tour.

Rauschenberg enjoyed the company of chiefs and heads of gov-
ernments in some countries. He loved meeting Castro and being
entertained by him. He wanted Caroline Kennedy to come to the
opening in Cuba, but she declined,[27] knowing no doubt that her
father had once plotted to assassinate the Cuban leader.
Rauschenberg says that Castro himself told him that he admired
the Kennedys, that they were the most important people we've had
in our country for years![28] Cuba was a perfect milieu for the globe-
trotting artist. Art in Cuba has remained strong; restrictions on
travel and cultural interchange gave Rauschenberg an opportunity
to excite the Cubans and bring the kind of recognition and reci-
procity he was looking for.

ROCI was surely a noble venture, but it had a dark side.
Rauschenberg said the goal of ROCI was to share selected informa-
tion filtered through art—to show people to themselves. The
colonization of natives has taken worse forms, no doubt. And when
Rauschenberg shows America to Americans, we can find it exotic
or irrelevant. But presuming to show people of other countries who
they are is surely patronizing and offensive.

Rauschenberg has not abandoned more personal work. Personal
iconography, however camouflaged, can always be found, even in

those works whose implications seem entirely public. But he still does occasional bona fide intimate pieces, like the 1982 series of three ceramic paintings called *All Aboardello Doze*, made in Japan but not part of the ROCI show, in which he superimposed his own signature (in Chinese) and other male images and symbols (including sumo wrestlers) over reproductions of Courbet's *Sleepers*, and the 1987 Bellini Series (photogravures) after Giovanni Bellini's *Allegories*, which includes another Ganymede. Yet this intimate work deals in strange displacements. In the Courbet series Rauschenberg puts forward a famous picture of lesbians—a strategy that brings to mind Ken Silver's observation that "female homosexual art is an acceptable (and even popular) way to defuse the potential power of 'otherness,' while male homosexuality is much more emphatically suppressed at the outset."[29] Rauschenberg seems oblivious to today's sexual and gay politics.

If Rauschenberg has continued to "alter what's expected" at all, he has done it primarily, in my opinion, through his record-breaking showmanship. Brilliantly suspended in his gap, he has never stopped using art to get away from life. Yet the life he continually escapes he carries around on his back. The ROCI project was named after his turtle Rocky, whom Rauschenberg brought into his household in 1963. In Asia, the turtle is a symbol that, like Atlas in the West, carries the world on its back. Rauschenberg has said he identifies his artistic mission with that of the Oriental turtle.[30]

After ROCI, what next? Maybe Rauschenberg will talk NASA into giving him a used rocketship to take his mission to the galaxies. He did say, "I'm old enough that I probably won't run out of land, but I would like to go to the moon."

1991

Notes

[1] Quoted in Barbara Rose, *Rauschenberg* (New York: Vintage Books, 1987), 72.
[2] Ibid., 85.
[3] Conversation with the artist, March 14, 1991.
[4] Conversation with the artist, September 12, 1990.
[5] Essay by Calvin Tomkins in Roni Feinstein, *Robert Rauschenberg: The Silkscreen Paintings, 1962–64* (New York: Whitney Museum of American Art, 1990), 15–16.
[6] Conversation with the artist, March 14, 1991.

[7] Jill Johnston, *Paper Daughter* (New York: Alfred A. Knopf, 1985).

[8] Related to the author by Mary Lynn Kotz.

[9] Conversation with the artist, September 12, 1990.

[10] Quoted in Rose, *Rauchenberg*, 114.

[11] David White's identification. The author thanks David White for his cooperation, providing information, photographs, and making records available.

[12] Kenneth Bendiner told me he believes the references in *Monogram* are to William Holman Hunt's *The Scapegoat* (1954–56), comparing, say, the hoofprints in the latter's sands of the Dead Sea to the footprints in *Monogram*.

[13] Feinstein, *Robert Rauchenberg*, 86.

[14] Rose, *Rauchenberg*, 61.

[15] Kotz says, "Some see the goat as autobiographical because as a child Rauschenberg had a pet goat whose death at the hands of his father upset him greatly." Mary Lynn Kotz, *Rauchenberg* (New York: Harry N. Abrams, Inc., 1990), 90.

[16] Calvin Tomkins, *Off the Wall* (New York: Penguin, 1980), 130.

[17] Feinstein, *Robert Rauchenberg*, 86.

[18] Ibid.

[19] Jonathan Brown, in *Velázquez* (New Haven: Yale University Press, 1986), says Velázquez could have seen the Hermaphrodite on one of his trips to Italy, when he was looking for sculpture there on a buying trip for the king.

[20] Charles Stuckey, "Reading Rauschenberg," *Art in America*, April 1977, 74–78. Roberta Bernstein followed Stuckey a year later: "Robert Rauschenberg's *Rebus*," *Arts*, January 1978, 138–41.

[21] Andrew Forge, *Rauschenberg* (New York: Abrams, 1964).

[22] Kenneth Bendiner, "Robert Rauschenberg's *Canyon*," *Arts*, June 1982, 55–61.

[23] See James Saslow, *Ganymede in the Renaissance, Homosexuality in Art and Society* (New Haven: Yale University Press, 1986), 52.

[24] *Rauschenberg Overseas Cultural Interchange* (Washington, D.C., National Gallery of Art, 1991), 90.

[25] Ibid., p. 179.

[26] The eleven countries of the ROCI tour were: United States, Malaysia, East Germany, USSR, Cuba, Japan, China, Tibet, Venezuela, Chile, and Mexico.

[27] Conversation with the artist, March 14, 1991.

[28] Ibid.

[29] Kenneth Silver, "The Body Politic," *Art in America*, March 1991.

[30] Kotz, 15.

Has Modernism Failed?

S uzi Gablik's book, *Progress in Art*, was acclaimed as an impor-
tant contribution to the theory of art history, a study in the
cognitive character of art. Since then the author has obviously had
a change of heart. Just as apparently, perhaps, Gablik herself does
not think so. In *Has Modernism Failed?* she writes that her new
work stands in complementary and dialectical relation to her ear-
lier book. But far from developing, completing, or adding to the
thesis of that work, Gablik has instead imposed a negative moral
judgment on her previous conclusions. The present work is not the
"psychological and social analysis" of art that Gablik claims it is,
but is in fact a moralistic defense of traditional values. It is also an
attack on what Gablik perceives to be the degenerative outcome of
the modernist ideas of autonomy and outrage.

In at least one important sense, *Has Modernism Failed?* actually
contradicts the thesis Gablik presented in *Progress in Art*. Central
to the earlier work was the notion that knowledge "is constructed
by the subject in an indissociable subject-object relation" and that
(in the Piagetian model of cognitive evolution) "the world as we
experience it is the cause of what we perceive and not the product of

our perceptions." According to that view, there is never an external reality independent of the thinking subject. In her book, however, the author assumes just such an independent reality, a reality that in this case takes the form of a transcendent authority. Though she never alluded to God in her previous work, it is the lack of (and need for) such a figure that now appears to be Gablik's true subject. She sees today's artists as living in a Godless state, as stranded in a society that created a dissident role for them, but then left them in the vacuum created by individualism and autonomy.

Gablik also views contemporary artists as dependent on the commercial machinery of capitalism—or what she refers to as "the bureaucracy." She believes that in the current commercial climate, with its emphasis on success, individualism has lost meaning. True individualism, in Gablik's terms, can (or should) only be identified as a condition of opposition. As the following excerpts indicate, Gablik defines modern art itself as an art of opposition: "The original meaning of the term avant-garde implied a double process of esthetic innovation and social revolt"; "the phrase art for art's sake is an unconscious protest against materialism"; "in its most abstract form modernism was self-consciously dissident, setting itself against the social order"; "for the committed modernist the audience doesn't really exist"; "painting was the one act of ultimate freedom that could transcend politics, ambition and commerce"; "our great art has been hostile or coldly indifferent to the social order."

Such comments summarize the ethic of opposition that dominated the modern art world until the recent past. For Gablik, that period is over. "It is more and more difficult to find a position of estrangement that continues to be relevant or potent," she says; "the negation in the outsider's position has lost its urgency." Moreover, provocations that once seemed radical have long since lost their power to shock; the most difficult art is comfortably familiar. "The once essential individuality and autonomy of the modern artist has now turned into an empty exercise in self-absorption and success"; "overweening narcissism, compulsive striving, schizoid alienation, have become the dark underbelly of individual freedom"; and "the moral burdens of autonomy are traded in for the comforts of security."

According to Gablik, modernism has failed because artists have been absorbed into the bureaucracy. "The archetypes of the artist

and the businessman, which previously straddled our culture as adversaries, have now joined hands." An ethic of failure (van Gogh is the modern prototype) has been replaced by a certain blasphemy of success (Julian Schnabel is a recent example). For Gablik, money and success are incompatible with meaningful art, which is art in contempt of capitalism.

Thus Gablik finds the "currently thriving art industry"—"the new pluralistic situation [in which] all modes of art can claim equal status . . . [and] everything can be accommodated"—clearly unacceptable. The diffusion of styles, the increased and widespread interest in art as well as in the practice of art, the confusion between success in the marketplace and good-quality work (or the lack of distinction between the two)—in all of these the author sees a dire lack of focus. More significantly, she sees a deplorable absence of the kind of authority that would give individuality its meaning. In Gablik's terms, authority can be defined in two ways—either as the power of the capitalist establishment or as the sway of those tribal societies that preceded the era of individualism, an era in which the artist was homogeneously contained. In her case against pluralism and postmodernism, Gablik makes a regressive appeal to this latter type of authority, an authority that, in her words, has "always drawn its vitality and influence . . . from the belief that its values transcend those of any one individual and go beyond merely personal aims." At the same time, she urges contemporary artists to flout the worldly trend of things, to reestablish the "heroic" age of isolation and contempt for success, of revolt and personal sacrifice.

Gablik's belief that today's artist has become estranged from society is contradicted by her own observation that artists are currently too enmeshed in the system, too caught up in the trappings that reflect society's dominant values. What she really means, one must assume from her argument, is that artists are now estranged from the kind of society she thinks we *ought* to have, either precapitalist or the oppositional (revolutionary) culture of modernism. Her criticism is directed, in the end, at the modern secular and capitalist state, which is good for the artist only if it opposes him and continues to define him (or her—though Gablik uses the male pronoun throughout) as a kind of failed capitalist, an outsider to the system. That there has been a historical dialectic between art and capitalist society—periods of opposition succeeded by periods of acceptance or co-optation—is ignored by Gablik.

There is a deep nostalgia in this book for the romantic outsider, whom Gablik still finds here and there, in splendid isolation, on the contemporary scene. She commends several artists for making art that (as yet) remains inaccessible, or opaque to the market, among them: Daniel Buren, Richard Long, Robert Janz, Jacqueline Monnier, Australians John Davis and Mike Parr, the early Chris Burden, and the Taiwanese expatriate Tehching Hsieh. One chapter, devoted to the graffiti artists of the late 1970s, stands out from the others in its more detached sociological approach. In this section, she lets artists and dealers speak for themselves, revealing a normal gamut of attitudes to success, a range of opinion not evident in Gablik's own reflections on the art world proper, which she presents as having arrived at a point of unchangeable conservatism. Moreover, she seems to excuse any success mongering engaged in by the graffiti artists.

A leading problem in this slim, provocative book is that the capitalist system Gablik opposes is the same system that has created the revolutionary artist she admires. The pluralist condition of contemporary art was largely produced by the very artists Gablik idealizes as transcendent giants. Duchamp, she reminds us, "demonstrated that art could be made out of anything" and that "there is nothing about an object—no special property or function—that makes something a work of art, except . . . our willingness to accept it as art." That willingness, which opened up the whole field of conceptual art, has vastly expanded the range of work produced on the contemporary scene. Gablik also hails the early Warhol for "subverting the notion of the handmade, 'original work of art'" and for calling the authorship of his work into question through his use of silkscreens. Warhol as celebrity, on the other hand, is viewed as a turncoat. To another observer, such a celebrity might appear to be a new kind of artist-hero (Erving Goffman, after all, has defined fame as a stigma); Warhol could be seen as an individual who successfully balanced his individuality against the demands of mass culture or corporate interests. Though to some he may have seemed unduly compromised, Warhol exemplified a new paradigm in society: the successful living artist.

Postmodernism has actually accomplished what Gablik prescribes—that is, it has undermined the modernist tenet of the separateness of the esthetic from the rest of life and has challenged the privileged status modernism claimed for the work of art. But

Gablik does not see this development as a positive change. Art, for her, should not be an instrument of capitalist interest, but rather a revolutionary tool. She suspects contemporary artists of having linked themselves indefensibly with those who should remain their foes—the self-serving capitalists. For Gablik, an acceptable alternative to the revolutionary artist is the artist as victim-savior (shaman)—the role artists have played in certain monolithic, homogeneous societies. Because our modern system, as she sees it, is wrong, individual artists should rebel against it—even if no popular consensus for rebellion exists. What Gablik doesn't recognize is that such a consensus is essential to attract individuals who are not simply self-destructive, or who have more than idiosyncratic personal reasons (youth, foreign status, other outsider credentials) for rebelling.

Regression to a precapitalist state (with artists submerged in the community) would mean a setback in the psychic growth in which artists have (or should have) a vested interest. As Gablik deals with issues of individual identity in relation to the state, or authority, it seems clear that she perceives that authority as an external condition—one that is imposed and given, rather than negotiable or transactional. For her, the individual is either submerged within the state (the original parent-child model) or pitted against it (the model of adolescent rebellion). She fails to entertain the possibility of subsequent stages of development—of adult reciprocity, individual responsibility, mutual trust, balanced exchange, processed agreement, common recognition, and so forth. Implicit in her account of the relationship between artists and society is an assumption of permanent political inequality. While artists *have* been cast as people who never grow up, the current businesslike attitude in the artistic community may be a sign that artists now wish to have more control over their fate—a stance that does not necessarily mean the forfeiture of creative zest.

The current, widely remarked abundance of artists, a phenomenon that seems threatening to Gablik, is a natural outcome of the great social convulsions of the 1960s and the early 1970s, and of political movements that represent the expression of emergent identities (chiefly women, blacks, and youth). Though the art world remains predominantly white and male, the channels for public exposure have opened up immensely to accommodate a wider range of participants. These are the fruits of any oppositional

period. To learn how to use new (or old) channels is considered by many to be an exercise in political intelligence.

Toward the end of her book, Gablik at last questions herself. "Sometimes it strikes people that I am claiming that worldly failure is the only virtue which can possibly keep the ideals of the professor from fading." Then, in one sentence, she curiously flattens out all her confusing polarities and distinctions, articulating the essential position of our times: "To be in any sense effective, we must proceed in conjunction with the system, by using its institutions as channels for positive change . . . only in this way can we strive for rescue from the system, even while we are enmeshed in it. We are the stewards, not the victims, of our circumstances." Indeed.

1985

The Artist as Social Worker

Eight years have passed since the publication of Suzi Gablik's last book, *Has Modernism Failed?* Her new work, *The Reenchantment of Art*, is a sequel to the earlier book, a restatement of her case against the modernist tradition and against society in general, and a more articulate, evolved, prescription for change.

Gablik says her discussions of art are focused on one essential theme: "What does it mean to be a 'successful' artist working in the world today?" She would like to redefine the conditions of success, and from everything I can gather, turn artists into ecologists and social workers, or at the least into contemporary *refusés*, celebrating nature with projects that can't be marketed. All her examples of artists working in the only way Gablik now considers significant show them cleaning up the environment, engineering structures for the homeless, participating in projects that involve kindness to garbage collectors, kids, street people, or drunks, or creating fragile objects in nature that summarily disappear.

The latter will be the most recognizable art described in her

book. Her English "ice-henge" artist, Andy Goldsworthy, who has created circles of packed snow bricks that "don't last even for a day" on a "ritual journey into wilderness at the North Pole," should bring to mind the walks and ephemeral earth drawings of Richard Long—marks made by his boots or by piling up sticks and stones in geometric formations the rest of us can't see, except in his photographs, which appear in museums and galleries. From Gablik's point of view, both Long and Goldsworthy should be considered crossover types. They have one foot pointed in the right direction, bringing natural wonders to our attention, but the other foot is planted squarely in hell—as both are commercially successful artists who sell installations as well as documentation of their projects in the wilds.

But Gablik covers Goldsworthy admiringly, and doesn't attack Long. Her special target is Richard Serra. For Gablik, the *Tilted Arc* controversy, in which Serra fought his opponents over the right to keep his big, leaning, curved steel wall in place at Federal Plaza in Manhattan, where it had been installed in 1981, represented "the ultimate model of social independence and the radically separative self; the heroic, belligerent ego of modernity, cultivating its divisiveness and lack of connectedness with others [and the] . . . refusal to be assimilated." For Gablik, Serra epitomizes the masculinist spirit, with its presumption of mastery, its "conquest mentality," its absence of accountability or compassion, and so on.

Gablik supports her fervid plea for a new kind of art with a matriarchist brand of feminism. She borrows her dialectic from a book called *The Chalice and the Blade* by Raine Eisler, which contrasts the patriarchal "dominator" model to the "partnership" model associated with the feminine. Gablik says, "cultural recovery of the feminine principle is the key to recovery from the institutional oppressiveness of patriarchy." She quotes from various examples of Goddess literature, most maddeningly the writings of one Marion Woodman, a Canadian Jungian who is scathing in her view of women who defect from "the feminine" by entering the masculine world, where the inevitably "act like men." Here Gablik makes common cause with many male Jungians as well, none of whom are so obvious as Woodman in their antifeminist descriptive polarities of the sexes as to suggest that women are too masculine nowadays.

In her overvaluation of traditional feminine principles of caring and relatedness, Gablik wants us to understand that she is no

feminist. The politics of equality—the striving of women to find meaningful work in the world under conditions of parity, and to be fully represented in government—contradicts the Jungian Goddess emphasis on the merits of femininity. Gablik quotes another female Goddess author, Linda Leonard: "When women hope to achieve the victories of men by being like them, the uniqueness of the feminine is subtly undervalued, for there is an underlying assumption that the masculine is more powerful." Jungians are notorious for their dissociation of the "feminine" and the "masculine"— "archetypes," which they see as groups of antithetical qualities located a priori *in nature*, rather than as characteristics produced by social programming and sexual politics.

Carl Jung's theory of archetypes can today be seen as a translation of the cultural gender biases of his time. One-half of his model for character completion—the male's development of his supposedly hidden female side—is actually the basis for the futuristic paradigm Gablik develops in her book for art. The other half of the Jungian model—the development by the female of her (hidden) male side—is seriously compromised by Jung's political view of women: "No one can get around the fact that by taking up a masculine profession, studying and working like a man, woman is doing something not wholly in accord with, if not directly injurious to, her feminine nature." The times have changed, but Jung's followers, now numbering Gablik among them, go on plying the same ridiculous claims. Chiefly, they continue to assert that the sexes *intrinsically* carry the traits associated with them by society. In Jung's time this belief pervaded society; in our time, it's possible to understand those beliefs as cultural, politically expedient, fictions.

It would be hard not to agree with Gablik that caring, compassion, and community are what's missing in our patriarchal world at large, as well as in special domains like art. But how are we to achieve a more caring society, and under whose auspices? Gablik seems to posit a new world brought about mainly through the agency of men who access their "feminine" sides. Indeed, in her book, fully 75 percent of the authorities quoted are male, while the majority of examples she cites as worthy of emulation are also male.

The individual versus society has been the particular adversarial dynamic of the modernist avant-garde. Now Gablik would have artists abandon their struggle against the world and join, instead, in cooperative, accessible modes of work. There is a problem right

here, however. If human society remains pathological, as Gablik and many of us seem to agree it is, artists are still leaders in deviating from that society or in (re-)creating themselves in contradistinction to it, and in the process commenting on it. "Art for art's sake," despite its apparent purposelessness and social uselessness, has had an important hidden agenda in twentieth-century thinking: it provides an arena of dissent for individuals raised in our society's pathological family structure that establishes a system of rights and privileges empowering one sex at the expense of the other, assumes superiority over whole classes and races, and includes the abuse or improper use of children.

The artist as child, a figure who transcends the childhood abuse endemic to the modern family, has been a hallowed entity in our culture. The artist as dissident remains a valuable model. *To be oneself*, to be an artist, has meant finding recognition and a self-empowerment that isn't a given in the patriarchal family (especially, of course, for girls, but also for boys of disadvantaged race, class, or individual circumstances). Gablik writes, "Within modern culture, society has been characterized as a hostile rather than a resonant environment for the self unfolding of the individual." And it still is.

Gablik is very good on the co-optation of dissent by the art market, with its ultimate cul-de-sac for the avant-garde. And she has an instructive chapter on the strategies of deconstruction—David Salle, Allan McCollum, and Sherrie Levine are among the artists discussed here—in which she deals with the closures of the avant-garde and the absorption of the imperatives for originality. For Gablik, however, deconstruction is an intermediary step, a transitional stage on the path to what she envisions as a "reconstructive postmodern practice" that will be an esthetic of "interconnectedness social responsibility and ecological attunement."

Admirable among artists working in the partnership mode is Mierle Laderman Ukeles, described by Gablik as an "unsalaried artist-in-residence at the New York City Department of Sanitation since 1978." In one of Ukele's early works, called *TouchSanitation*, lasting eleven months and taking up eight hours a day, she visited the five boroughs of New York and personally shook hands with everyone in the sanitation department. More recently, in *Flow City*, Ukeles designed an observation deck for the public at the site of the

city's new marine transfer station on West Fifty-seventh Street, where zillions of tons of garbage are transferred every day from trucks onto barges for transport to the Staten Island landfill. Gablik extols another New York artist, Tim Rollins, for his work as a teacher of art to learning-disabled children, inspiring collaborative projects, mainly large-scale paintings, derived from classic works of literature. The environmental-minded artist Dominique Mazeaud has involved herself in a project called *The Great Cleansing of Rio Grande River*. Once a month, on the same day of each month, she went out to clean up the river, using garbage bags donated by the city of Santa Fe.

Despite the dominant isolationist esthetic of modern art, artists in our time have always responded to high-profile cultural and social issues: wars, depressions, civil rights struggles, feminism, and now concerns for ecology and the dispossessed. Gablik provides a service with her book in bringing forward examples of artists addressing the social problems of the day. But she has created, based on these anomalies, an entire new paradigm that seems to suggest that the end of patriarchy is nearly at hand. Or, if it is not, she proposes that artists, by giving up the most important thing they possess—their individuality, their power to define themselves—can end patriarchy themselves (despite the fact that most of them, as men, have a stake in the patriarchy).

Gablik is drawn to artists working outside themselves, functioning in essence as ecologists, social workers, and nature lovers. There is a movement among a different group of artists, those who go inside themselves and use their autobiographies as subjects, that is given no place in Gablik's book. Yet there is a logical progression, in the modernist tradition of dissent, toward deeper, more personal revelation, with the aim of uncovering in greater detail, with more piercing scrutiny, the actual sources of dissent in society.

A truly big autobiographical movement in art could be as challenging to the cul-de-sac of modernism and to the art market as social work. Artists may be refugees from the modern family, but they are also paid, in a sense, to cover up their early experiences within it, and serve the market-supported perpetuation of various abstract esthetic ideals.

Gablik's "true community" of caring, compassionate people could emerge in the art world through shared autobiographies, that could in turn link artists with writers and people at large, many of

whom are already telling their own stories as if their lives depended on it. Suzi Gablik's own story—just say, the recent part, about how she came to make her dramatic transition from art world insider to save-the-world outsider—could make a lively contribution.

1993

List of Publications

The following articles originally appeared in:

Art in America

The Artist as Social Worker
Carrington: A Life
Family Spectacles
A Fluxus Funeral
Hardship Art
Intimate Moves
Jigs, Japes, and Joyce
Has Modernism Failed?
Painting Charleston
The Punk Princess and the Postmodern Prince
Tracking the Shadow
Trafficking with X
Walking into Art
The World Outside His Window

Movement Research

How Dance Artists and Critics Define Dance as Political

MS Magazine
The Inner Life: When Reality Fails
Sins of the Fathers
The New York Times Book Review
Daddy, We Hardly Knew You
Divided Against Her Father
Fictions of the Self in the Making
For Sylvia
Imagine a New Kind of TV Soap: Bloomsbury Comes to Dallas
Lies My Mother Told Me
Living on Borrowed Importance
Why Iron John Is No Gift to Women
The Village Voice
Remembering Charlotte Moorman
Wiesbaden/Da Capo
Between Sky and Earth